W9-AZA-244

digital photography
special effects

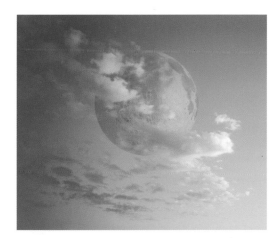

digital photography
special effects
michael freeman

Amphoto Books
an imprint of
Watson-Guptill
Publications
New York

First published in the United States in 2003
by Amphoto Books
An imprint of Watson-Guptill Publications
A division of VNU Business Media, Inc.
770 Broadway, New York, NY 10003
www.watsonguptill.com

© The Ilex Press Limited 2003
Images © Michael Freeman

This book was conceived, designed, and produced
by: **The Ilex Press Limited, Cambridge, England**

Publisher: **Alastair Campbell**
Executive Publisher: **Sophie Collins**
Creative Director: **Peter Bridgewater**
Editorial Director: **Steve Luck**
Design Manager: **Tony Seddon**
Editor: **Chris Middleton**
Designer: **John Grain**
Development Art Director: **Graham Davis**
Technical Art Editor: **Nicholas Rowland**

*Any copy of this book issued by the publisher as a
paperback is sold subject to the condition that is
shall not by way of trade or otherwise be lent,
resold, hired out or otherwise circulated without
the publisher's prior consent in any form of binding
or cover other than that in which it is published and
without a similar condition including these words
being imposed on a subsequent purchaser.*

Library of Congress Control Number: 2002109273

ISBN 0-8174-3825-4

*All rights reserved. No part of this publication
may be reproduced or used in any form, or by any
means–graphic, electronic, or mechanical, including
photocopying, recording, or information storage-
and-retrieval systems–without the prior permission
of the publisher.*

Manufactured in China

1 2 3 4 5 6 / 07 06 05 04 03 02

For more on this title and on digital photography
special effects, please visit: **www.dpspecialfx.com**

Contents

The Revolutionary Spirit

PHOTOGRAPHY is regularly claimed to be undergoing one kind of revolution or another, and sometimes this is true. 35mm film, single-lens reflex cameras, color film, autofocus, point-and-shoot cameras—all have had an impact on the way photographs are taken, by whom, and of what. Many of the significant changes, however, have taken time to be recognized—for instance, the emergence of reportage photography with the invention of the Leica. This camera was designed to use the newly available, sprocketed motion picture film stock, and inspired all other handheld, eye-level cameras, which in turn made it possible to shoot quickly and unobtrusively.

Now we have digital photography, which, on the face of it, is a large amount of technological change for the sole purpose of replacing film and fitting photography into the world of email. While there is some truth in this, it is far from the whole story. An invention this radical, which is changing almost every piece of equipment, challenges the forms that photographs take, *and* what can be done with them.

It's seventy-odd years since the motion picture industry introduced us to 35mm film, which crossed over to still photography as well. That industry also gave us the term "special effects," coined for all those techniques that were invented (from the earliest days of cinema onward) to transcend reality. Movies, and Hollywood in particular, have led the way in special effects, because of two factors: a demand for things that audiences have never seen before, and the finance to create them. Of course, special effects began long before digital imaging, but until Stanley Kubrick's *2001: A Space Odyssey* these required a massive suspension of disbelief on the part of the audience. After *2001*, the standards of cinematic realism were set. So when digital effects became possible, they were bound to take over—for the simple reason that anything, absolutely anything, could be done to an image with digital technology. Without turning this into a history of cinema, the turning point was *The Abyss*, which hinged on the complete believability of a sequence where a horizontal, moving column of water developed a human face.

Up until now, mainstream photography has not used this kind of technique. After all, one of still photography's hallmarks has been its actuality. While this is fertile ground for passionate argument, most

photographers have used the camera to show what they've seen, not what they've invented. This has usually been seen as a virtue, but it was also largely unavoidable. It takes enormous effort to alter a photograph taken on film. For some photographers this was a frustration, or at least limited what they were able to do. Man Ray, the American Surrealist photographer who worked in Paris in the 1920s, considered "straight" photography to be no more than a "banal representation"; an extreme view, perhaps, but a legitimate one for an artist bent on subverting reality. "I do not photograph nature. I photograph my vision," he declared.

Ray's techniques were those at hand, such as photomontage, multiple exposure, hand retouching, and any darkroom procedure that came along by chance, such as solarization. Photomontage was also used by John Heartfield, László Moholy-Nagy, and Hannah Hoch in their constructed images. Other photographers who worked imaginatively were Jerry Uelsmann, Clarence John Laughlin, Josef Sudek, and Harry Callahan, who all used multiple printing; Ernst Haas, who sandwiched color slides; Hiro (Yasuhiro Wakabayashi) with his multiple exposures and light streaks; and André Kertesz, who used distortion. There has always been a talented body of photographers who have invented, added, and altered.

The constraints were technical, and doubtless discouraged less determined photographers from exploring this kind of imagery. Within the space of a few years, however, these limitations have been lifted, which makes for a very interesting state of affairs. When you load a digital image into a computer you are presented with the option of adjusting its color, brightness, and contrast. This is merely a first step in image management. If there is any lens distortion, you can correct that. And if you feel that some element mars the composition.... well, I won't labor the point. There is no break in the sequence of things that can be done to the image, all the way up to a complete restructuring.

Whether or not you work on an image digitally is less important than the fact that you can. The process of photography, which with film (for the most part) ended with the exposure, now extends as far as you want to take it. Digital photography becomes rich with new possibilities that do not have to conform to any traditional view of what a photograph should be. It is these that this book explores.

Michael Freeman, London 2003

TOOLS

DIGITAL PHOTOGRAPHY is all about software, and most of it is for the computer, not the camera. The hardware issues, relating to cameras, computers, and peripherals, are mainly those of performance rather than the type of machine. Photographic images occupy significant disk space because they are complex and detailed entities. For the most part they exist as arrays of pixels, usually between a few and many millions, and changing large numbers of these requires substantial computing power.

Modern desktop and laptop computers can handle most procedures, but the more demanding ones, such as distortion, can still be unacceptably slow. A few may be beyond the computing power of certain machines—that is, they need more memory and faster processing speeds. These are the practical matters to be sorted out at the very beginning.

All imaging software involves changing the values of pixels, but software for special effects has, appropriately, a special characteristic. It is designed to alter our perception of what the image is about. To work, it demands recognition of what the subject is, and a plan for what the subject is going to be. Put another way, all special effects operate on an axis between two states—source and destination—and there is a perceptual difference between the two. This is why such software is usually complex, and the processes can rarely be completely automated. It needs the user to decide what should happen, and why.

The distinction between software tools that simply change images and those that create specific effects is important when understanding how the latter work. For example, in a standard image-editing program,

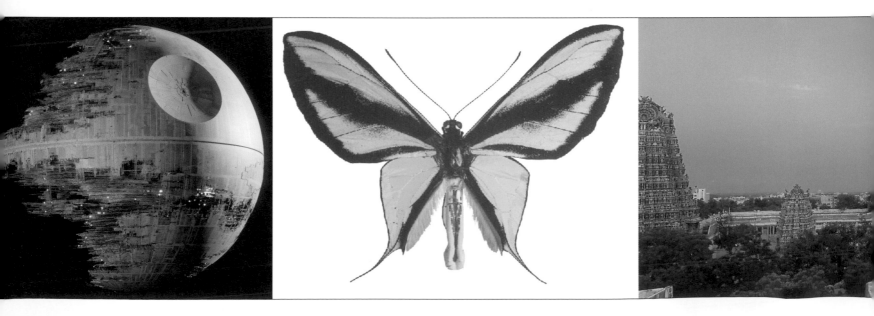

a tool that makes the highlights brighter and warmer does it by finding the brightest pixels, increasing their brightness by a certain percentage, and shifting their hue toward red and yellow by another percentage. A flame-generating filter also brightens and warms the colors of pixels, but it has to do much more besides: it needs information on what flames look like and how they behave, and also about where to place them. To do this, the designer of the software must first research the physics and behavior of flames, and the user must guide the filter to the parts of the photograph that will appear to burn.

Using this information to change the right pixels in the right way is the job of an "algorithm," which is simply a formula for solving a particular problem. Algorithms are at the heart of all special effects and translate the appearance of the desired effect into digital changes. The algorithm for flames is very complex, involving many parameters, as we will see. It is because special effects are highly specific ("make flames," "add water," "squeeze an object," "grow fur") and usually complex that much of the software is written independently of the main image-editing programs, like Adobe's market-defining Photoshop.

While software dedicated to creating particular effects has a well-defined role, it is important to put it in perspective. If you know enough about the real effect that you are trying to simulate, you can probably create it from within your basic image-editing program, using standard tools like selections, cloning, blurring, and so on. What many of the independent effects programs offer is the knowledge of which procedures to use and the convenience of pulling them together under a few simple controls. But you, the user, are still in charge.

Your Camera

There's a bewildering variety of digital cameras available, many of which look very different to the familiar SLR. So what are the issues?

This is no place for a primer on the technology of digital cameras, but we should consider the particular advantages these cameras offer for special effects. If you are coming to digital photography from traditional photography, you probably have an archive of images, on film of course, that will be useful source material. These need to be scanned, either by you or a commercial lab. However, for original photography, the arguments for switching to digital are now compelling.

Pixel-Packing Solutions

The most obvious argument is the smoother workflow. As the special effects are going to be applied digitally, it is much faster and less messy to shoot digitally, transferring the images directly to the computer, than to scan and correct film. In addition, the image from a decent-quality digital camera is cleaner than a scanned film image—no dirt, scratches, or other artifacts (blemishes that have been added to the image by the process).

In fact, a digital camera image is arguably cleaner than film, period. Why? A digital image is built from pixels. As long as the image is not over-magnified, these remain invisible. A film image, on the other hand, is made from grain (or the dye-cloud residue of grain, in the case of color transparencies), and this is often visible. Of course, not everyone agrees that this is a defect. Many photographers like the texture. One of the standard procedures in making digital images look like photographs is to add a little "noise," as you can see in several instances in this book. Nevertheless, grain remains an artifact.

A benefit of digital photography that is peculiar to special effects work is registration. Imagine that you are shooting a scene with, and without, one element— perhaps a person—or a scene in two kinds of lighting. You may wish to combine the images in some way. With a digital camera on a tripod, you'll have a perfect match, to the point that you can paste one on top of the other in an image-editing program in exact register. This is much more difficult with two scanned film images, because even if the dimensions are equal, one is almost certain to be rotated slightly in relation to the other.

Any Port in a Storm

Any digital camera from which you can transfer images to a computer is usable. Quality is another issue, but what matters is how you intend to use the final image: onscreen, or in print. If it's the former, the resolution can be low; the most you are likely to need is an 800 x 600-pixel image at between 72 and 96 dpi (the size and resolution of a typical monitor). Such an image will not be bigger than 1.5 MB uncompressed. In print, resolution matters. As a rough guide a five-megapixel camera will be fine for an A4 print. Other factors are the optical quality of the lens and dynamic range of the chip (how much color and tone it can distinguish), but the key issue remains resolution. The more megapixels the better!

Digital cameras range from the familiar-looking to the baffling—if your background is in traditional photography. But your main concern should be whether you can match the camera's resolution to the final purpose of the pictures you are taking. Print? Or Web?

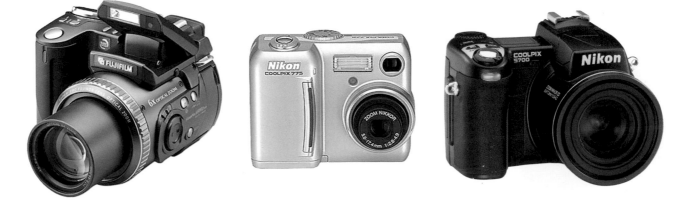

◀64mb Memory Stick

STORAGE CAPACITIES

Storage capacity

Zip	100–250 MB
CD-R	650 MB
DVD-R	5.7 GB
Hard drive	60 GB

Megapixel camera image: normal JPEG

0.7 MB

Image to print A5 size @ 300 dpi: RGB TIFF LZW compressed

1.6 MB

Image to print A5 size @ 300 dpi: RGB TIFF uncompressed

12 MB

Image to print A4 size @ 300 dpi: RGB TIFF uncompressed

25 MB

Storage size of an RGB image 2200 x 1600 pixels

Uncompressed TIFF

Typical photographic content 13.3 MB

TIFF with LZW compression

Typical photographic content 8.8 MB

Photoshop .psd file

Typical photographic content 10.0 MB

JPEG maximum quality

Typical photographic content 2.8 MB

Note: precise storage requirements depend on the image's content.

Memory is everything. Today there are a bewildering number of standard and proprietary storage options available for digital information. For example, Sony's Memory Stick (*middle left*), is interchangeable across Sony devices, but not other manufacturers' products. There are also a variety of storage cards that can be inserted into digital cameras, external card readers, or even into cards that can be inserted into a computer's PCMCIA slot.

Computers and Storage

Platforms, gigabytes, hard disks, RAM—such terms are a feature of the computing world. But what do they mean to you?

Most recent desktop and laptop computers are well equipped for handling images from digital cameras. But by definition, special effects involve more than the usual image manipulations. The criteria for choosing or upgrading a computer to handle special effects imaging are simple enough: speed and memory, and as much of both as possible. You can never have too much, and there are no drawbacks other than cost. Expense is no trivial matter, but imaging is always hungry for performance, and paying for it is one of the best investments you can make. Ultimately, performance boils down to the processor speed—how quickly the computer can perform operations—and the amount of RAM (random access memory) available to hold copies of the digital files on which you are working.

Making the Grade

Memory upgrades are easy to install on most computers (within the limits of your machine), and this makes the processor speed the more critical factor when you buy a computer. This is measured in hertz (mega- and, more recently, giga-), but the stated clock speed is less important than the speed at which a particular imaging application will run. Nor is it useful to compare clock speeds across platforms—Macs, at least for now, run faster than PCs of the same clock speed. Your best guide is an up-to-date dealer's catalog.

The rule of thumb for memory (as opposed to storage capacity) is to have between three and five times as much as the size of the image file you are working on. If you have a 20 MB file, for example, which would do for a page in a book like this, then 64 MB of RAM would be good, but over 100 MB would be better. In special effects, as with more routine image manipulation, your basic software is an image-editing program. However, many other, third-party filters and programs are designed to work on top of this as plug-ins. These may well make considerable demands on your system—distortion software is heavy on processing power—and as you acquire more plug-ins, you can expect to use more RAM. Indeed, there are minimum RAM requirements for all of this software, and they have a habit of increasing with new versions.

Mac or PC?

The arguments over platform, whether PC or Mac, tend to be partisan and exaggerated. We all have our preferences—mine is for the Mac, which is traditionally the professional's choice for imaging—but the majority of computers in the world are PCs running a Microsoft operating system. Because of these numbers there is a greater choice of software available for them. In the end, this matters less than your choice of processor speed and RAM. Cross-platform image-editing programs (such as Photoshop) run in much the same way on a PC and a Mac.

Software availability is certainly an important factor. In the broader context, the dominance of PCs means that there is more software written for them. But, this being digital imaging, Macs have the established hold, so both platforms are well served. Almost all of the software featured in this book has been chosen because it is available on both platforms—and if you happen to come across a program that isn't available for your operating system, there is always (as a last resort) emulation software that

MEMORY ALLOCATION

Depending on your operating system, you can often improve performance by allocating the maximum RAM available to the program you are using and quitting everything else. This was standard procedure on a Mac up to and including OS 9, but if you have purchased a Mac running OS X, the operating system will dynamically allocate the ideal amount of RAM to the application you are using.

CAMERA CONNECTIONS

One essential is the ability to move images from digital camera to computer, and there are several alternatives. One is a card reader, basically a holder for slotting in a memory card. Another method, depending on the camera, is to connect it directly by USB or the faster FireWire cable and port. With some cameras, you can shoot from the computer, using an interface that controls the camera settings. This is useful for studio work.

enables Macs to run PC software, and vice-versa. Unix and Linux (the "open-source" operating system that was based on Unix) have a smaller choice of imaging software, but if you are running either of these then you have almost certainly made a considered choice already and understand the implications. Linux, though, benefits from a global community of developers who share their wares.

Special Requirements

Special-effects work generates extra files, and these often add up to many times the size of the finished image. The reasons are straightforward enough. First, most special effects involve combining different elements. As you'll see in this book, there are few effects that involve only a single change to a photograph, and even when they do it's prudent to manipulate a copy of the original. That immediately doubles your storage needs. The second reason is the number of versions of any special-effects project. Although everything I'm showing here is tried and tested, I don't want to give the impression that the results are completely predictable. It would be boring if they were! Often, you will have two or three slightly different effects at different stages. Finally, because layers are so important, you will probably have a layered workfile several times larger than the "flattened" image that you output, and this workfile is always worth keeping.

How many of these steps you keep in the end is another matter, but the nature of special effects demands more storage space than usual. There are two kinds of storage: a "parking" area for work in hand, and archiving, which aims to be permanent. Fortunately, hard disk storage is both cheap and abundant.

Magnetic Personalities

Archiving calls for security, and some storage options are better for this than others. In particular, media that cannot be overwritten easily have the advantage, and non-rewritable CDs and DVDs are popular. Magnetic media like Zip drives, external hard drives, and tape can potentially lose data if they are placed near a strong magnetic field —admittedly unlikely in normal circumstances, but it's certainly something to consider.

How you store image files is as important as what you store them on. There is a variety of image file formats in general use, and these compress data in different ways. To reduce confusion, there are two that are almost universally accepted—TIFF and JPEG—and if you send files to other people or to labs, it's best to stick to these. TIFF files

(tagged image file format) have become a standard in digital imaging, particularly where printing is concerned, and they have the suffix .tif. They can be given lossless compression by the LZW (Lempel-Ziv-Welch) method, which does not degrade the image in any way but it is not universally readable.

JPEG (Joint Picture Expert Group) is both a storage format and a compression method, and files have the suffix .jpg. It reduces file sizes dramatically, but loses data in the process. Each time you save an image as a JPEG, you will degrade it farther, so it is best to leave JPEG-stored images straight out of the camera as they are—and if you color correct or manipulate them, save the result as a TIFF and as a copy. You can always convert a TIFF to a JPEG later, should you wish to publish the image on the Web. See the table on page 11 for storage differences for an image that would print at 300 dpi to roughly 5x7 inches.

GENERAL STORAGE MEDIA

CD-R
Features Tough, stable, and unaffected by magnetic fields. High capacity and widely used
Drawbacks Disks can be damaged by scratching
Good for Archiving; transferring large files

DVD
Features All the qualities of CDs with even greater capacity
Drawbacks Disks can be damaged by scratching. Not yet as widely used as CDs
Good for Archiving; transferring large files

Pocket hard drive
Features Very high capacity, small size
Drawbacks Magnetic, so not quite as safe as CDs and DVDs
Good for High-volume storage

Magneto-Optical
Features Rugged and unaffected by magnetic fields. High capacity
Drawbacks Less widely used than before; slow
Good for Transferring files; archiving

Zip
Features Inexpensive drives; very widely used
Drawbacks Limited capacity, so relatively high storage cost. Cartridges vulnerable to magnetic fields
Good for Transferring files; short-term storage

Tape
Features Inexpensive drives and tapes
Drawbacks Needs special software and some training in how to use
Good for High-volume, short-term storage

Monitors and Peripherals

It might seem obvious, but until your image is printed or posted on a Web site, your monitor is your sole viewpoint. It has to be a good one.

A good monitor is critical in image editing: it's where your images will spend most of their active lives. But special effects are not just about seeing; they're about judging as well, particularly where color balance is concerned. Special effects usually attempt to fool the eye, by adding to or adjusting a photograph in such a way that it still looks real. Small slips give the game away, which makes it doubly important that what you see onscreen is what you get in print. And the only way to see them is at a variety of magnifications on a big (21-plus inches), accurate monitor.

Color Management

The eye sees a range of colors in real life—far more than either photographic film or a digital camera can capture. Any monitor can display even fewer than a photograph, and a printer fewer still. In other words, the image passes through equipment with progressively smaller color reproduction capabilities, and the problem is to keep the result both acceptable and consistent.

At the very least you must calibrate your monitor. There are a number of ways of doing this—your computer has some options preinstalled—but the general idea is to get whites, blacks, and mid-grays absolutely neutral. The quick and easy method is to eyeball it yourself. This involves judging a neutral gray, which you can do in a darkened room. At the opposite end of the accuracy scale, the colors onscreen can be measured with a spectrophotometer, but as these tend to cost a great deal of money, they are out of the question for most individual use. In between are calibration kits that use a colorimeter (the "home brew" version of a spectrophotometer), of which the Monitor Spyder, used with PhotoCal or OptiCal software from ColorVision, is a perfectly good option to choose.

COLOR MANAGEMENT BASICS

The key to color management is to build profiles for all the devices that you use—typically camera, scanner, monitor, and printer. A profile is a computer-readable description of how a device behaves in its handling of color, and fortunately the software that most photographers use now recognizes profiles automatically. For instance, if you open a camera image in Photoshop, a dialog box will prompt your acknowledgment of the recognized input device. At a professional level, things are not so simple. Proprietary color management systems measure color targets with a spectrophotometer, and the manufacturer's profile usually needs adjusting.

Because of all this, it pays to take care when selecting a monitor. Most laptops and some desktops (including some Macs) offer no choice—they come with a built-in screen—but if you can buy your monitor and computer separately, shop around. Some monitors are better technically, others are designed to give a particular balance, which is an esthetic choice.

One source of confusion is the success of flat, active-matrix screens, which are increasingly taking over from traditional CRTs (cathode-ray tube monitors). All well and good, but with an active-matrix screen the apparent brightness and color depend on the angle at which you view it. This is a problem inherent in the technology, and is less evident the farther away you sit.

Among the innumerable devices that you can connect to a computer—peripherals, in other words—there are just a few that are essential for imaging. The priority lies on just three: a scanner (if you have film originals); a printer (at the least for proofing); and a graphics tablet. The latter might come as a surprise, but try drawing long, smooth strokes with an airbrush tool while using your mouse.

The Pixels are Coming

Digital cameras will take over most photography, but until that happens, scanners have a vital role in converting slide, negative, and print images into digital form. Indeed, they are growing in importance as photographers with archives of traditional pictures feel the need to digitize them. As with all digital equipment, the choice depends on the final use, with resolution being the prime consideration. Most professional photographers need to supply images that can be printed up to full-page or double-page size. In the stock photography business, where images are licensed to book and magazine publishers, 40 MB is an acceptable high-resolution scan size.

Hence the success of 4000-dpi slide scanners, such as the Nikon Super Coolscan range. After a professional drum scanner, which in terms of expertise and cost is beyond most individuals' means, these are top-end scanners, and their resolution is more or less equal to fine-grained transparency film, like Fuji Velvia. Midrange slide scanners

operate in the 1500–3000 dpi range, delivering file sizes of roughly 50 MB from a 35mm slide.

Inkjets Join the Dots

The revolution in inkjet printers has challenged the photo-finishing business. The technology has jumped the barrier of results that are good enough for most purposes, and by shrewdly selling the machines cheaply to make money on the ink and paper, manufacturers like Epson and Hewlett-Packard have made home printing apparently affordable. Inkjet printing in the early days was a lowly technology, using "dithering" (also known as "uncontrolled splatter") to mimic the half-tone dots used in printing books and magazines. Constant refinements, however, have made it the technology of choice for home printing.

As we are dealing exclusively with images, and for the most part manipulating them, a graphics tablet with a cordless stylus is such a "natural" piece of equipment that I can think of no reason not to have one. A mouse is fine for jumping and clicking around the screen, but for those image-editing tools that mimic brushes, pens, and erasers, a pen-like stylus has no rival. Manufacturer Wacom, incidentally, offers a free suite of good special-effects software with its tablets, including a distortion brush.

The latest development in graphics tablets has the potential to really upset the order of things. Pioneered by Wacom, active-matrix tablets offer a screen-on-a-pad: the drawing area of the tablet mirrors the image on the monitor. Using one of these (currently expensive) tablets, you can draw with the pen directly on the image, which is quite a different way of working. In effect, the tablet replaces the screen. An interesting idea, although anyone who has grown up with normal graphic tablets will probably not feel any pressing need to change.

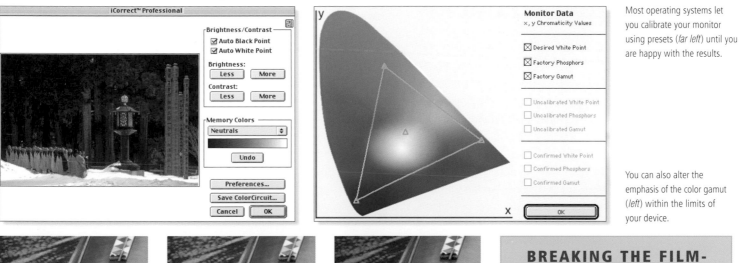

Most operating systems let you calibrate your monitor using presets (*far left*) until you are happy with the results.

You can also alter the emphasis of the color gamut (*left*) within the limits of your device.

An image scanned at 1200ppi on a Linotype flatbed scanner.

The same image scanned at 2400ppi on a Linotype flatbed scanner.

Finally, the same image scanned on a Nikon Coolscan 8000 scanner.

BREAKING THE FILM-GRAIN BARRIER

Film grain sets a limit to the level of detail that can be captured in conventional photography. A good scan should be able to resolve the grain, but while professional drum scanners have long been able to reach this level, it has until recently been beyond desktop scanners using CCDs. With the Coolscan 4000 and Coolscan 8000 (the latter accepts 120 rollfilm as well as 35mm) Nikon have effectively broken this barrier. At a maximum resolution of 4000 ppi, these scanners more or less reach the resolution of fine-grained emulsions, such as Fuji Velvia. Coupled with a 4.0 dynamic range, they open the doors to digitizing existing photos professionally.

Image-Editing Programs

Large image-editing applications are constantly updated, and they get ever more complex. Where do photographers stand?

If you already have an image-editing program, you will have most of what you need to create special effects. The immediate interest with such programs is which parts are genuinely useful for the combination of photography and special effects, rather than for illustration, Web site design, page layouts, and so on. Version changes always add, never subtract, but it's healthy to be sceptical about many new software improvements. Many of them are made solely to keep the product's momentum going, or to add the Holy Grail of so much software today: "Web functionality." Few software engineers have a deep understanding of photography, so you have to pick what you need from the plethora of digital tools and forget about the rest.

Feature Rich, Information Poor

Image-editing programs, being main applications, are dense and complex—"feature-rich," in software jargon—and they offer considerably more than any one type of user will ever need. Photography is only one aspect of imaging. It would be a waste of time to attempt to master everything in such an application, so for the purposes of this book we can ignore type, page layout, Web page design, animation, and professional printing. On the other hand, it is important to be familiar with the full range of procedures for altering images. Many special effects that are not immediately obvious are made possible through the mutually beneficial effect of combining two or more procedures. This, as we'll see on the following pages, is the basis of many third-party filters.

But here I intend simply to highlight certain features selectively that have a special relevance to both photographic images and to the kinds of special effects we visit on them. There *are* other essentials, but they apply equally to other kinds of images and purposes.

Color information is stored in channels, one for each defining part of a color mode. To manage digital photographs, you need access to these channels. I stress this now because not all image-editing software lets you do this. The three most common modes are RGB (red, green, blue), CMYK (cyan, magenta, yellow, and black—the "K" stands for "key plate"), and Lab (luminance and two color axes). In addition, of special importance in photography is the color model closest to human vision, known as HSB (hue, saturation, brightness) or HLS (hue, lightness, saturation), or Munsell's (hue, value, and chroma). This is not accessed through channels but is usually available through a dialog in the program.

Channels are also used for storing selections and masks (of key importance in special effects). The various methods of selecting parts of an image are described throughout this book, and they are the first step in making a composite image. You need to be able to save selections, and this of course means saving them into a channel. (The software term for this non-color variety is "Alpha channel.")

Another fundamental way in which software subdivides images is into layers. The usual analogy is a stack of transparent sheets, each containing an element of the image, that when viewed from above combine into a single visual. Layers are created as wanted. They are immensely useful in compositing images and for applying separate procedures to different parts.

Photographic Unrealism

The texture and detail in most photographs is distinctive and difficult to imitate. Among the numerous tools found in most image-editing program toolboxes, the *Clone* tool (known as the *Rubber Stamp* in Photoshop) has a special value because it can paint areas of an image using any other part of the image as source material (of color, texture, or image element). The brush settings that adjust size, softness, and opacity are a critical part of the process.

Filters—small individual programs that reside within the main application—are the basic functional unit of special effects. They are available from other manufacturers as plug-ins to the main application, but a number are also supplied bundled with it.

Finally, the ability to correct mistakes by stepping back through procedures is extremely valuable when your work involves a long sequence of changes. In Photoshop's *History* palette, not only the record of the changes you've made can be accessed, but it is also possible to restore an earlier stage selectively with a brush.

Adobe Photoshop (*above left*) Adobe's cross-platform image-editing software is still a benchmark of quality, and remains most professionals' choice.

Adobe Photoshop Elements (*above right*) Photoshop's sibling is a cut-down, entry-level version with many of Photoshop's features, plus useful presets and effects.

PhotoRetouch Pro (*above*) Binuscan's pro package has numerous pre-press, calibration and device profile functions, and does not force you to work in layers.

Paint Shop Pro (*right*) From Jasc Software, PSP is the main rival to Photoshop, offering over 75 special effects, animation, and presets at a budget price.

Effects Suites and Plug-ins

Image-editing software is a main application, so the more specialized, expert tools will have to be sourced separately. This is a good thing.

There is another world of software that will loom large in this book, and it is inhabited by programmers and programs dedicated to photographic special effects. Why this should be so is only partly explained by user demand for new techniques and procedures. The realm of special effects lies close to the heart of digital virtuosity. Because it is challenging and specialized, it attracts talented software engineers. Some of the software you will see here was clearly designed by those with a love of solving problems rather than merely commercial motives. This, I imagine, is what makes most of it affordable. Some of it is free, none of it is shoddy, and some of it is astonishingly good.

Here is a rundown of what is easily available, filtered to remove effects software which, in my opinion, is of little use in professional photography.

Getting Fired Up

Because image-editing is the basic application that everyone uses for digital photography and manipulation, most specialist software is designed to work within it. This involves adding software modules known as "plug-ins" to the main application. As Adobe Photoshop is by far the largest image-editing application, all plug-ins work with it. Files need to be added to the operating system preferences, and sometimes extensions do as well. A few programs operate independently (as "standalones"), and at least one (Auto FX DreamSuite) offers the choice of running as a standalone or as a plug-in once installed. Although some filters are sold singly, groups of them are known as suites, the most usual form in which effects filters are sold. There may be no choice but to buy the lot, or else there might be a discount for purchasing the full set.

The role of these often small third-party suppliers is an important one. Special effects are, by definition, specialized, some of them so much so that it's not worth including them in a main image-editing application. The research and software engineering involved is heavy and costly, as even a glance at one of the more technical, less user-friendly filters, such as Panopticum's Fire, suggests. Only companies with the killer combination of low overhead and high enthusiasm can do this!

Some effects software is designed to meet a clear demand: realistic drop shadows, for example, are tackled admirably by Alien Skin's Shadowlab in its Alien Skin 4000 suite, or the many photographic filters in nik Multimedia's Color Efex. Other software has appeared because it seemed like a good idea and a challenge to invent—for example, Lloyd Burchill's program for creating planets, LunarCell, from Flaming Pear. Occasionally, a filter is an unexpected by-product of other software, such as Craig Hockenberry's Organic Edges (from Furbo Filters), which came from research on satellite images.

One of the problems that these software manufacturers face is that good, necessary ideas tend to get appropriated by the main image-editing program in its next version. Distortion brushes are a case in point: the one introduced in Photoshop version 7, called *Liquify*, is very good and more or less removes the need for any third-party alternatives. Consumers benefit from this because third-party software companies have to stay on their toes and produce better tools to stay ahead of the giants.

ACQUIRING SOFTWARE

Before you commit yourself to purchasing software, most developers offer you a means of finding out what it does. This may be in the form of a demonstration, or a trial version that is time- or save-restricted, or which has had its output options limited. In other words, the software will expire after a period (usually 30 days), or will not let you save any work, or export it. Sometimes, the trial version can be converted to the full version by releasing a code once payment has been made. Downloads are an increasingly popular means of delivering software, and some manufacturers offer a discount for doing this. Otherwise, software is traditionally delivered on CD.

"Shareware" is created by smaller independent programmers, usually individuals, and relies on trust. The software is available for download. If you like it you pay a modest amount, receiving in return some nominal advantage, like the manual, or freedom from adverts.

Freeware is just that, offered altruistically and usually without frills. Do not expect technical support!

Popular plug-ins

Andromeda's *LensDoc* is a single filter aimed at solving the problems of lens distortion, which it does extremely well.

Flaming Pear's *Melancholytron* brings together all the controls for distressing an image in ways that create a melancholy mood.

Alien Skin's Eye Candy 400 features an impressive "shadowlab" that lets you create drop and perspective shadows with ease.

nik Multimedia's Color Efex Pro is a collection of 46 filters used to create mood, turn day to night, and add polarization for example.

Corel's *KnockOut 2* is excellent for removing backgrounds, and copes well with masking around hair, fur, and foliage.

Auto FX's DreamSuite filters includes a *Cubism* filter that can be applied to images, backgrounds, and even type to create often dramatic effects.

Panopticum's *Engraver* lets you "engrave" lines on your images to create dramatic geometric patterns.

WORKSHEET

Idea
A frame-filling view of
famous movie props,
displaying a few
special effects!

Solution
Mix still-life photography
with digitally composited
objects

Software
Image editing, *Flare* filter

Techniques
Layer compositing, flare

DIY or Off-the-Shelf?

With so many specialist options out there for the creative photographer, how do you distinguish the good from the bad?

The availability of all this third-party software raises the question of how much of it is really necessary. The decision to purchase a third-party filter is partly a question of cost, but it also has to do with originality. Many image-editing applications' effects will be familiar even to a general audience if used without great care. They have a "signature," in that the images they create are distinctive and unvaried, or their options are limited (such as with certain flare and motion blur filters). In general, effects software can either aim at convenience, or it can aim at creating original effects. The two are not always mutually exclusive, but software tends to lean in one direction or the other (as the sidebars on page 21 explain).

Convenience versus Originality

"Convenience" filters are best judged by whether they save you time, which usually means whether they are cost effective. The more inventive filters can be assessed in

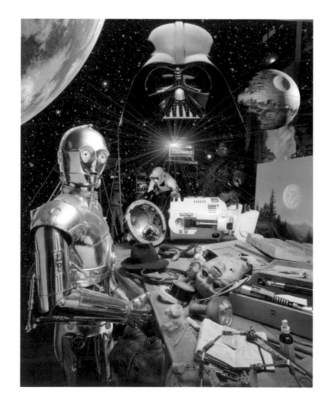

In a composite of the *Star Wars* and *Indiana Jones* trilogies, the space is filled with a mixture of wide-angle, deep-foreground photography and layered special effects.

terms of how much you actually need the effects. Effects for novelty's sake rapidly date. But even assuming for the moment that all of the third-party effects programs out there were freely available, would they still be worth having? Even if we exclude software that is not particularly competent (most programs are technically good) and software aimed at non-photographic imaging, this still leaves a large selection of technically good photographic filters. How then are we to discriminate?

Taken as a whole, software is always being improved, meaning that software engineers build on what has already been written. Code does not deteriorate or get lost. Casting a hypercritical eye over the options, we can find effects software that does not *quite* achieve what it promises—at least, not yet. A brief look at the history of metallic filters shows what can happen. Around 1995, the best you could hope for was a colored gradient shading in KPT (Kai Power Tools) and the Chrome filter in Photoshop (offering only the two parameters of "detail" and "smoothness"). Compare both of these unsatisfactory solutions with the more recent *Chrome* filter in Eye Candy 400. And then compare this with the even more recent metal effects in DreamSuite. This is one effects problem more or less solved, but there are others still in the pipeline. You might think twice, for example, about bothering with some "flame" filters until they improve considerably.

Dropping the Shadow

Some effects will remain beyond automation for the foreseeable future. Shadows are a good example. For some unknown reason, it took a few years for image-editing programs to come up with soft drop shadows, but once the need for these had been appreciated, the idea of perspective shadows was explored. This was an attempt to be procedural and have the shadow fall realistically on surfaces that already existed in the image. However, to be fully interactive with a scene, the software would have had to deal with the height and angle of the object and its surroundings—basically, a lost cause. This was exactly the problem for the image of the melting watch on page 131, and the solution was to create the shadow by hand.

A mixture of effects

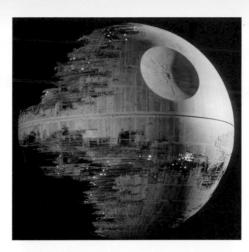

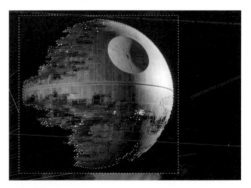

For an article on Industrial Light and Magic (ILM), props from some of its best-known movies were assembled in the warehouse. The shot was composed for later addition of objects.

For the sinister, looming presence of Darth Vader, the helmet, separately photographed, is pasted in oversized, so that it appears to hang in the background ominously.

As a pun on the dénouement of *Raiders of the Lost Ark*, the movie's Ark of the Covenant was placed in the center, and some flare added to its half-opened interior.

The backdrop to the whole scene is the planet Tatooine from *Star Wars* and a model of the notorious Death Star with all its practical lights, against stars.

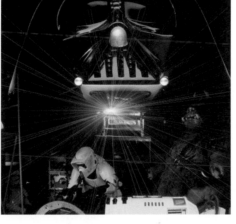

CONVENIENCE FILTERS

These filters are all reproducible with image-editing tools, but with a high degree of effort. They principally automate a sequence of procedures, and the time and effort they save is not to be disregarded.

Selective focus	Spotlight	Water
Perspective	Polarization	Embossing
Graduating	Day for night	Tiling
Center darkening	Mist and mood	Displacement
Old photographic processes	Lightning	Motion blur
	Some textures	Colorizing
Glow, halo, and corona	Metal	Simple fragmentation
Diffusion	Opaque plastic	

FILTERS: BEYOND THE BASIC

Because of the level of engineering—often involving advanced mathematical calculations—the effects of these filters cannot be reproduced with standard image-editing tools. Thus, while you could imitate a flare effect with painting and blurring, you would not be able to work out how it should appear for a given lens and a given light source.

Optical blur	Advanced organic textures	Morphing
Lens correction		Art media
Sunlight	Glass and plastic with refraction	Advanced fragmentation
Clouds		
Flames	Fractals	Immersive imaging
Fur	Distortion brush	

Stitchers

Image-stitching or panoramic software is an excellent example of a special effect that mimics and enhances our view of the real world.

In a category by itself is stitching software, and this is justified both by the software's unique capabilities and by the different forms in which the images can be created. By far the main use is in producing panoramas from a series of photographs, and for this reason you will also see it referred to as panoramic software. However, it has other applications that exploit its underlying ability to make seamless joins between overlapping images.

Stitching software has to be accurate to within one pixel. To work, it needs sufficient information in adjacent images; as a rule of thumb there should be a 30 percent overlap, but this depends on how much detail there is. If most of the overlap is a texture like sky, or distant grass, the software will not have enough to work with. At the software's heart is a set of procedures that fits images together so that their overall shape and innermost details coincide. It then adjusts their color and brightness for a perfect blend.

Warping for a Truer Image

The first part of the process involves warping one image so that it matches the next in shape and detail. The methods and interfaces vary from program to program and may combine manual and automatic procedures. One of the most basic is for the user to find the same detail in two images and place a control point, or node, over each. The more pairs that are located, the better the fit. This procedure naturally suits panoramas, which are ideal for landscapes, particularly those seen from a high viewpoint. Specialized panoramic cameras are no longer necessary; stitching software does it all. The results can be created as a flat image or in an interactive, scrolling movie form.

To create a digital panorama you need specific software. There are many packages available, some as shareware. In principle, you shoot an overlapping sequence of photographs by rotating the camera until you complete a full circle. You then import these images into the software, which joins them into one image. If you tilt the camera up and down to complete more rows of images, the software can create a complete spherical image. The basic method for stitching the images together is for the user to locate pairs of nodes precisely on adjoining images—the same technique used in morphing (pages 88-9). However, the software used in the example here is more sophisticated. It can work out the matching details and the necessary distortion, provided the images are placed closely by eye.

All in a Spin

Panoramic movies are a form of what is called "immersive imaging," and this is dealt with in Chapter 11. However, with the same software you can also produce normal still panoramas—indeed, the difference between the two is only in the final stage, the rendering. Such panoramas can be as long or as short as you like, and if the output is to be a print, a full 360-degree view will probably be too long. Yet another use is to create a mosaic of images up to any dimension, as the view of the Albert Memorial in London (*opposite*) demonstrates. The curvature is typical of panoramic images, even those produced on film by rotating panoramic cameras. While it is possible to straighten it out with distortion tools (see Chapter 7), it has its own character. One other advantage of creating a panorama or mosaic in this digital way is that the final image file can be large enough for an extremely high-resolution image (good enough for a poster).

Because the software can cope with distortion, a wide-angle lens is ideal, as it needs fewer images to make a panorama, and for the same reason, a vertical format is usually better than a horizontal, as it has more depth. To avoid parallax, which makes it difficult to match images, the camera should ideally rotate around the nodal point of the lens rather than around the camera body, but this is significant only when there are nearby objects. In fact, most modern stitching software can cope with handheld shooting; nevertheless, it is better to rotate your view around the camera than around yourself.

The software procedure varies according to the program. In the largely automatic Stitcher from RealViz, used here, the focal length and the warping it needs to match images is estimated and updated by the program. Prior to rendering, the images are equalized to adjust brightness, but the actual blending of colors and tones is performed during the rendering.

High-resolution mosaic

1 Using a 100mm lens handheld from one position, a series of overlapping frames covered the restored and regilded Albert Memorial. As in the panorama, the blending of the sky is faultless.

2 Some of the three dozen images loaded into the *Image Strip* window of the RealViz Stitcher software, prior to assembly in the *Stitching* window.

A six-frame panorama

1 The six overlapping frames that are to make up the panorama, all exactly the same size, are first loaded into the program, then dragged one at a time into the *Stitching Window*, where they are automatically warped to fit.

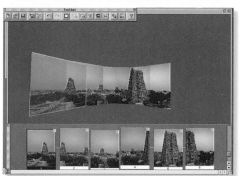

2 A planar output of 2344 x 643 pixels reveals the excellence of the stitching procedure in the seamless blend of the sky —almost impossible to achieve manually.

STITCHING SOFTWARE

For a description of the following software, see the panoguide.com Web site.

RealViz Stitcher (Windows, Mac)
PanoTools (Windows, Mac, Linux freeware)
Image Assembler (Windows)
Panorama Factory (Windows shareware)
QTVR Authoring Studio (Mac)
MGI PhotoVista (Windows)

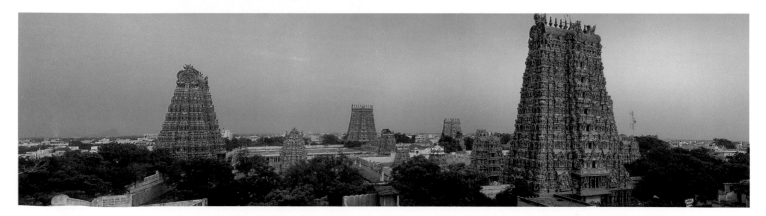

3-D Programs

They may be the diametric opposite of the normal photographic process, but 3-D programs can create photorealistic landscape features.

3-D software is the antithesis of photography. It creates pure fiction, digitally, in a virtual space—a world of wireframe modeling, basic shapes (primitives), extrusion, lathing, and raytracing. Why include it here? Ultimately, because of a particular kind of 3-D software that models landscapes. Much as I would rather not focus on just one program (there are other fractal modeling programs, such as Terragen), it is Bryce, introduced as an accessible 3-D modeler by Kai Krause, that deserves the credit.

Primitive Worlds?

3-D software is famously difficult, not only in the complexity of its techniques but in the learning necessary to orient oneself in a wireframe environment onscreen. The beauty of Bryce is that it is designed for non-professionals and is easy to use. What Bryce does beautifully is to build believable landscapes with erosion, water, sky, clouds, and even trees, and then render them to a high degree of photo-realism. Rendering, in 3-D terms, means calculating the way that the lighting (set by the user) reacts with the material properties (also set by the user) on the various objects, then producing from this a flat, pixel-based image. Bryce uses a high-quality method called raytracing, in which rays are traced mathematically from a "virtual camera" into the scene, where they assign a pixel value based on the way the rays interact with different objects and surfaces. This, of course, is precisely the opposite to the process used to form a photographic image, in which the rays enter the camera *from* the scene.

The Terrain Maker

In the final stage of raytracing, the Bryce software makes an anti-aliasing pass, which softens jagged edges on diagonals. Of special interest to photorealism, this is done by oversampling, which means that more than one ray can be used to determine a pixel's color. The number can be adjusted, up to 256. One key to the effectiveness of this kind of landscape modeling is its use of fractals to create the multiscale randomness associated with landforms and clouds. This is what is primarily responsible for the realistic appearance of terrain and skies, to the degree that they can be pasted believably into composite photographs.

A TRADITIONAL 3D PROGRAM

Unlike Bryce or ImageModeler, traditional 3-D programs, such as Strata 3D, are perhaps not best-suited to still, realistic photographic images where the eye will rapidly detect a "fake."

MAKING PHOTOGRAPHS THREE DIMENSIONAL

One remarkable new piece of software from the makers of Stitcher (see opposite) makes it possible to reconstruct the full 3-D information from still photographs. Called ImageModeler, it is not only a breakthrough in 3-D modeling, it also opens up new possibilities in the way you can use photographs. First you shoot a number of photographs of an object from different viewpoints. Then, on the computer, you identify several points on the object that appear in more than one image. ImageModeler calculates the position and characteristics of the camera and then calculates the 3-D coordinates of the object. Displayed conventionally as a wireframe, this 3-D version of the object can be used in any 3-D program. Even better, it takes the original photographs and wraps them around the wireframe.

Pelican mesa

The steep mesas and dry valley that make up the landscape are a Bryce creation, with the pelicans added later once the scene had been rendered as a 2-D image. The birds in flight are from one photograph, in east Africa, those on the ground are from another in the United States.

The 3-D elements in Bryce include a base plane, extruded mountains, and two lenticular clouds around the mesas—flattened spheres with cloud textures applied.

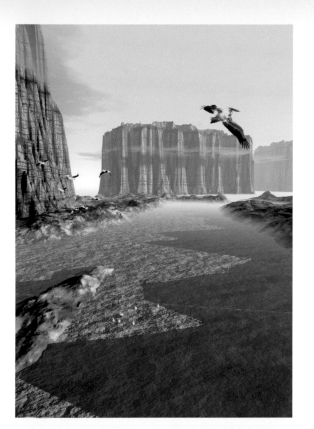

Terrain 6
2097152 polygons
00:00:00.00

IMAGEMODELER

This imaginative software allows 3-D models to be constructed automatically from a series of still photographs, in this case of a postbox.

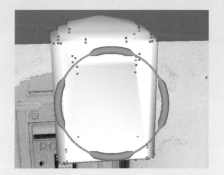

Here the 3-D object has been created, but has no surface features. The circle is a "space manipulator."

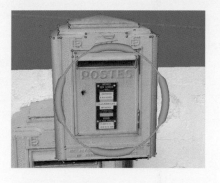

Using this to orient the object, textures from the photographs can be captured and mapped onto it.

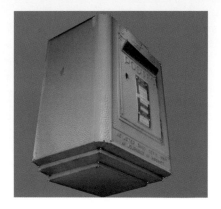

The final 3-D texture-mapped object can now be exported to any 3-D program and used within it.

Managing Your Library

Starting out with good archiving and cataloging techniques will let your image library grow over the years without major problems.

Sooner or later your images need to be sorted so that they can be easily retrieved. In the case of special-effects images, this should be sooner rather than later, as digital images have no physical presence; they reside on hard drives, disks, and other media accessible only through computers. Fortunately, computing in general has well-established procedures for finding files. As long as the images are reasonably well identified, there should be no great difficulty in locating and managing them.

Special effects in particular make great demands on cataloging because many are composites, with the source images drawn from different places. This not only quickly multiplies the number of images being created, but also makes it important to be able to trace source images any time you want to rework a composite. And, because of the need to experiment with special effects, you are also likely to generate different versions before settling on the final image. You may want to save these.

Tagging Your Images

Before anything else, images need to be given consistent identification tags. Computing protocol makes filenames compulsory in any case, but as you will be accumulating images from the start, you should think the system through. How many images are you likely to have after a few years? Thousands? Tens of thousands? You will need to give each one a filename that makes sense and distinguishes it. I use a number (in sequence according to when the picture was shot) followed by an obvious short description, such as "94.8.04 Mount Vernon." This means that, by default, images are cataloged in the order they were shot or created, but I can also search by the most obvious name. This is just one of many possible systems; whatever you choose simply has to be logical and suit your way of working.

There is no escaping an image database for cataloging, and there are many available—some free, some shareware, some fully priced. The last thing you want to do is to have to change from one database to another after you have cataloged a few thousand images, so it is important to study the specifications of the databases and choose the one you will stick with. The essentials are that it will deal with any image file format that you are likely to use (including, of course, the data direct from the digital camera); that it will work with your operating system and within the available memory; that it will be capable of handling the number of images you are likely to make, and that you can add information for each image (and, if necessary, change the filename). A good image database should do all of this and more. The one shown here, which I have used for a long time, is Extensis Portfolio.

A Good Self Image

A side issue is the provenance of images. With film, whether negative or transparency, there is only one original. Everything else is a derivative, whether a duplicate or a print, and always slightly different. Digital images, on the other hand, can be duplicated perfectly, with absolutely no difference between them. This is one of the collateral benefits of digital photography, and is a marvellous protection against loss and damage, but it can cause confusion. One solution is to add a suffix that identifies a particular version of an image; this has the advantage that versions are grouped with the same root filename. Another possibility is to give images new numbers and names, but to refer to related images in the image record.

As your image library grows, it will have to move off the main hard drive to find more room. In any case, it is important to make at least one backup of everything, and the archives need a physical location. We've already discussed storage options on page 13, but it is essential that there is some logical link between the image database and the CDs, DVDs, or whatever media you choose for archiving. The database will automatically identify the digital location in terms of the volume, which means that this should have a sensible identification. With CDs, for example, you might identify each by number, such as "archive CD 006," and then stack them in order on a shelf.

YOUR PORTFOLIO OPENED UP

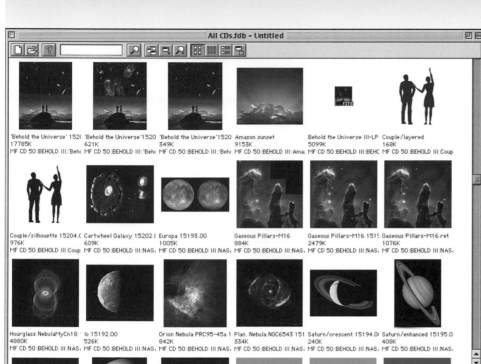

The basic display is in the form of thumbnails, with key information below each (specifically, filename and volume). The form of the display, including the size of thumbnail, can be customized.

For complicated special-effects projects, an attached record enables extra details to be added. Here, this includes the sources of the individual elements and the software used—information that might be forgotten.

Searching follows the usual digital procedure, which is why it is important to use a simple method of identification that comes naturally to the user.

TECHNIQUES

SPECIAL EFFECTS are all too often presented simply as amazing things to do to pictures—a kind of game. To be useful for photography, however, every effect needs a purpose. Once you have determined that, you can then decide what the final image should look like. This might sound obvious, but there is a basic, important difference between playing with a special effect just to see what you can do with it and planning a result. Obviously I am arguing for the latter: the role of special effects in photography is to create images that you, the photographer, already had in mind.

With so many potential effects available, from the standard tools of an image-editing program to dedicated software, there is enormous potential for confusion. The first skill in digital special effects is in choosing the procedures. Not only is there likely to be more than one way of achieving a given effect, but most effects benefit from a combination of techniques. To make a smooth gradient, for instance, you might first use the *Gradient* tool, then run a noise filter to eliminate banding and perhaps give it a photographic grain texture, then apply *Gaussian Blur* to smooth the transition, then blend it selectively with a color layer, and so on. Equally, the effect of even the most expertly designed filter can almost always be enhanced by your own judgement and tweaking, because no effects software solves problems on its own. Every project has an individual character, and one of the worst (and most boring things) you can do is to apply filters by rote, as if on a production line.

Certain key image-editing skills are always needed in special effects work. These are selection, channel and layer management, cloning, mask painting, and blurring. There are others, but for me these are the most important and most often needed. Selection alone involves a subset of other skills, including brushwork, path drawing, and setting tolerances. Its prime importance comes from the fact that the majority of filters are applied not to the whole image, but to one part of it that has been carefully defined by the user.

Selections are stored in Alpha channels, and some filters, such as those for shadows, will not work without these. An alternative to channels is to store selected images, with their backgrounds deleted, in individual layers. Typically, filters operate one layer at a time, so this is a useful way of restricting their effect.

Cloning is the technique of painting one part of an image with a copy of another part, and is an extraordinarily effective way of removing unwanted elements from a picture, especially when dealing with complex textures such as foliage, brickwork, hair, or terrain. Masks are a way of viewing and altering selections (Photoshop, for example, lets you toggle between a selection and a mask), and skillful painting and airbrushing in *Mask* mode helps to create sophisticated selections. Blurring is important, not so much for the out-of-focus effect it can produce (although this has its place), but for the way it can soften selections, gradients, and various maps that will then be used to alter the image.

The techniques in this section are grouped according to their result, which for our needs as photographers is more important than the kind of software used to produce them. As it happens, some groups of effects, such as distortion, employ similar software, but really this is incidental. Edge detection, for example, turns up all over the place, from organic textures to embossing. In any case, the interfaces usually conceal the software engineering. They can also, in some cases, hide the purpose, which is less helpful. Some KPT filters are guilty in this respect, following the manufacturer's "play-with-me" philosophy. You might not guess that KPT5 ShapeShifter, billed as a tool for text effects and buttons, produces a good plastic surface for objects.

Finally, beware of stereotyping. The more specific an effects filter, the more likely it is to produce a recognizable result—because other people have already used it. This is anathema to anyone who values originality. The solution goes back to the point I made earlier. If you keep your own hand on the effect, adjusting the filter's operation to suit the needs of your photograph, then it remains yours.

Selective Focus

Selective focusing can help isolate subjects and create even more striking images from good compositions.

A soft-focus background and foreground directs the eye to the subject and helps it stand out more clearly. This technique is known as selective focus, and you can see it widely used, for instance, in magazine food photography.

But shooting conditions don't always give you full choice in this regard. Fortunately, selective focus is an effect that can be created in the manipulation process. There is, of course, very little that digital sharpening can do to improve an unfocused image, but when it comes to defocusing, there are no such problems.

There are several ways of approaching this. One is to make a selection of the area that you want to remain sharp, then apply a blur to the rest. Photoshop's *Gaussian Blur* is a good starting point, although there are third-party blurring filters that are more convenient in some ways. One, Andromeda's VariFocus, applies the blur progressively away from the protected area in imitation of increasing distance from the camera.

For the purists, none of these procedures accurately replicates true camera blur. The aperture in the camera has an effect on bright highlights, generally creating blurred circles. This is difficult to reproduce, but you can get close to it by adding a second blur layer in which the highlights are strongly blurred.

A more sophisticated approach is to make the blur increase, as it should with distance from the camera. The only way of guaranteeing this is to make a mask that has a gradient ramp from near to far—a map of the depth in the scene. The shot of the pelicans (*opposite*) illustrates this technique, in which you work in a mask layer and use the gradient tool. You can see another application of this kind of depth map on pages 64-5 for use with mist.

To shoot this stuffed bell pepper the lens was set at maximum aperture for a shallow depth of field, but this was still judged insufficient. The picture is acceptable, but lacks impact.

Two layers of blurring, one for the unprotected areas and one for the highlights, combine to provide a degree of selective focus that would be difficult to achieve by any other means.

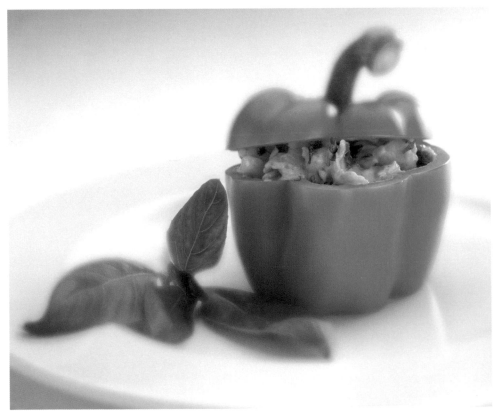

Enhancing selective focus

1 The areas to remain unblurred are selected by painting over them in a mask layer, using an airbrush.

2 Apply either *Gaussian Blur* in Photoshop, or use a third-party specialist filter, such as Andromeda *VariFocus*, which blurs progressively away from the protected area, or *Classical Blur* from nik Color Efex Pro.

4 The highlight selection is pasted into its own layer. An alternative would be to duplicate the main image layer, invert the highlighted selection, then delete.

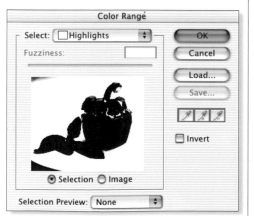

5 At this point the highlights are deselected, and a fairly strong *Gaussian Blur* (15-pixel radius) is applied to the entire layer.

3 To make the blur more camera-like, the highlights are selected. An easy way of doing this is to use the *Color Range* in Photoshop.

Progressive blur with distance

The original shot of these rift valley pelicans was taken with a 600mm lens at full *f*-4 aperture, has limited depth of field, but I still felt that the flying pelican could be better isolated.

1 The flying pelican and others in the foreground are protected from the blurring by painting over in a mask layer.

2 Two areas of the foreground, including the pelican in flight, have been saved as selections. In the mask layer these are loaded and inverted, and then the gradient tool applied from top to bottom.

3 One of the Alpha channels is reserved for the completed depth map — and can be accessed in the usual way as a saved selection.

4 Loading the depth map as a selection, any of the blurring procedures described here can now be applied, judging the strength by eye.

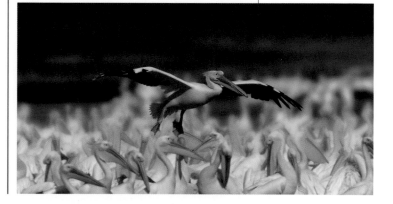

Composite Focus

Sometimes it's not possible to take a clear image of either very small, or multiple, subjects. Digital special effects can help.

We just saw how the depth of field in a single image can be altered digitally. With some planning, you can also build an image from different shots, altering the sharpness of each one. All it demands is some forethought about how the scene will be composed. The beauty of doing this digitally in post-production is the freedom it gives you to adjust the image and change your mind, as well as being able to achieve a precision in the depth of field that might be impossible with the camera alone.

Sweet Smell of Success

The image, opposite, of a group of perfume bottles is a good example. If you had to shoot this without manipulation, what lens and what aperture would you use to keep the central bottle sharp while strongly defocusing the others? It's not easy to calculate, and simply altering the spacing of the bottles would change their relative sizes.

Composite focus is especially suited to still-life photography, where you can control lighting and camera position and shoot against backgrounds that make digital selections easy. In this example, I shot the collection of

bottles individually, with backlighting added to show the transparency and translucency of the different types of glass. The outline of each bottle was then selected and the basic, sharp composition organized. The amount of *Gaussian Blur* was judged entirely by eye—for instance, to make sure that the detail on the background bottle remained clear.

While there is little improvement that digital sharpening can make, there is a technique for deepening the focus if you plan it at the time of shooting. The idea is to take more than one shot, with the lens focused at different points in the scene, and composite the separate images into one. For instance, you could take one photograph focused on the foreground, a second on the middle ground, and a third on the distance. This creates a depth of field from front to back much greater than the laws of optics strictly allow. The difficult part, of course, is in the compositing, as it means placing all the images in separate layers in perfect register, and erasing the blurred parts of each.

Sharp operators

Despite the time and effort involved, this is a powerful technique for overcoming the optical limitations of depth of field, and there is one situation where an extremely narrow depth of field holds sway—photomacrography, or "macro" for short. Digital photography enables any object, no matter how small, to be rendered in full, front-to-back sharpness by the simple principle of tracking—the camera-bellows-lens set-up is moved backward or forwards at a constant focus, and a series of frames are exposed at each movement. The result is a series of images each of which contains one thin "slice" of sharp focus that together cover the entire depth of the object.

During image editing, each image is superimposed in register over the one below, and all but the small area of sharp focus is erased. The result is an image composed of just the sharply focused areas. The only significant problem is that parallax can conceal some of the distant areas behind nearer blurred parts, but this can be retouched. If it is really important, the object can be moved a few millimeters to one side for a few shots.

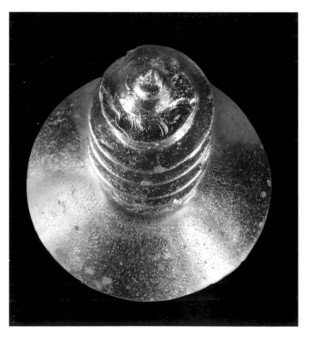

The final image of the screw, although in extreme close up, is still perfectly in focus.

Layered selective focus

1 Using a curved translucent light table, a series of perfume bottles from a collection were photographed one by one, in scale. Each was then selected from its background.

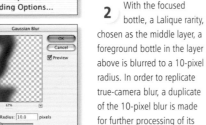

4 As a small part of the central, sharp bottle will be seen through the clear glass areas of the foreground bottle, the left lower edge is treated lightly with a distortion brush.

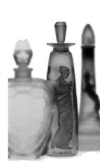

2 With the focused bottle, a Lalique rarity, chosen as the middle layer, a foreground bottle in the layer above is blurred to a 10-pixel radius. In order to replicate true-camera blur, a duplicate of the 10-pixel blur is made for further processing of its highlights.

5 The same blurring procedure is given to a third, background layer, adjusted to keep the lizard motif recognizable. As a final touch, parts of the foreground bottle are erased to let the left edge of the central bottle show through.

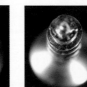

3 In the duplicate layer, a further 20 pixel-radius *Gaussian Blur* is applied. This is then blended in *Lighten* mode to flare the highlights realistically.

Deep focus for a tiny screw

1 Using a 100mm bellows extension on a 60mm lens, the subject of this macro shot is an 11mm-long steel screw. The rail of the bellows extension has a manual drive that lets the camera and lens to be racked forward and back in small increments.

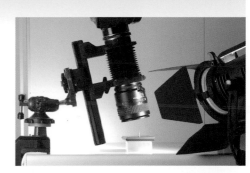

2 Even at the minimum aperture of *f*-32 of the 60mm Micro-Nikkor lens, there is very little depth of field, while diffraction at this setting damages sharpness.

3 Here are all the individual shots of the same screw taken so that every part, when combined, is in focus.

Flare

Do you have the flair for flare? Once regarded as an undesirable image artifact, lens flare is helpful in digital imaging to create authenticity.

Lens flare is non-image-forming light. In other words, flare is light that enters the lens and reaches the sensor without necessarily contributing to the image. It is most familiar as a line of polygons or near-circles stretching across an image. Lenses are complex devices, particularly zoom lenses. They contain several glass elements of different shapes and sometimes different compositions, so there are many internal surfaces that reflect small amounts of light. Despite modern lens coatings that reduce these reflections, if you have a bright light in the frame, it will often show up. The polygons are caused by the camera's aperture blades, which create a polygonal opening. This is at its most angular when the lens is stopped right down.

With all the tools in the digital special effects inventory for creating realistic images, there is also a need to add what would in earlier days have been called imperfections. Lens flare is one technique you can use to make certain types of images look convincing, and it is very widely used in motion pictures to make artificial effects look more natural. A lens flare filter has been included in Photoshop from the earliest days. Its easy availability has contributed to the biggest problems with adding flare—overuse and "standardized" use. One straightforward solution is to apply the filter into its own black layer rather than directly onto the image. The layer blending options then give you full control over adding it to the image, and you can alter it in any way you like.

Better still is a specialist flare filter, and the best, without doubt, is Knoll Lens Flare Pro from Puffin Designs at Pinnacle Systems. Designed by John Knoll, co-creator of Photoshop and Visual Effects Supervisor at Industrial Light and Magic (ILM), it is a very sophisticated but easy-to-use suite. It contains nineteen lens primitives, from a glowball that gives halation and light scattering around a light source, through polygon spreads to asymmetrical spikes. All of these can be altered by sliders in various parameters.

Lens primitives are the raw material for constructing a customized flare. They can be combined as one or, for greater control, applied individually to layers, which are then blended according to taste. This range (*below*) is in Knoll Light Factory.

Chromafan

Chroma Hoop

Disc

Ellipse

Faded Ring

Glowball

Photon Spike Ball

Poly Spike Ball

One other flare plug-in, with a smaller choice of parameters and primitives, is KPT6 LensFlare (above).

Random Fan

Sparkle

Star

Stripe

Poly Spread

All combined

Flare to add color

1 The original shot of this tomb on a cloudy day has only a small range of quite gloomy colors— acceptable, but it could be livened up.

2 Six primitives were combined, with special attention being paid to the *Chroma Hoop*, which creates a circle of streaky rainbow lines radiating from the source.

3 The final effect, although it degrades some of the detail on the tomb, adds considerably to the mood, and introduces a welcome dose of color below the upper window.

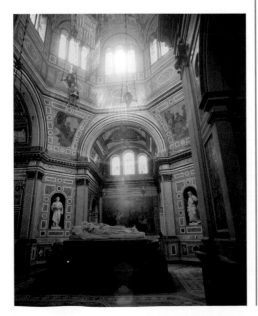

Dynamic flare

1 In the original, a grad filter was used to even out the balance of light to reveal as much as possible of the interior, and so also to lower the contrast.

2 In Knoll Light Factory, four primitives are combined, emphasizing the polygon spread. The distribution and angle of these is computed automatically according to the position of the source.

3 Digital flare gives the best of both worlds: a feeling of brightness and sunlight, while still maintaining detail throughout the image and a natural feel.

TECHNIQUES

Lens Distortion

Unlike the technology inside digital cameras, lenses are resolutely analog. But you can correct lens distortion selectively.

The shot of this old monastery building in northern Thailand was shot on a large-format camera, using a wide-angle lens shifted to the right. This was then scanned on a drum scanner. The corrected image is seen on the final book jacket (*above*).

With so much attention on the digital heart of the camera, it's easy to overlook the fact that the lens remains very much an analog instrument. Lenses have been improving for years, but they still obey the laws of optics.

This means that, good as modern lenses can be, they are still subject to imperfections, one of which is distortion. Most people's idea of distortion is that the image has been pulled or bent out of shape. While this is sometimes true, distortion is also an inherent feature of lenses, particularly wide-angle and telephoto ones. Whether it is undesirable is often a matter of taste and judgement.

Technically, lens distortion causes changes in magnification across the image—stretching or compressing it if you like—and there are different kinds. In practice, distortion is most common with wide-angle lenses, and the most obvious type is geometric distortion. This causes progressive stretching away from the center, and so is most extreme near the corners. Circular objects, such as a round

coffee table, become oval. How much this matters often depends on how familiar the viewer is with the object.

Another variety is perspective distortion, which happens when a wide-angle image is viewed too small (from far away or from a small print), and a telephoto image viewed too big. It also happens with shift and tilt lenses. A good example is the Thai temple image, opposite.

Curvilinear distortion is the third kind, a problem of lens manufacture that makes straight lines curved, either as barrel distortion (slightly spherical) or pin-cushion distortion (slightly pinched). The lesson from all this is that most distortion is perceptual—that is, in the eye of the beholder—and whether you eliminate it or use it depends on the purpose of the image.

Diving in Deep

The example on the far right—the shot of the swimming pool—has real curvilinear distortion resulting from a deficiency of the lens. Interestingly, because digital cameras use sensor arrays that are smaller than 35mm film, the old range of focal lengths give less of a wide-angle view than they did with film. As a result, manufacturers have been working on even shorter focal length lenses, but these tend to have more aberrations. This shot was taken with a 17–35mm zoom lens at its widest, and this precise, head-on view shows up the barrel distortion at its worst. You could apply the reverse effect by using, for example, Photoshop's *Spherize* filter with a slight negative value, but in practice this is difficult to get precisely right. The solution used here is the excellent *LensDoc* filter from Andromeda—an example of a filter that does just one thing (corrects lens distortions) but does it perfectly.

The other image, of a Thai temple, is more of a perceptual issue. The building is twisted out of shape because of its age. This is exaggerated because it is near the edge of a wide-angle shot (even more so because a shift lens was used). The distortion became important when this off-center part of the image was selected for a book cover. The solution was to apply perspective distortion and rotation by eye, lining up the key lines to a grid overlay. But I didn't change the building—that would have lost its charm.

Eye-balled adjustment

1 The grid was first adjusted for optimum visibility under *Preferences*, and the *Perspective Distortion* tool was applied, concentrating mainly on the alignment of the steps.

2 The compression of the image to the right left little space for the book's title. To compensate for this, a rectangular section of sky was extended vertically with the scaling control.

3 A very slight rotation was necessary for exact alignment of the horizontals, applied after the perspective correction. An alternative would have been to use the more flexible *Distort* command under *Image/Transform*.

Barrel distortion

1 The original shot highlights the barrel distortion of a Nikon 17–35mm lens by the precise camera viewpoint and by the pool's edge being so close to the image frame.

2 Using Andromeda's LensDoc filter, three targets in each of two horizontal rows are placed exactly along a line that is supposed to be straight. The greatly magnified window at right enables precise positioning.

3 The procedure is repeated along two lines that are close to the edges of the image. For some lenses, though not this one, the distortion coordinates are already known and can be accessed via the *Specific Lens* button.

4 On the basis of the information entered by the user, the filter computes an overall straightening for the image to give perfect correction.

TECHNIQUES

Color Control

Thanks to the way digital photography works, you now have unparalleled control over the use and appearance of color in images.

One of the instant benefits of digital photography is the extended control it gives over color. Digital cameras offer a range of white balance settings to cope with different color temperatures of light, from orange tungsten to blue skylight. This is possible because colors are recorded by separately filtered sensors in the CCD, and stored in three channels—red, blue, and green. In film, these layers are stacked and they interact with each other, but in a digital image, colors can be manipulated individually.

The Graduate

This means you can move away from literal interpretations of a scene. As with so much digital special-effects work, the most sensible plan is usually to shoot in a straight, non-stylized manner, and manipulate later in post-production. The color control possibilities are infinite.

The digital updating of optical filters probably begins with grad filters, which in optical form are the standard means of darkening and/or coloring skies. They also have other uses, such as balancing the fall-off in illumination from a window. The demand for darkening skies arose because of differences in brightness and the limited ability of film to capture the full range. The principle of the optical grad is a sheet of glass or plastic, half of which is clear and half tinted, with a soft shoulder separating the two. Set in an adjustable mount, the filter can be raised and lowered, and rotated, to align the transition zone with the horizon.

This is something for which digital filters are perfectly suited, not only because a gradient ramp is a straightforward procedure, but because the effect can be tailored more precisely to a particular image. As shown opposite, the transition of the gradient is completely flexible. The only optical control is aperture, which affects the depth of field. You can overcome the serious disadvantage of a traditional grad—it darkens everything above a certain point, including landscape details.

But the possibilities of color control extend well beyond this, to as lurid and stylized an effect as you want. In the two examples shown on pages 40-1, rubies and grass, the key is selection—that is, choosing parts of the image to be enhanced without resorting to manual selection.

The shot as taken is a telephoto view of the Acropolis in Athens, just before sunrise, directly into the light—a silhouette with some shadow detail.

PROTECTING THE LANDSCAPE FROM THE GRADIENT

Select and save the sky
In a clearly defined image like this, the sky is easy to select, using the *Magic Wand* auto selector. This is saved as a selection.

Apply the filter to the selection
The digital grad filter can then be applied just to the sky. In this example, a customized filter from nik Color Efex is used.

Digital grad filters

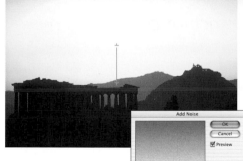

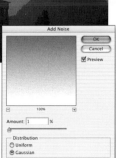

1 The procedure is divided into steps so that changes can be made later. First, a gradient ramp is made in *Quick Mask* mode from above to below.

2 To remove any possible banding in the gradient, a tiny amount of noise is added—one percent of *Gaussian*.

3 Out of *Quick Mask* mode into *Standard*, the gradient is saved as a selection. A warm color is chosen for the foreground color and in a new layer the selection is filled, then blended as *Darken*.

4 The opacity is reduced to give the most pleasing effect. Because the gradient ramp has already been saved as a selection, this is not an irrevocable decision.

The graded sky now has some tone, giving a better balance to the picture. For extra precision, the hills behind have been protected from the effect, as described.

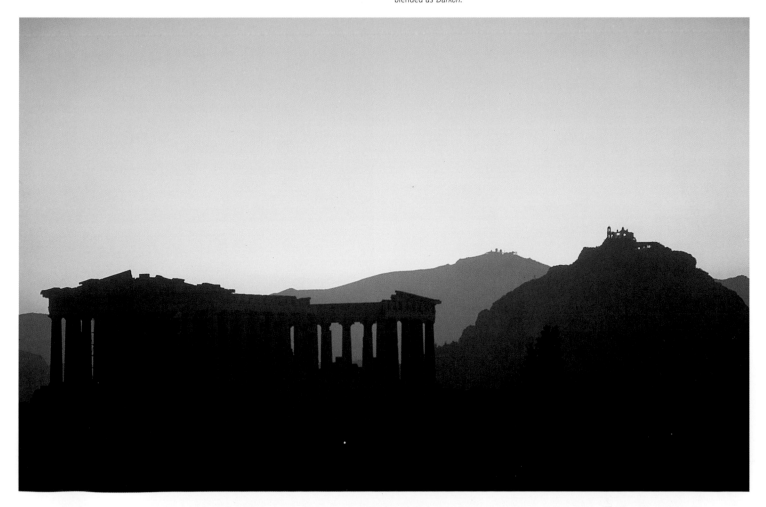

Intensifying color

6 Double intensification adds some zip to the original shot, without appearing to be artificial. The result was proofed on a printer to check the intensity of the red.

7 A similar result comes from the *Brilliance/ Warmth* filter in the nik Color Efex suite, but here the saturation has exactly the same effect whether applied to an RGB, CMYK, or Lab.

1 A selection of rubies at a gem dealers, tumbled out onto a white cloth and lit by a soft "window" light attachment in front of a flash unit.

2 The procedure is to choose the range of colors to be intensified and raise the saturation. The hue selector in Photoshop's *Hue/Saturation* is ideal.

4 The bright reds are copied into a separate layer and de-selected. Gaussian blur to a radius of 8 pixels is then applied to the entire layer.

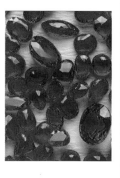

3 To go one step farther in the enhancement, the brightest reds are selected in *Color Range*, using the sampler and a medium *Fuzziness* setting.

5 The blurred layer of bright reds is blended with the underlying in *Lighten* mode, which adds a light diffuse spread into the surroundings.

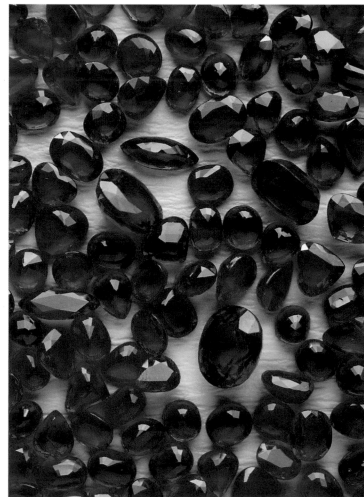

Selective enhancement

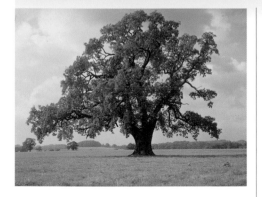

1 Photographed during a long, dry summer, the grass surrounding this fine old oak tree is more yellow than green—nothing objectionable, but the image is certainly a candidate for enhancement.

2 Using the *Hue/Saturation* control, the range of hues is adjusted to cover the grass, then the hue is shifted toward green, saturation increased, and brightness reduced. The result is greener, brighter grass. Striking, if a little unnatural.

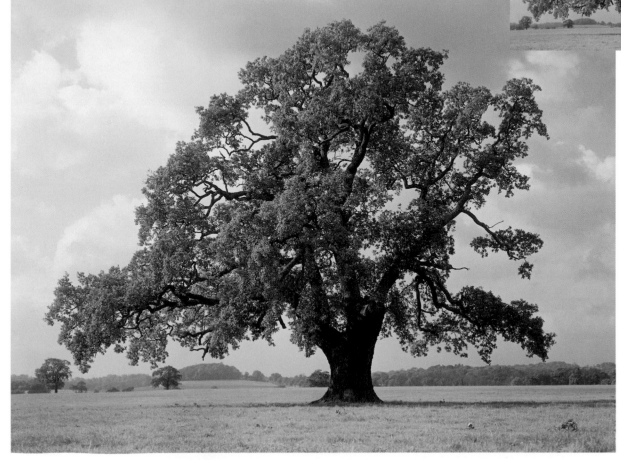

3 A customized color contrast filter provides selective intensification similar to the degree of control traditionally enjoyed by black-and-white photographers using strongly colored filters.

Black and White

Since color photography has become dominant, the unique attractions of black-and-white have become clear.

Black-and-white photography has a special appeal that goes beyond its historical importance. Not the least of these is its limited palette, which pushes photographers into a different way of thinking. There is a simplicity and economy to an image that is a modulation of a single tone, and this concentrates attention on composition and texture. Color film did not kill off black-and-white, and neither will digital photography. Instead, it's become a specialized medium with a lead role in art photography and reportage.

A Unique Performance

One of the appeals of working with black-and-white negatives and photographic paper has always been the ability to manipulate and fine-tune the image. Ansel Adams famously referred to this in a musical analogy, with the negative as the "score" and the print as the "performance." The English photographer Bill Brandt, for example, reworked his prints later in life to make more dramatic images—a different "performance." You can also apply a variety of overall tones, such as sepia, to create a different kind of monochrome image.

Digital imaging offers an immense range of techniques for "performing" a black-and-white image, which goes far beyond changing modes from RGB to grayscale. Perhaps the most useful is manipulating the color channels.

In traditional black-and-white landscape photography, strongly colored filters are used to alter the tonal relationships in a view. The principle is straightforward—placing a filter of one color in front of the lens would block the other colors in the spectrum from reaching the film. A blue sky, for instance, contains hardly any red, so using a red filter darkens it dramatically.

Digitally, you can now achieve the same results by working with the red, blue, and green channels (or by converting to *Multichannel* and working with cyan, magenta, and yellow). In the *Channels* palette you can see the difference in the tonal range between the three black-and-white thumbnails. Turn off green and blue (which automatically turns off the color) and you will see the red component of the image alone—the equivalent of using a strong red filter. An opposite effect is to use just the blue channel. In a landscape shot that takes in the full distance to the horizon, the effect is to increase the sense of depth—in other words, heightening the aerial perspective. Copy the single channel and paste it into a new image file.

These are basic, one-step moves, but you have much greater flexibility if you combine channels in different proportions. Photoshop's *Channel Mixer* is perfect for this. Access it through *Image/Adjust*, check the *Monochrome* box, and adjust the sliders.

The extremes of channel mixing

Stark silhouette
Low red and very high blue channel inputs isolate the tree almost completely from the background, more strongly than any blue filtration could achieve during black-and-white photography.

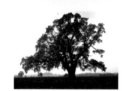
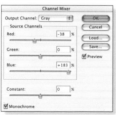

Mimicking Infrared
A combination of strong red and strong blue produces an effect similar to black-and-white infrared, with the grass appearing almost as bright as snow.

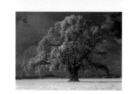

Adobe preset
One of the presets supplied with Photoshop emphasizes yellow by turning up red and green (which combine in the additive system to yellow) and reducing the complementary color, blue.

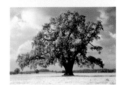

A dramatically darkened sky

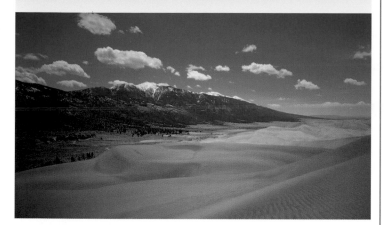

1 The color original of this winter view of the Great Sand Dunes in Colorado features an intense blue sky against the warm-toned sand.

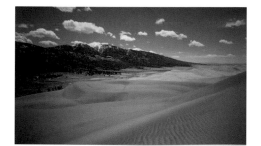

2 Converting from RGB to grayscale in Photoshop discards the color information to leave a predictable black-and-white version.

3 The red channel gives an almost lunar quality to the landscape, eliminating nearly all tone from the sky.

Adding depth to a landscape

1 This shot of a Khmer monument in Cambodia at dawn has a softness associated with haze, which adds a slight blue cast to the distant trees.

2 Converting the image unmodified to monochrome preserves most of the expected tonal range, including the haze.

3 The blue channel alone changes the visual aspect of the scene to give a feeling of strong mist—almost fog, with no detail in the sky and trees receding into the distance.

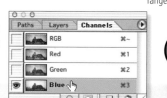

Photo Stylizing

Why always go for the extremes of modernity when you can elegantly enhance an image using digital versions of age-old techniques?

Digital special effects are awash with stylizing effects, many of them by-products of other lines of development—which is to say, they are usually by-products for which no one could think of a serious use. The majority of these, including the impractical and gaudy, are dealt with later in Chapter 10, but I've reserved a few that are directly relevant to photographic images. The theme of this chapter so far has been effects related to the technical realities of lenses and film, so it's appropriate now to turn to the ever-changing styles of color images.

This is not intended to be an obsessive restoration of historical processes, but the technology of reproducing the colors of real life has changed over the last century, and while the accuracy is greater than ever before, some of the older processes had a certain flair about them. The two most famous early color processes were Autochrome, invented by the Lumière brothers in France and available commercially from 1907, and Kodachrome, developed before the Second World War by two musicians working for Eastman Kodak. Autochromes in particular had a distinctive, rather subtle appearance, featuring muted greens and browns.

A Sense of Style, Period

In essence, to stylize an image toward a "period" look is to "distress" it, and this kind of treatment often comes under fire for leaning toward pastiche. The controlling factor is how extremely you apply the effects, and how often. The usual recommendation is to be sparing. If possible, you should have a reason for wanting the effect. A recent example from cinematography is the muted and contrast-enhanced colors chosen for the film *Saving Private Ryan*, which went onto win an Oscar for Best Cinematography.

None of the several adjustments that go together to give an "antique" effect are complicated, with desaturation, color cast, graininess (noise, in digital terms), and fading all featuring strongly. The time-consuming part comes from having to apply them consecutively. As shown here, a number of third-party effects companies produce filter sets to do just this. At the modest prices charged, they are good value. Flaming Pear's Melancholytron, for example,

combines nine parameters, arranging them into three groups, *Shape, Focus,* and *Color*. The *Shape* parameters define how the other effects are applied across the image, generally "fatiguing" it away from the center. *Focus* applies blur with the option of protecting the luminance channels, and *Color* provides degrees of desaturation, dampening and color cast.

Distressing Images?

Beyond this, there is the possibility of distressing the surface appearance of the image to simulate damage to the paper, emulsion, and edges. One software manufacturer in particular, Auto FX, specializes in this kind of treatment in its DreamSuite Series 1. Surface effects like these work best in layouts published in either print or on the Web, so that they can be presented as three-dimensional objects lying on a page.

The *Crackle* filter from Auto FX DreamSuite applies the appearance of a physically cracked texture—one of a series of surface effects.

Distressing the image

The ruined and abandoned appearance of this ancient Thai city makes it an appropriate subject for an antique style of imagery.

Several software manufacturers now offer filters to distress the image in a number of ways, each combining a number of parameters.

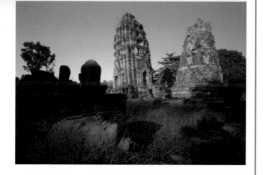

Color Stylizer

Melancholytron

DreamSuite PhotoTone

Mr. Contrast

These two treatments were made with a combination of the featured third-party filters, one emphasizing aging with vignetting and halo effects, the other concentrating on the subtleties of color fading.

A period look

Two models, photographed in London's Café Royal for a magazine article on theatrical costumiers.

As a first step, the edges and corners of the image are faded away, using the *Vignette White* filter from Greg's Factory Output.

This filter from nik Color Efex combines brightness, grain, paper color, and contrast sliders, with the option of channel mixing. Applied with moderate grain and paper color on top of the vignette effect, it has the look of an antique black-and-white print. For added interest, the result was then copied onto the original and blended at 80 percent opacity.

TECHNIQUES

Glows, Halos, and Coronas

Making your subject glow has many creative applications, both in fantasy images and in mocking up realistic ones.

Making objects luminous is a staple special effect for which digital imaging is perfectly suited. There are "realistic" uses, such as lighting a lamp or enhancing the brightness of an existing source of light, along with many more conceptual and decorative ones. It is essential first to create a selection of whatever you intend to illuminate. From this, there are various ways of creating an area that surrounds it, and then applying a degree of blur. Applying color can be done to various degrees of sophistication, but it's essentially an easy effect to create by yourself because the tools are all found within standard image-editing programs like Photoshop.

In the main example, opposite, the intention is to surround the profile of a head with a neon-like glow that follows the profile. Probably the easiest way of surrounding the head is to take the head as a selection and then expand the selection. The result is quite blocky, but strong blurring takes care of this. One way is to feather the selection from the Photoshop menu, but for visual

The *Gradient Glow* filter from Extensis, applied to a copy of the same image, has the advantage of multiple sliders, including blended color gradients. These are possible to do yourself, but it's far less convenient.

feedback I prefer to work in the mask layer and apply blur to that. But first a note of caution: if your selection is not completely clean you will find unwanted blobs in it, for the simple reason that a single pixel left stranded outside the selection will be expanded.

The process so far works as a selection for a glowing halo, but it is also easy to separate it from the head profile. For this we simply need to subtract a less extreme expansion of the original selection. In the example here, I worked backward from the outer halo, and the result is an isolated, blurred band that traces the outline of the head. Working in a new layer dedicated to the halo, it's a simple matter to choose a color and fill the selection with that. You could even apply a gradient between two colors, or use any number of other methods of varying the hue. A convincing technique with glow, however, is to have a deeper colored edge around a brighter center — this gives a better impression of emitting strong light. The solution here was to layer two colors.

The example of the light bulb on page 49 is a more realistic use of glow. The lamp in question is Thomas Edison's from 1879, which used a carbonized cotton thread as a filament, so there was no question of actually wiring it up. This is where digital effects can, pardon the pun, really shine. A path drawn with Bézier curves was the best way to "select" the filament, with the *Stroke* command used to apply varying degrees of soft glow. A photograph of another lit bulb was used for reference.

A corona is a gaseous or luminous electrical discharge with visible texture, and the *Corona* filter, also from Extensis, uses the basic glow procedure with the addition of a random, flamelike element.

LIGHT EFFECTS 4

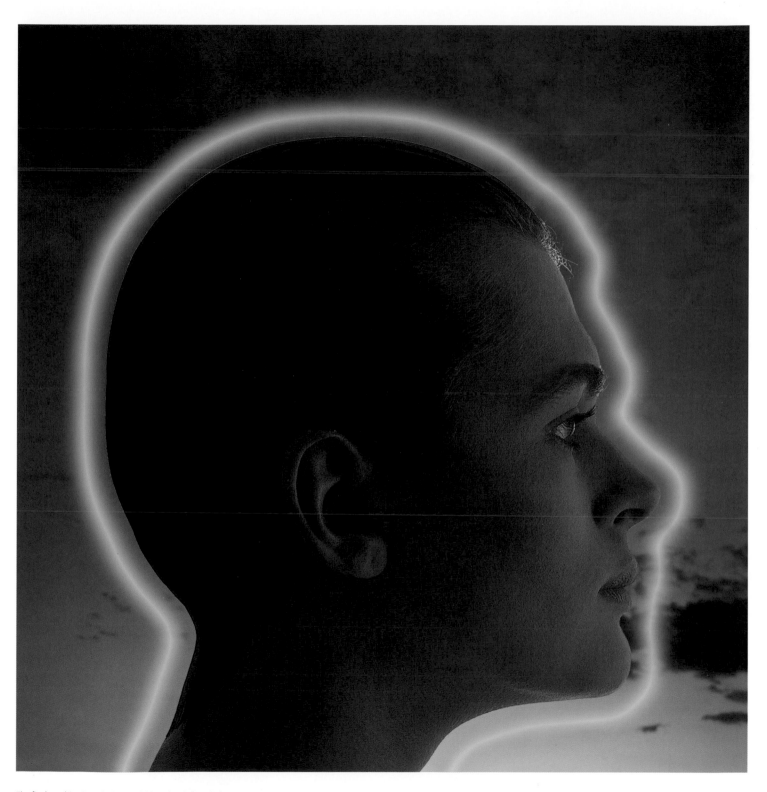

The final combination of white and blue glow is kept in its own layer (which many proprietary filters do not do) so that the blending can be fine-tuned if necessary, or the color, brightness, and contrast altered.

TECHNIQUES

Creating a halo in Photoshop

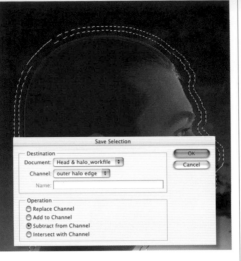

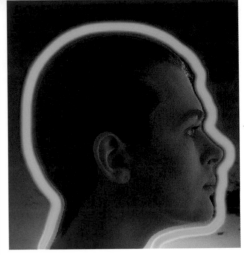

1 The selection of the head outline had already been prepared, and it is used to drop the head onto a sky background. For the outer limits of the glow, the selection was expanded significantly, by 100 pixels, and saved.

2 For the inner edge of the glow, to be separated from the head, this outer selection was contracted by 50 pixels.

3 To create the basic shape of the glow, the new selection was subtracted from the already-saved enlarged selection to make a 50-pixel-wide band.

4 The selected band was viewed as a mask, and a fairly strong amount of *Gaussian Blur* —25 pixels—was applied to it. The amount was judged by eye in the preview window.

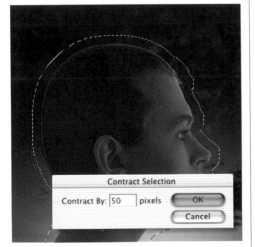

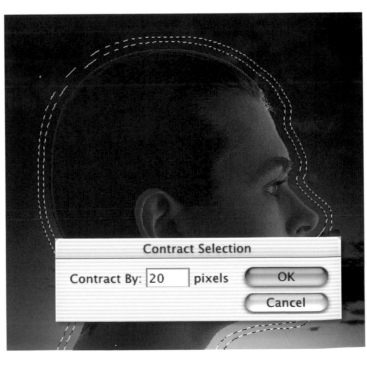

5 The blurred selection was filled with an electric blue. To give a brighter, hotter core, this soft band was contracted by 20 pixels, and the new selection filled with a paler blue.

Lamplighter

1 The hand-blown incandescent glass lamp, invented by Thomas Edison, photographed in a museum—a delicate and inert exhibit.

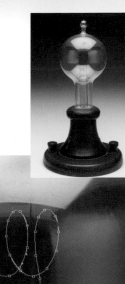

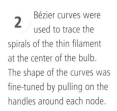

2 Bézier curves were used to trace the spirals of the thin filament at the center of the bulb. The shape of the curves was fine-tuned by pulling on the handles around each node.

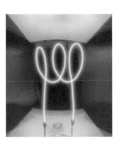

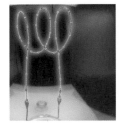

3 The *Stroke* command in Photoshop provides a direct way of applying any preselected style and thickness of brush—in this instance a broad, soft airbrush stroke colored orange.

4 To make the glow of the filament more realistic, the same path was stroked twice more, with the airbrush width reduced and two brighter colors selected—yellow and white.

5 In the final composite, each of the five elements of the glow (three for the filament, and two reflections) are kept separately in their own layers, for later fine adjustment.

Diffusion

Whether you see a soft, diffused glow as romantic or kitsch, it has its practical applications in digital special effects.

A relation of glow is the soft-focus effect that was at one time popular in portrait photography for giving a soft wash to the image without losing significant sharp detail. The term "soft-focus" is misleading; in reality it's the spreading of highlights into surrounding areas—diffusion, in other words—and the softening comes from a combination of three effects: scattering, refraction, and diffraction.

From Kitsch to Ethereal

The idea behind using soft focus in portrait photography was to hide skin blemishes and to add what was considered a romantic air. While you are unlikely to see it in modern portraiture, it has other uses, such as emphasizing the spread of warmth from fire and flames (see pages 68-9) and evocations of the mysterious and ethereal.

The original in-camera solution was either a costly soft-focus lens, which retained some amount of spherical aberration (a lens defect from using glass with curved surfaces) or diffusion filters that were either engraved with tiny grooves or had thin, transparent deposits on the glass. You could still use a lens filter like this, but to what advantage? The problem with any optical filter that degrades the image is that once you've shot the image, there's no way of restoring the full information other than shooting extra unfiltered frames.

The digital solution is much more efficient and economical, and it offers greater control over the effect. Start with a clean image, make a copy, and work on that. As the intention with diffusing filters is to keep the fine detail, the key is to apply partial blurring and blend it in such a way that it does not obscure edges. There are many approaches, depending on how much control you need to exercise, but my preference is to first isolate the highlights.

As you can see in the examples here, there is a difference between the rough-and-ready technique of blurring a copy of the entire image and then blending it in *Lighten* mode and the more sophisticated procedure of eliminating all but selected highlights in a layer and blurring those.

Nevertheless, *Lighten* mode is useful when working with several layers, as it ensures that brighter details in the base layer are not covered. Other procedures that you might consider include making hand-drawn selections, gentle erasing with a low-intensity, wide-diameter airbrush, and reducing the opacity.

The starting shot is of an evening Buddhist ceremony, shot by the available light of candles held by the worshippers.

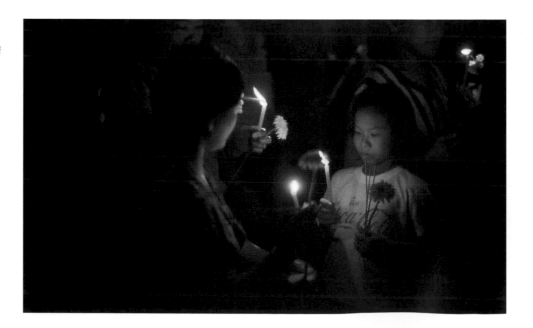

LIGHT EFFECTS 4

Diffused lights

1 The easiest technique is to blur a duplicate layer heavily (to 40 pixels) and then blend this in *Lighten*. The drawback is that the diffusion applies equally to faces and the girl's t-shirt.

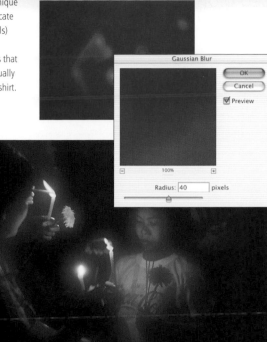

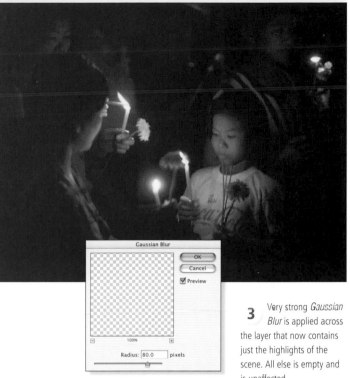

3 Very strong *Gaussian Blur* is applied across the layer that now contains just the highlights of the scene. All else is empty and is unaffected.

2 To restrict the diffusion to the lights, the first step is to select highlights, here performed in Photoshop's *Color Range*. The selection is inverted because the surroundings will then be deleted.

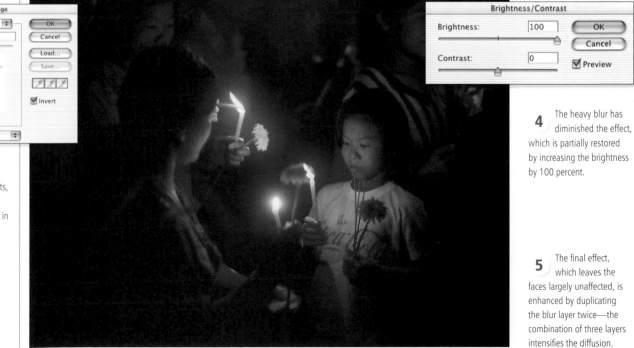

4 The heavy blur has diminished the effect, which is partially restored by increasing the brightness by 100 percent.

5 The final effect, which leaves the faces largely unaffected, is enhanced by duplicating the blur layer twice—the combination of three layers intensifies the diffusion.

Sunlight and Spotlight

You've learned how to create artificial light and even halos, but how do you create natural-looking light to illuminate a dull scene?

One of the greatest challenges in lighting special effects is to create the impression of bright, direct light. Sunlight transforms outdoor views, and in landscape photography the major variable is the shift of light according to the weather. Sunlight, more than any other condition, interacts with the scene. On a cloudy day the light envelops the landscape, and the more overcast it is, the more neutral and directionless the illumination becomes. But when the sun emerges from the clouds, watch what happens: the lit areas become much brighter, the color saturation and overall contrast increase, the color temperature shifts from blue toward yellow, and, most important of all for digital simulation, hard-edged shadows appear.

Walking on Sunshine?

This view of a cottage veranda was shot in partly cloudy conditions, which are ideal for applying the *Sunshine* filter—there is some differentiation in contrast.

Because of this complexity, which is highly selective, simulating it digitally on a shot taken in cloudy weather is a daunting task. Nevertheless, there are ways of getting close, and one software company, nik Multimedia, has developed a *Sunshine* filter that uses a combination of

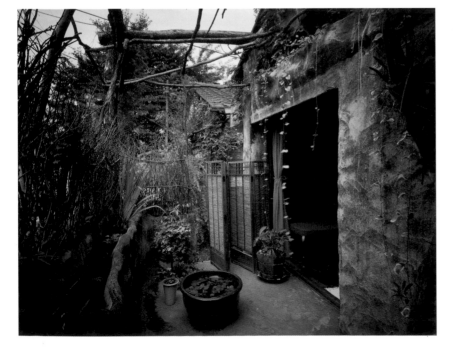

procedures. The most sophisticated of the Color Efex Pro suite, it relies heavily on a choice of prefilter to establish the contrast of the image before applying the effects and on a choice of light-casting algorithms designed for different picture types. Other procedures include increasing saturation, warming the overall color, and casting a glow from the "sunlit" areas into their surrounding "shadows."

Impressive, but none of this tackles the key feature of a sunlit scene: shadows are cast by almost everything. In a sense, sunlit scenes are the equivalent of a procedural effect in nature because they vary according to the physical contents. It's out if the question to paint in every possible shadow in a scene, unless it is a simple close-up of something with bare features. Perspective ensures that the shadows are at all scales, down to the infinitesimal.

However, human perception is a funny thing, and under the right circumstances we are happy to believe all kinds of effects if our eyes are given the right clues. Indeed, nik Color Efex Pro's *Sunshine* filter relies very much on the willingness of the viewer to take the visual suggestion of sunshine farther and translate it into a properly sunlit scene.

Mixing and Matching

The example here uses the nik Color Efex filter, which is an impressive attempt at solving a difficult imaging problem. Frankly, if you need to make this kind of manipulation, this is the way to go. That said, it is possible to go it alone almost as well with the tools in Photoshop or another image-editing package. You could also go for the best of both worlds by using the nik Color Efex filter on selected parts of the image. And there is one extra step that could make all the difference. A few foreground shadows may be all you need to fix the idea of sunshine in the viewer's perception. Of course, with only a cloudy scene to work on, you would be guessing the shape and position of the shadows, but as long as the shadows look plausible, the viewer may be fooled.

By comparison, adding a spotlit effect in an interior is child's play. Select what will be affected in the scene, then choose a soft and roughly circular area for brightening. The church scene on page 54 demonstrates the procedure.

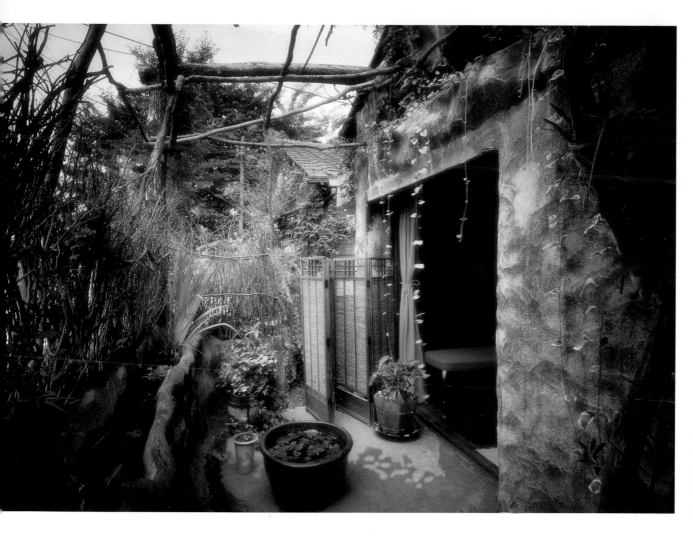

This formerly gloomy, outdoor shot has a bright center and some plausible shadows that invite the viewer to believe in the image.

Turning on the sunlight

Saturation Correction 40 %	
CCR Effect 30 %	
Light-Casting Algorithm A	
Sunlight Intensity 25 %	
Radius 12 pix	
Prefilter Combination	
Prefilter Strength 50 %	

1 In addition to the slider controls for saturation, warming, intensity, and the spill-over effect on surroundings, the nik filter offers a choice of preset light-casting algorithms.

Saturation Correction 40 %	
CCR Effect 30 %	
Light-Casting Algorithm A	
	B
Sunlight Intensity C	
	D (off)
Radius 12 pix	
Prefilter Combination	
Prefilter Strength 50 %	

2 A different light-casting algorithm gives a higher contrast effect with some burning-out of highlights, for an overall impression of more sunlight. The effect isn't perfect, but it is acceptably "natural."

Switching on the sunlight

3 To make the effect more convincing, a simulated shadow of leaves and trees is first drawn with the freehand selection tool, following three-dimensional contours where they are obvious.

4 In Photoshop, the freehand selection representing shadows is given a slight blurring, one pixel wide, in *Quick Mask* mode for a softer, more realistic edge.

5 In a new layer, dedicated to the shadow, the selection is filled with black, and this is then blended into the underlying image by reducing its opacity to 25 percent.

Focusing a spotlight

 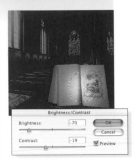

1 Opened to the Gospel according to Matthew, this Bible on a lectern in an Oxford church, is evenly and legibly lit, but could possibly do with more "atmosphere."

3 The brightness and contrast of the area of the book within the selection are both raised to a point just under legibility. For safety, this is done on a duplicate layer.

4 For a more intense impression of spotlighting, the surroundings are darkened by reversing the selection and reducing contrast and brightness.

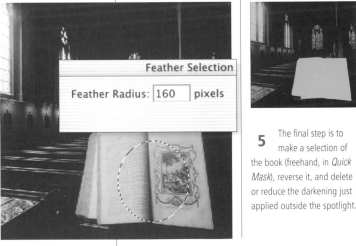

5 The final step is to make a selection of the book (freehand, in *Quick Mask*), reverse it, and delete or reduce the darkening just applied outside the spotlight.

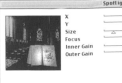

2 An approximately circular selection is drawn over the center of the book. This will be the area that defines the spotlighting effect. The selection is softened appropriately, according to how focused the spot should be. In this case, a strong blur, 160 pixels wide, is applied.

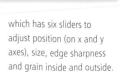

Greg's third-party
A third-party alternative is the single-step Spotlight filter from Greg's Factory Output, which has six sliders to adjust position (on x and y axes), size, edge sharpness and grain inside and outside.

The final image has the page
"spotlight," throwing more
emphasis on the central
subject of the photograph.

Polarization

Polarizing is one of the many traditional photography techniques that digital filters can imitate—it's a complex, though rewarding, process.

Polarizing filters that fit on the camera lens are one of the few means you have of making significant changes to the lighting of an outdoor scene when shooting. Their two most obvious effects are darkening blue skies and reducing reflections from water and glass, and this is what most photographers use them for. A valuable by-product is an increase in color saturation. To an extent, you can reproduce these effects in post-production—"imitate" would be a better word—but because they act selectively on a view, it's important to first understand the theory.

Light waves vibrate at right angles to the direction in which they are moving, and under most conditions, they vibrate at all angles. However, when they are reflected off some surfaces, this vibration becomes restricted to just one plane. This is called polarization. A special filter made of minute crystals that are aligned parallel to each other can block this polarized light. On the principle of a Venetian blind, it passes light vibrating in the same plane as the parallel "slats."

Blinded by Science

Light reflected from the sky is partially polarized because it bounces off microscopic water droplets. It is strongly polarized when it reflects off any smooth, non-metallic surface, notably water and glass. Because of this, the effect is stronger in some directions than in others, depending on the camera viewpoint and on the position of the sun.

Polarizing filters come with rotating mounts, and turning one in front of the lens gives maximum cut-off at one point and no effect at all at 90° later. The greatest polarization from the sky is at roughly right angles to the sun, and at an angle of about 55° from reflections off water and glass. If you have a polarizing filter, it's worth experimenting with it by rotating it in front of your eye with different views.

With apologies for the detour into physics, we now have the information needed to recreate at least some of the effect of a polarizing filter. The principle photographic use is to intensify skies, and this is well within the ability of image editing, as is an increase in color saturation.

Reflections are more of a problem, but we can go some way toward dealing with them digitally, after the event.

There is a third-party filter that makes a respectable attempt at polarizing an image in the nik Color Efex Pro suite. But as the manual warns, the task of doing this perfectly borders on the impossible. This is a simulation of the effect on blue sky by combining a number of routines, and it comes with the disclaimer that it cannot filter away surface reflections. While this is a fair warning, it really means that the filter can only do so much without user input. Just as sunlight is interactive in the sense that its effect depends on the physical details in a scene, so the effect of a polarizing filter depends on where the sun, sky, and reflecting surfaces are in an image.

The Sky is Not the Limit

The easy approach to the sky is to select a range of blue with the *Hue/Saturation/Brightness* control and increase saturation while darkening slightly, as in the shot opposite, which was taken straight up through trees to an October sky. To be realistic, vary the strength according to where the sun is in relation to the image. Also, if the lens was wide-angle, then, strictly speaking, the intensification of the blue should vary across the sky, but as this is one of the drawbacks of polarizing a shot, there's an equally good visual reason for keeping the effect more even.

Beware, however, of continuing the effect into shadows. Far from becoming bluer, polarized shadows under a clear sky actually become warmer. You might try protecting them first by painting over them in a mask layer and inverting that selection.

The effect on reflections depends on the angle, and in the simplest case of water in a pool or lake, the polarization is opposite to that from the sky directly above, which is good news for realism (intensify the sky, but leave the water reflections alone). Nevertheless, the procedure for reducing reflections is an overall darkening and extra darkening for blue sky reflection. The one thing that really *is* impossible is to reveal what lies under the water or behind the glass, so darkening is the best option.

Intensifying blue sky

1 The *Hue/Saturation* control in Photoshop accesses the always-useful *HSB* model. Choosing blue restricts the effect of increasing saturation and reducing brightness to just the sky, without any need for complicated selection.

2 The *Polarization* filter in nik Color Efex Pro performs essentially the same operation, although the *Rotate* slider is actually nothing of the sort, but a control for color contrast.

Water reflections

1 Having excluded the blue reflections by masking, the range of blues and cyans are selected and the saturation and lightness sliders adjusted. The result is a polarized sky, with which there would be no effect on the water.

2 Maximum polarization of the water reflections occurs in reality when a polarizing filter is rotated 90° from the maximum for the sky—when there is no effect on the sky itself. Here, the pre-selected water is darkened overall, with added darkening for the small area of blue.

Day for Night

A technique often used badly in many mid-twentieth-century motion pictures, day for night can make for some striking still images.

In the days before fast lenses and film stock, the standard technique in the movie industry for dealing with outdoor night scenes was to shoot them in daylight, underexposing and sometimes filtering to give the impression of semi-darkness. This was called "day for night." In countless Westerns, horsemen galloped across the plains in blazing sunlight only to appear on the screen like shadowy figures under a full moon—more or less.

In fact, there was nothing illogical about this early special effect. Not only was it practical, but in reality the only difference between moonlight and sunlight is quantity. The moon reflects sunlight, and as it has no color itself, the result should look exactly the same—provided that the exposures are long enough. Ansel Adams went to the trouble of calculating the correct exposure, on the basis that the intensity of moonlight from a full moon is about 400,000 times less than that of sunlight, and came up with an exposure of 8 minutes at *f*-4 with ISO 64 film before compensating for reciprocity failure (the slowing down of film response with unusually long exposures). But he also noted that "just what values moonlit objects should have to give the impression of moonlight depends on personal visualization," adding "Obviously, there is no reason to imitate daylight with moonlight!"

Night and Day

If you shoot a night scene fully exposed, it will merely look like daylight with a darker sky and star streaks. But there are reasons for imitating moonlight using daylight, if you want to give the impression of night, and as we are now in the digital world, you might as well do it during image-editing. The exact amount of underexposure, or darkening, is a matter of judgment. It should be at least bright enough to make out the subject in an image, yet dark enough to seem deliberate.

The one definite perceptual difference is that in low light the eye ceases to register color, and so we get a monochrome view. For various reasons, a bluish tinge seems to fit in with most people's impression of night, and we also think of the sky as being darker. All of this can be dealt with simply. Reduce the overall level of brightness, reduce saturation, perhaps add a slight bluish cast, and darken the sky even more (by selecting it first or, if it is a blue sky, adjust the blue range in *Hue/Saturation*). Among third-party products, nik Color Efex has a dedicated *Midnight* filter which also includes, purely for impression, a blur control to give what they call a "washed" look.

Depending on the scene, the best visual "clue" to a nighttime look is to add lights to buildings, as in the example, opposite. The key to making this look real is in the blending, using *Overlay* mode and intensifying it.

A surreal blend of night and day

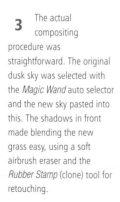

1 The picture as taken is of an old court house in Vicksburg, Mississippi, photographed at dusk rather than later so as to have some impression of the sky.

2 Sky and foreground were selected from other images, making sure that the sun's position matched in each. White cumulus clouds have the most obvious modeling and were deliberately chosen to communicate "daylight."

3 The actual compositing procedure was straightforward. The original dusk sky was selected with the *Magic Wand* auto selector and the new sky pasted into this. The shadows in front made blending the new grass easy, using a soft airbrush eraser and the *Rubber Stamp* (clone) tool for retouching.

A realistic night view

1 The starting image is of old stone buildings in the forested Ardennes region of Belgium, photographed in the late afternoon. The lack of direct sunlight will help make the night version look realistic.

6 An appropriately warm color is chosen for the interior lighting, to mimic tungsten lamps. This is applied as a solid color to the selection in a separate layer.

2 Using a custom filter, the basic day-for-night conversion applies a small amount of blue cast and a little blurring, as well as a stronger reduction in brightness.

7 To make the yellow-orange appear to come from behind the window, the color layer is blended as an overlay, which reveals the window panes and other details. To intensify the effect, this layer is simply duplicated.

5 As a first step in illuminating the windows, they are selected by first outlining them with paths, and converting these into a selection.

8 The final version is a convincing night-time scene. Success very much depends on the balance of lighting, which can only be judged by eye.

4 The darkening is followed by adding a slight color cast, towards blue in the shadow areas of the image.

3 The alternative manual procedure is to reduce overall saturation and brightness in the HSB model, using Photoshop's *Hue/Saturation* control.

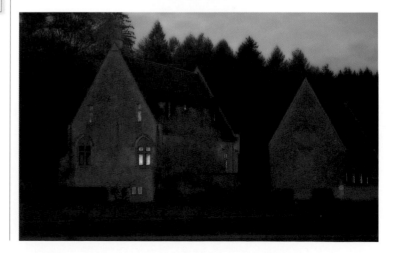

Sky

The sky is no longer the limit when it comes to digital technology —you can create, enhance, or paste it—whatever sky you need.

The near-universal background in outdoor photography is sky, and this makes it an essential ingredient in special effects. Scenes shot outdoors are the staple of photographic imagery, and if you have the facility to alter, add to or replace skies—or even create them from scratch—then you will have established a good, basic repertoire.

There are two reasons why you might want to change the sky in an image. The technical one is to make it match the lighting on a subject in a digitally combined image. One certain way of giving the game away when combining images is to have different lighting—for example, having a figure lit softly from one side when the clouds behind are clearly under bright sunlight.

The esthetic reason is to create a mood or add drama, or simply to spice up an uninteresting sky (as skies are rated, a flat overcast of low cloud is near the bottom of the league, while ragged storm clouds tinged by a setting sun are close to the top). In landscape photography, the quality of the sky can make or break the overall image.

Probably the best source of sky backgrounds is a library of real ones that you have already shot. Whenever I come across a good sky, I take a shot for the collection, not necessarily with any particular use in mind. Things to bear in mind when shooting for future use are that generally, wide-angle views are more useful than telephoto (they take in more), and that the more sky that you can include close to the horizon, the better. Naturally, vertical obstructions can be a problem, although to an extent they can be removed using the *Clone* or *Rubber Stamp* tool.

Blue-Sky Technology

With an endlessly changeable sky to photograph, you might wonder what the point is of creating one in the computer. Thanks to the evolution of 3-D software and the use of algorithms that use fractals to create a natural-looking feel, building a sky with varieties of clouds is very simple. The added advantage, though, is that you can adjust the viewpoint and focal length of the lens to match your subject—and the sunlight. Corel's Bryce is the pioneer of affordable and easy-to-use software in this area. It even comes supplied with presets, which are convenient starting points for making adaptations.

A really bright-blue sky completes this striking image.

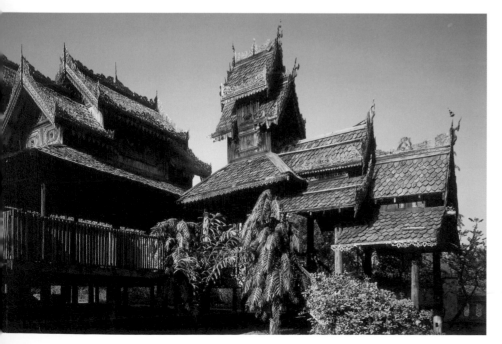

Use a standard image database, such as Extensis Portfolio, to keep a separate catalog of potentially useful skies, as shown here.

Making a blue gradient sky

Plain blue is a kind of "default sky"—not particularly interesting, but serviceable enough—and you can manufacture it onscreen with little difficulty. However, study real blue skies and photographs of them and you can see that they are not plain as they might seem. The color and tone grows lighter toward the horizon. If you shoot with a normal or wide-angle lens, this lightening is greater in the center of the picture. So, for realism, use a radial gradient and then squash this vertically, as shown. And to keep the shading moderate, make the artificial sky oversized—as a rule of thumb, twice as wide as the landscape.

2 In a separate layer (for full control), use the *Radial* option for a gradient from a lighter blue of different colour to transparent.

4 Paste in a pre-selected scene, into a third layer, and move around until it fits as well as possible. Adjust the percentage of the radial lightening layer to taste.

5 Crop the combined image. Finally, add a tiny percentage of Gaussian noise to each layer of the sky to remove banding and to help it blend texturally with the scene layer.

1 Choose a suitable darker blue for an image twice as wide as you will eventually need, and three times taller than this.

3 Squash the image to a third of its height so that the gradient is more elongated and natural in appearance.

Bryce skies: With all other elements—objects, planes, and landscape—turned off, work just on the atmosphere parameters. The controls are detailed, perhaps too much for most uses, but clicking through the preset examples illustrates what parameter has what effect.

TECHNIQUES

Clouds

Purist landscape photographers might scoff, but editing, cutting and pasting, or creating new cloud textures can bring flat images to life.

It might sound obvious, but the character of a sky—how interesting it looks—depends largely on clouds. Every landscape photographer knows how much the weather can contribute to a scene. Ansel Adams, perhaps the most meticulous of them all, said, "When the clouds and storms appear, the skies and the cloud shadows on the mountains bring everything to life." The photograph, opposite, of an adobe church north of Santa Fé, New Mexico, is a case in point. There's nothing wrong with it, but a cloud texture would certainly improve the image. To make it realistic, I chose a new sky carefully from my library—the lighting conditions and the blue tones were similar. The technique was the usual cut and paste, with some adjustments to the blending so that the white crosses on the church would not become lost in the white of the clouds.

Tangled up in Blue

More complex, but very effective, is to wrap clouds around a scene. There are only a few reasons to attempt this, and they include making clouds hang low around mountains or, as shown (*opposite, far right*), pass in front of the moon. This image is heavily manufactured, with the moon being not only way out of scale, but also a model, though a very accurate and detailed one. They key here is to sandwich the scene—in this case the moon—between two identical layers of cloudy sky, with the top layer at about half opacity. Then gently erase parts of the middle layer so that the moon, in this case, disappears in places behind different thicknesses of cloud. In theory you could work with just two layers, but this makes the erasing process much more difficult.

Clouds Made to Order

Back in the world of 3-D, a landscape generator like Bryce makes clouds like this possible. By creating customized clouds against a neutral background in Bryce, you can then copy them and blend them into photographic scenes. In the example shown here, the background has been set at neutral gray. The two methods are to create either a cloud plane (which is flat), or a squashed sphere (which has volume). The program's *Materials* editor lets you choose different kinds of clouds, from flat to fluffy, with different degrees of turbulence. In Bryce there is a dedicated section for cloud textures. Having created one using this, export the result as a 2-D image, and paste it into the photograph as a new layer.

Creating 3-D clouds in Bryce

Cloud plane
One method is to create a flat layer of cloud by clicking on the cloud plane icon. This appears in perspective as a wireframe.

Choose the characteristics
The Bryce *Materials Lab* gives a wide range of preset cloud types, in addition to sliders controlling the many parameters.

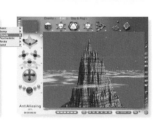

Render
Rendering the cloud plane with a roughly created tall mountain illustrates the interaction of clouds and landscape.

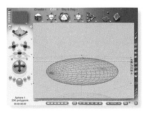

Individual cloud
A second method is to create a primitive shape. The most useful for clouds and mist is a squashed sphere, as shown above.

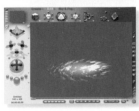

Rendered single cloud
The rendered squashed sphere, using a turbulent cloud texture. The program provides the necessary transparency to the cloud.

Adding clouds to a plain sky

1 A perfectly clear morning in New Mexico gives a sky that is too perfect for some tastes, without a trace of cloud or haze. Perfect for editing!

2 Separated by a few hundred miles or so (and several years), this richly textured sky was photographed in Texas. The blue areas are similar to those that will be replaced.

3 The sky area is selected by using the *Magic Wand* tool, an easy process given the clarity of the blue. This selection is saved and loaded ready for the next step.

4 Having matched the scales of the two images approximately (the Texas photograph needed to be reduced in size), the replacement sky is pasted into the original.

5 The new sky seemed to fit better into the image when flipped horizontally, and was then moved around slightly to improve the composition. Fortunately, the clouds have no evidence of the sun's direction, otherwise flipping would not have worked.

6 The final task was to blend the new sky into the old by adjusting both the blue and green sliders. This operation has to be done carefully so that the result is realistic.

7 In the finished composite, the new sky sits comfortably and seamlessly, mainly due to its being a good choice, but also because of the blending. This helped to match the blue areas in each sky and to lower the values of the whitest clouds, thus leaving the white crosses clearly visible.

Clouds passing over the moon

1 A selected image of the moon is pasted into the sky and scaled to fit. The original image is of a NASA model of the moon.

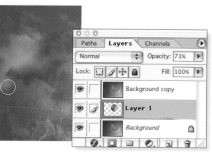

2 To simulate the natural effect of the atmosphere partly obscuring the moon's image in real life, the opacity of the moon layer is lowered.

3 The background layer of clouds and sky is duplicated, and this identical layer is placed on top of the stack, so that the moon is effectively sandwiched between them.

4 The upper layer is reduced in opacity so that the moon shows through, and then the areas of the moon behind the densest cloud are erased very softly.

5 In the final composite, the moon not only blends realistically into the sky, with a soft blue haze, but also disappears appropriately behind cloud.

Mist and Mood

Creating convincing mists and moods was something that eluded predigital photographers, but you have the tools at your disposal.

Mist is one of the qualities in an outdoor scene that provides what most people consider to be "atmosphere." It softens and obscures our view of anything in the distance, making it less distinct, silhouetted, and less saturated in color. When strong enough, mist imparts a sense of mystery to a scene by hiding part of the landscape and consigning elements to the margins of visibility. For the technically inclined, mist is made up of microscopic water droplets hugging the ground. It is between fog (dense, ground-level cloud) and haze (which can include dust and smoke).

Play Misty for Me

Like many atmospheric effects, mist is valued in photography for being relatively uncommon. It is one of those conditions that can make an image both distinctive and enigmatic. Digitally, it can be reproduced beautifully with some effort, but it is best used sparingly. Apart from its general mood-creating qualities, mist has one very valuable property for two-dimensional images: it creates a strong sense of depth. On a typical misty morning, objects close to you will be clear, those in the middle distance slightly hazy, and ones in the distance will be more or less obscured. This gradient, or "ramp" as it is sometimes called, is the real challenge in making digital mist.

Why Digital is Better

In predigital photography, a mist filter was basically a colorless sheet of glass or plastic with the upper half slightly opaque, which could be shifted up and down in front of the lens. The idea was to match the misty part with the upper, more distant areas of the view. In practice it was fairly useless, as it would apply the effect even to tall foreground objects. It worked on the same principle as a grad filter (page 61), with a transition from clear to opaque glass. But mist needs a smarter approach, one that takes into account the actual depth in the scene—in much the same way as we saw with selective focus (pages 30-1).

In the image opposite, of an ancient Thai monument, there is already some mist in the scene—in fact, the image needs no improvement. I use it simply as an example because it contains prominent vertical objects, which would cause problems with a simple, graduated filter.

The technique is to isolate by hand the different buildings and to create a mask which reflects the depth in the scene. This involves a combination of solid masks, such as for the foreground, and a gradient ramp from front to back. The final mask will effectively be a depth map, also known as a z-map (from the z-axis in 3-D programs that represents depth from the viewer). This mask can then be applied to any amount and color of mist. The steps described on page 66 show how.

Melancholy Mornings

There are several other ways of "distressing" an image that will convey a sense of mystery, period, or other-worldliness. The components of "mood" in this sense are desaturation, grain, blur (of one kind or another), and color shifts. All of these are well within the range of normal image-editing, applied one at a time, but there is a case here for using specific third-party filters geared to creating a multiple effect. A number of software designers produce these filters, including nik Color Efex Pro and Flaming Pear. The advantage of these filters is less in the engineering than in the convenience of combining several effects by means of sliders in a window that previews the effect.

There's nothing wrong with the original image, but the composition and the perspective make it an ideal testing ground for adding convincing mist—something pre-digital filters were very poor at achieving.

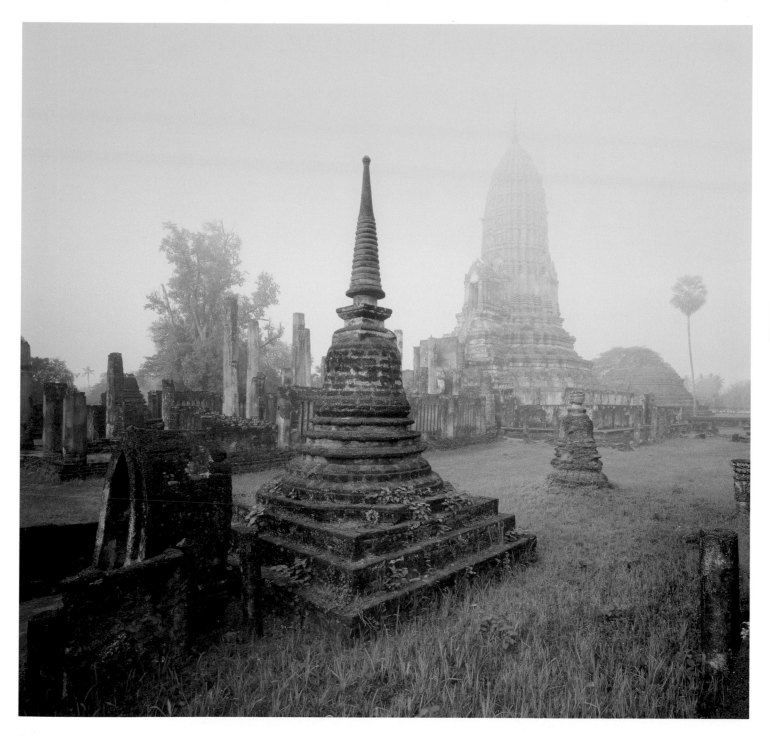

Hitting the *Delete* key removes the gray "mist" in proportion to the gradient in the selection. By performing this in a separate layer, the strength of the effect can be adjusted afterward by moving the opacity slider.

Applying realistic mist

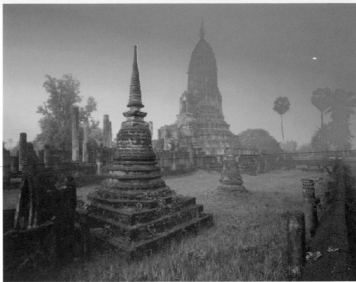

1 Mask off the foreground using a combination of auto-selection tools and hand drawing.

2 Next, invert the selection and create a gradient mask for the middle ground and background that increases toward the distance and with height. The new gradient mask will not affect any part of the image covered by the solid foreground mask.

3 The result is a blended gradient mask that becomes more solid with distance and height, as would happen in nature with real mist.

4 Reveal some of the middle-ground details covered by the gradient mask so that they will stand out a little more prominently. This work is done by hand using the *Eraser* tool.

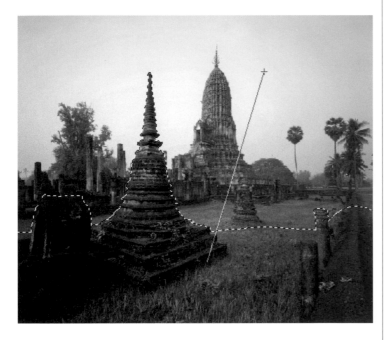

5 Finally, a new layer is filled with a pale, almost neutral gray. This is the mist layer. The opacity slider is adjusted to give the desired maximum effect in the distance. Then the gradient selection is loaded.

MOOD VARIATIONS

One image, of a waterfall in Iceland shot in subdued light, subjected to a variety of mood effects. As there is no clear objective in applying this kind of filter, you need to exercise some discipline in judgement. The key is occasional use.

Monday Morning

This filter (really a group of four) from nik Color Efex, affects noise, brightness, smear, and saturation, for a cool, gloomy look.

Midnight (blue)

A "day-for-night" filter set for a darker, sinister effect, using *Color*, *Blur*, and *Brightness* sliders, and a blue colour range.

Bicolor (moss)

This filter colors upper and lower zones in two variations of green. The dividing line can be rotated and moved vertically.

Classical blur

This filter gives a halo-like diffusion for a soft, washed-out effect. Its success lies in its ability to preserve sharp detail.

Graduated (moss)

A digital gradient filter; the upper part of the image is tinted. The horizon can be rotated, and shifted up or down.

The "source" image before applying any third-party digital filters shown above.

Flames

Dancing, flickering, unpredictable, destructive—all qualities that make flames so difficult to simulate. What are your options?

Flames are volatile and fugitive and notoriously difficult to imitate. Indeed, it is only recently that software of sufficient complexity has been written to come close to delivering a convincing effect. Flames contain some of the most difficult graphic qualities—they're intricately detailed yet soft, randomly shifting, and layered one on top of another—and there are endless transitions and blends between them and their surroundings. Not only this, but they flicker constantly, and while this movement helps imitations enormously on video and film, in still images they have to be frozen in time—and this puts them under greater scrutiny than usual.

Shot Down in Flames

Unless you are an illustrator of considerable skill, there is no point in attempting to draw or airbrush flames by hand. The odds are heavily stacked against their looking natural. Because fire is destructive, viewers will assume that flames in a carefully set-up photograph are artificial in some way. The only solution, if you really must set things alight and can't afford for one reason or another to do it for real, is software dedicated to creating flames. This is very much a niche market, and at present there is little choice. KPT FraxFlame does not even attempt to look realistic and so rates very low on the functionality scale. Eye Candy 4000 produces workmanlike flames, but they are simple, predictable, and clean, with a distinctly "illustrated" appearance.

At present, the most convincing flame filter is the excellent, and painstakingly engineered, Fire 3.0 from Panopticum. The dialog box (opposite) shows how many properties are involved in flames, and what is displayed here is only one of seven parameter groups. Flames, as you might expect, have randomness (in technical terms, the processes involve free-radical chain reactions), so digital filters rely heavily on fractal noise to produce them. Panopticum applies this to tongues of flame. This function forms the basic parameter group, with eight sliders.

Realistic Options

In all, there are an impressive 38 parameters that can be adjusted—it sounds complicated because it is. Nevertheless, this lets you create almost any kind of flame, provided that you take time to familiarize yourself with the process. Normally, I wouldn't concentrate so firmly on one piece of commercial software, but this one is exceptional in an area where there are few alternatives.

If this all sounds too much, you can always reuse real photographed fire, although you will need to find some suitable flames to shoot. This is likely to need some preparation, as the most useful raw image is of flames against a black background. Cloning, nudging, and distortion are all ways of extending and changing the shape of flames. Then you can use a straightforward blending procedure, such as *Screen* or *Lighten* in Photoshop to lay a flame layer into another image—as in the creation here of a fireball from oil refinery flames. Other kinds of random imagery can sometimes be pressed into use, as in the example of a projected laser light show, blurred appropriately.

The original shot is of a prepared hide, illuminated in the traditional way with calligraphy and gold leaf. Although the intention of the photograph was not to set it on fire, accidents can happen!

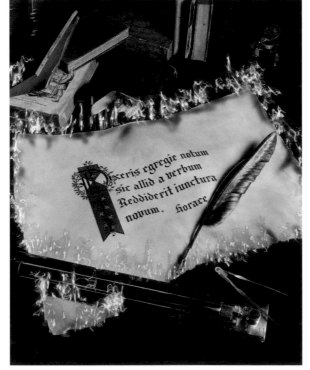

In the final result, flames ignite from the edges, which are also blackened. Note that by masking out the brass parallel ruler, the flames are convincingly made to lick around it.

Setting light to parchment

1 The first step is to select the area that will be set alight, in this case the parchment. Here, the mask has been completed to cover it, and the digital flames will be applied to its edges.

2 The dialog box for the chosen software, Panopticum's Fire 3.0, offers a huge number of permutations, reflecting the inherent complexity of flames.

3 For full control, the flames are applied to a black layer, which can then be blended into the underlying image as wanted. The chosen option here is *Screen*.

4 The flames are retouched—in this case, as they are supposed to be rising from the parchment, the lower edges outside the area are erased.

5 While the filter intelligently adds singeing to the inner edges of the parchment, the effect is enhanced by selective airbrushing.

Real flames for a fireball

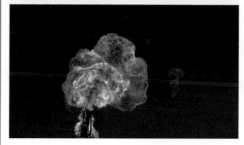

The burn-off from an oil refinery stack makes a useful billowing flame source for later use. Two consecutive shots were rotated and composited, with cloning to extend the black billowing smoke in all directions.

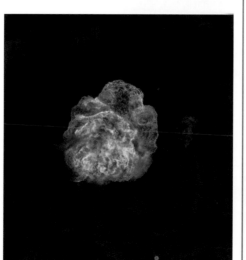

Fake laser flames

A still photograph from a projected laser light show bears some passing resemblance to fire, particularly when blurred.

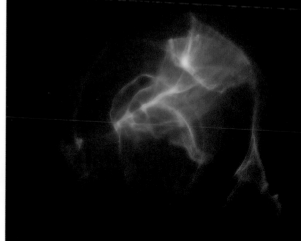

FIRE 3.0 IS NOT THE ONLY OPTION

The very limited choice of fire filters includes the Eye Candy 4000 version and KPT's FraxFlame, but each has fundamental limitations, as explained in the text.

Pyrotechnics

More dramatic in nature than flames and fire, lightning and other pyrotechnic displays are easier to simulate with digital effects.

Going a stage beyond flames, there is a wide range of events that involve combustion and electrical discharge. As with fire, they are not easy to get right—that is, to make convincing—and the solutions depend either on software that relies on random factors, or on reworking existing photographs of similar effects. Combining layers of different elements, such as bolts of electricity and sparks, into a single image is one way of building up the complexity that helps to make such effects believable.

Conducting lightning

Lightning is the most manageable of these effects, as its main ingredients are branching, randomly wavering lines. If you use picture references of real lightning strikes, these are reasonably easy to draw by hand, as long as you do it shakily. The realism in lightning bolts comes from the color, glow, and softness: typically the center of the line appears white, surrounded by a bluish glow that blends into the underlying image. For this, all you really need is

a random white line, which you can soften by blurring. Draw it in a new layer and it becomes easy to select. For the glow, duplicate the layer, thicken the line (*Select/ Modify/Expand* in Photoshop) and fill it with blue or violet. Finally, adjust the blending with the image underneath.

The software manufacturer Alien Skin produces two plug-in effects that do the job very simply in its Xenofex set—*Lightning* and *Electrify*. Both work in exactly the same way, except that *Electrify* applies the arcs to a selection to create the effect of an object spitting out or attracting bolts of electricity. As you can see from the two dialog boxes (*below, left*), there are several parameters, mainly to do with shape and direction. Like many atmospheric effects (clouds or flames, for example), arcs of lightning have a strong, random element. Accordingly, the software makes use of fractal noise and there is a *Random Seed* control that will produce strong, unpredictable changes of shape and direction.

Explosive material

Of course, lightning is just one variety of pyrotechnic event or energy discharge. Explosions are another, but one that is not well catered for in still imaging software. There really isn't a widespread demand to make the considerable effort in software engineering worthwhile. However, motion pictures and videos certainly justify it, and there are some powerful effects suites available that use particle generators and shaders. If you have an interest in this area, a reasonably priced suite is Puffin Designs' Image Lounge from Pinnacle Systems, a plug-in for Adobe After Effects, but digital video is really beyond the scope of this book.

To an extent you can build up an explosion from different elements, one of which could be a fireball similar to that on the previous pages; another, a radial glow, and perhaps also a radial flare. For examples of the last two, see Flare on pages 34-5. Try adding several different effects one on top of another in layers, all of them centered. Play with the blending options and the opacity of each layer. The difficult part is creating solid fragments; to date there is no 2-D filter that does a proper job of fragmentation, and the work would be painstaking by hand.

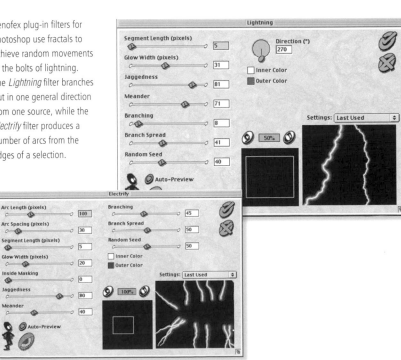

Xenofex plug-in filters for Photoshop use fractals to achieve random movements of the bolts of lightning. The *Lightning* filter branches out in one general direction from one source, while the *Electrify* filter produces a number of arcs from the edges of a selection.

Brewing up a brainstorm

In this three-part composite image, a brain section is superimposed on a girl's head, and lightning arcs added to symbolize the energy of creative thought-processes. The lightning arcs were generated separately on black, and introduced as an individual layer so that the blending and positioning could be controlled precisely. The original lightning effect was added to and retouched to fit the brain, and blended in at 90 percent opacity in *Lighten* mode.

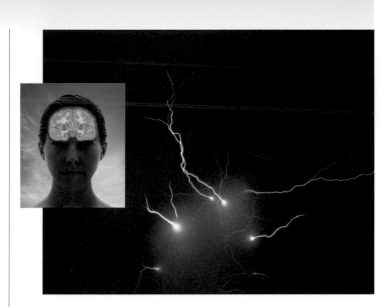

The KPT FraxFlame plug-in mentioned on the previous pages. While of little use for realistic flames, it uses fractals to produce unpredictable streaks and swirls that offer ways to imitate pyrotechnic effects.

Knoll Light Factory offers a sufficient variety of flare elements to build up part of an explosion. In this example, three elements have been applied, each to its own black layer, and then blended to taste.

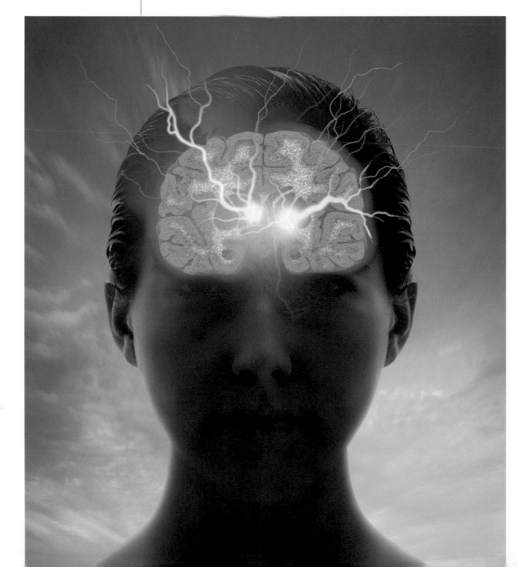

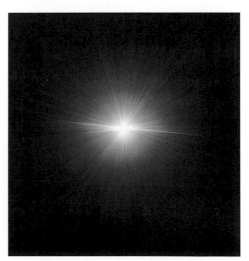

Organic Textures

Perhaps the hardest textures to mimic digitally are organic ones. The secret to doing it convincingly is in the minute details.

The original cup and saucer. The starting point is a plain white ceramic cup and saucer of Finnish design. The cup and saucer are also shot individually. Selections are made of the outlines, using Bézier paths.

A furry cup and saucer. The assembly is in layers. To make the fur conform better to the shape of the cup, the various angles of fur in different layers are blended by erasing parts of each.

Surface textures are commonplace in digital imaging, but most of them belong in the realm of illustration. One of the greatest technical challenges in digital imaging is to create textures that look as if they could believably have grown in nature. Clean and regular is much easier than bitty and chaotic, which is how many natural surfaces appear. I'm stretching the definition a little to include such things as earth and rock, but the principle is the same.

Universes in Grains of Sand

What makes organic textures so difficult to manufacture in the ordered environment of a computer is their defining qualities of randomness and fine detail. Take a magnifying glass to your skin and you'll see how complex the texture is—even more so if you happen to have some hairs on it. To get close to this irregularity and detail digitally, the software has to introduce random components and the user needs to work on a large image file that can later be reduced in scale. This is not something that the ordinary user has much chance of creating, and you will have to rely on specially constructed filters. Even then, only a few are convincing enough to produce usable results.

Then there's the other factor that comes into play. This is the nature of human perception, which is little understood, and difficult to fool with artificial textures. We can intuitively judge whether things are "natural." Perhaps this is the point to introduce a belief that I've long subscribed to in special effects: redundant detail. It applies to more than just textures, and it affects any image in which you are introducing an artificial construct and trying to convince the viewer that it is real. Anyone viewing a "real" image knows there to be more detail than the photograph shows at the distance it was taken, and receives subtle clues from the picture that this is so. For example, a pinpoint of light on a distant house at night would resolve itself into a window if the camera moved closer. For believability in special effects, it is important to build in more detail than can be read easily from the image.

Subverting the Familiar

One of the most difficult organic textures to get right is fur and hair, for all the above reasons, and painting these by hand is out of the question—unless you have ambitions to be a Persian miniaturist. I've applied the texture (left) using two competing filters, to the unlikely combination of a cup and saucer—in homage to Meret Oppenheim's Surrealist icon. Oppenheim used real fur for her sculpture. The software solution isn't too far off.

Among the things you can do to help is apply the filter to a large image file and then downsize it to make the detail finer, but this will tax the computer's performance. Also, consider retouching the result by shading and pushing pixels about with a *Distortion* brush or *Smudge* tool. The effectiveness of the other sample textures you can judge for yourself from the image.

As we're dealing with digital images, you can always experiment, copy, and undo and redo, but if your aim is to distress the texture further and add chaos, this will almost certainly take time and be boring. Software achieves randomness and detail by using the complex math and algorithms, called fractals. Understanding fractals makes it easier to adapt certain basic filters and create your own surface textures.

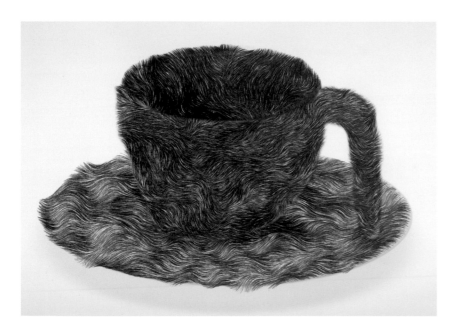

Furry cup and saucer

1 The Eye Candy 4000 *Fur* filter lets several parameters be altered, including the direction of the hairs, which is set horizontally for the saucer. An alternative program is FiberOptix from KPT5.

2 As the filter is applied indiscriminately across the selection, a depression is added by reverse spherizing. This is later shaded by darkening.

3 The filter is separately applied to the outside of the cup and the visible part of the inside, first blurring the selections to conceal hard edges.

An organic filter

1 The original for this project is a still-life close-up of a lemon, bell pepper, and kitchen knife. The filter will soon alter its wholesome appearance.

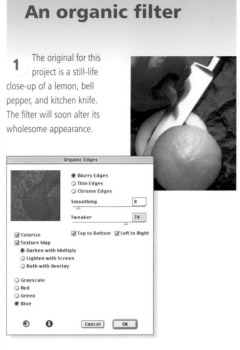

2 Applied first to just the red part of the bell pepper, the *Organic Edges* filter from Furbo Filters, derived from GIS edge-detection software, finds and manipulates edges. The blue channel here gives a stronger contrast.

3 Separately applied to selections of the pepper and the lemon (selected by their color range), the filter gives a wrinkled and rotted texture—unmistakably organic.

A VARIETY OF TEXTURES

Various third-party software companies produce texture filters that have a more or less natural feel. One of the most natural is the *Crackle* filter from Dream Suite, which provides different degrees of branching and irregularity, together with variations to the crack depth, spacing, and the upward curling.

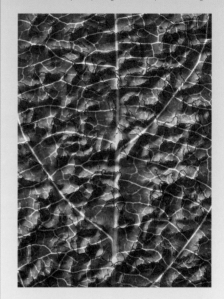

DreamSuite *Crackle*

KPT *Texture Explorer*

Eye Candy *Marble*

Xenofex *Baked Earth*

Furbo *Vibrant Patterns*

Shiny Stuff

All that glisters is not gold, but it could be metal, plastic, or glass. All have characteristics that digital effects are uniquely suited to copying.

The complete opposite of irregular organic textures are smooth, hard, manmade surfaces that have characteristic reflective qualities. The most common of these are metal, plastic, and glass, and digital special effects excel at reproducing them. It's easy to see why: brushwork by hand has an inevitable imprecision, and is "unplanned" in the sense that it works one dab at a time. Digital imaging, by contrast, has to be set up in advance, and code written to determine what happens to each pixel. It's no surprise, then, that painting reproduces natural, non-repeating textures with ease, but has great difficulty with an artificial surface like metal, while the reverse is true for digital effects. Flat surface qualities can be defined perfectly with a few basic parameters, and texture is easy to simulate.

Get Your Glasses On

The key parameters of smooth materials are reflectivity, specularity, diffusion, ambience, color, transparency, and refraction. The beauty of this approach is that every smooth material has a particular combination of these. Setting them is exactly what digital procedures are good at. What makes metal, plastic, and glass distinctive is that they interact with their surroundings. Some reflect, some transmit—all in particular ways and to varying degrees.

All things bright and beautiful—even creatures great and small can be given a futuristic appeal.

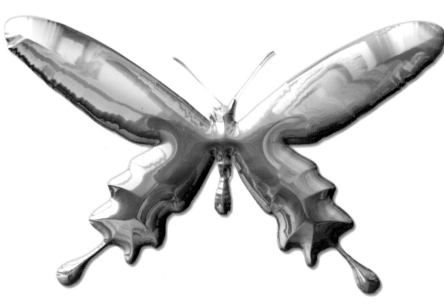

Metals tend to be reflective, and what distinguishes one from another are subtle differences in color and surface texture. Highly polished silver or chrome is 100 percent reflective with 100 percent specularity and no diffusion, while brushed silver has more diffusion and less reflectivity.

Setting the parameters is easier in 3-D than in flat images because raytracing automatically calculates reflections. In a flat image these have to be simulated, and blurring is the crucial component—not only for metals that are not so highly reflective, but also to give the impression of depth of field. If the surface is in focus, reflections from the distance will be out of focus.

Fools' Gold?

In real metals, the colors of reflections are filtered through the diffused color of the metal itself. With highly reflective metals, you'll need an image to "reflect." The solution is a reflection map, which can be any pattern or scene that seems appropriate. To map the scene onto a metal surface, it will need to be heavily blurred, given a degree of transparency, and distorted to fit the contours of the surface.

For height and texture, the solution is bump shading to give a form of bevel at the edges, and bump mapping (see pages 78–9). Plastics are easier to simulate because they are characterized by being shiny but not reflective, and they are often strongly colored. The parameters are high specularity, low reflectivity, and plenty of diffused color.

The main characteristic of glass, of course, is transparency, which fortunately is one of the easiest qualities to add digitally with the opacity slider. Realistic glass, however, involves considerably more work. Of all materials, it involves the greatest use of all the parameters: high reflectivity, high specularity, variable refraction (greatest near the edges), volume color that increases with thickness, and even multicolored diffraction.

The best dedicated software tends to subdivide the parameters so as to control the differences very finely. For this reason, DreamSuite from Auto FX is notable for its sophisticated metallic effects, and Lens Pro II from Panopticum is the superior software for glass. Plastic is the poor relation in the family, being the least complicated.

Metallic effects

1 DreamSuite's sophisticated metal effects involve four groups of controls: *Effect*, *Surface*, *Environment*, and *Lighting*. Texture and reflection maps can also be added.

The complexity of glass

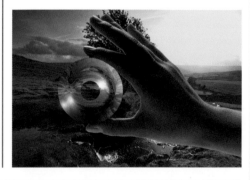

1 The backlit hand is photographed holding a neutral disk for the correct appearance, then superimposed on the landscape before the lens filter is applied.

2 Choosing one of several lens shapes in Panopticum's Lens Pro II, the 25 separate parameters for glass, in four groups, are then adjusted.

2 The three-dimensional effect is achieved by a combination of bump shading and distortion of the reflection map, and works best with relatively flat subjects like this.

DEFINING ANY SURFACE

The appearance of any surface depends on two things: the properties of the material, and the kind of lighting in which it is seen.

The following parameters include both:

Reflectivity How much light is directed straight back toward the source, giving a mirrored effect.

Specularity The intensity of highlights, defined by how much of a direct light is reflected straight at the viewer. Specular highlights are the brightest points on a shiny surface.

Diffusion How much direct light is reflected by scattering. The more the diffusion, the more matt a surface appears. Diffused light reflected from a surface is the same from whatever angle it is viewed.

Ambience How much indirect light is scattered (it's related to diffusion). Ambient light is the pervading illumination from the surroundings, the sum of all the reflections. The more ambience there is, the brighter the surface will be.

Color The complexity of surfaces such as metals comes from color as applied to different parameters. Diffuse color is that of the material itself, ambient color is indirect from the surroundings, specular color is that of the highlights, and transparency color is that of the volume (for instance, the greenish tinge to thick glass).

Transparency How much light passes through a material, and so how much of the background is visible through it.

Refraction How much light is bent as it passes through a material. Refraction appears as distortion.

A variety of shiny surfaces

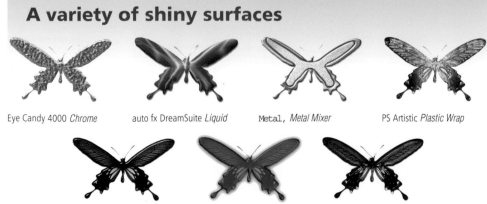

Eye Candy 4000 *Chrome* auto fx DreamSuite *Liquid* Metal, *Metal Mixer* PS Artistic *Plastic Wrap*

Extensis *Photo Groove* KPT 5 *ShapeShifter* Eye Candy *Glass*

Water

Water, water everywhere... it's one of the easiest textures to create convincingly, despite its organic, random nature.

After the complexities of reproducing organic textures, it might seem surprising that digital techniques are very successful at creating water effects. As the picture here shows (the Shwedagon pagoda), it's difficult to fault this kind of "digital water" if it is applied intelligently. The trick is to pay attention to the two most recognizable visual clues—reflections and ripples. Reflection is straightforward, with the first step being to copy and invert the upper part of the scene. Ripples then distort the inverted image, together with random water turbulence.

A Couple of Swells

Waves, ripples, and swells are just variations of distortion (covered in the next chapter), and mainly involve pushing pixels left and right in bands. You could create this yourself by making a banded displacement map (see pages 86-7), but given the availability of distortion filters, there is little reason to. Within Photoshop, the following filters are all useful: *Ocean Ripple, Ripple, Shear, Wave,* and *ZigZag.*

Third-party filters that create waves and ripples are mainly available as part of a suite, such as *Splash* in Greg's Factory Output, *Ripple* in Auto FX DreamSuite, and *Turbulence* in KPT 6. One fully dedicated piece of software deserves special mention: Flood, from Flaming Pear. This well-thought-through filter combines waves and ripples with several parameters (*Waviness, Complexity, Brilliance, Blur, Size, Height,* and *Undulation*), and provides adjustment of viewpoint, altitude, perspective, and the positioning of the water horizon.

Drops in the Ocean

Another possible route is 3-D modeling, for example via the ever-useful Bryce. For extra detail, just think about real water reflections. These will be darker and stretched vertically, the amount depending on the angle of view. Also consider lens effects, such as the degree of perspective. Flaming Pear's Flood includes such adjustments and more.

Droplets are another kind of water effect, such as you would see on a rain-spattered window, and they have many of the qualities of a lens. To make a droplet, draw a deformed circle as a selection, apply spherical distortion, shade it, and add a highlight. To take the pain out of creating hundreds of droplets, there are filters available, notably Eye Candy's Water Drops. Apply on a separate layer.

For obvious reasons, the height of the water horizon is set above the heads of people in the original. The *Ripple* controls, which create a circular ripple, are off.

Inundation

1 The original image is a straightforward shot of an exotic location—one of the largest Buddhist pagodas in the world, in Yangon.

2 The *Flood* filter from Flaming Pear is applied. The view parameters lets the water be matched to the original camera position and lens focal length.

A VARIETY OF WAVE AND RIPPLE

Despite different interfaces, the results from these filters are essentially the same: perturbations in the image that follow wavelike forms. The term "ripple" refers usually, but not always, to concentric waves that give the appearance of a pebble thrown into a pond. Ripples are useful for giving life to flat sheets of water.

Sprinkling water

1 This filter, from Alien Skin's Eye Candy suite, distributes water drops randomly according to the random seed chosen. Here it is applied to a pretextured surface resembling fine-grained granite.

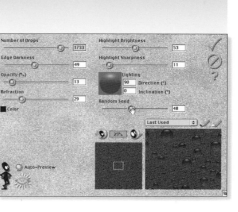

2 Given the final camera angle of the image, the sprinkled surface is given strong perspective. This was prepared for by making the original texture oversized.

3 Following the minimum width at the top of the trapezoid, the image is cropped to exclude the blank surroundings.

4 Both to match the chosen lighting (an overhead diffuse lamp) and add depth, the upper part of the image is shaded off by creating a black-to-transparent gradient in a separate layer, and adjusting the opacity.

5 The subject of the picture—a cooked lobster—is copied, already selected, from another photograph, and pasted on top of the background. A soft drop shadow is added.

6 As the lobster lies in its own layer, retouching to perfect the blend with the background is straightforward, using a small *Eraser* round the edges.

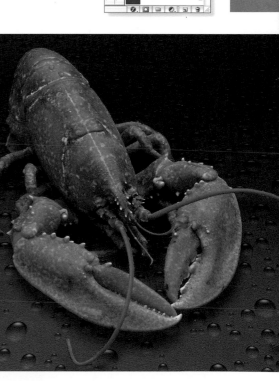

7 The composite has the lobster sitting on a slab that appears to have been sprinkled with water. Final retouching with *Eraser*, *Smudge*, and *Rubber Stamp* (*Clone*) tools reduces the regularity of the drops.

Bump Maps, Embossing

The techniques for creating minutely roughened textures within an image, and turning a single image into a texture are very similar.

Texture implies relief, and if a surface is being created from scratch in the computer, that means simulating relief. Despite the apparent jargon of "bump shading" and "bump mapping," the principle is simple. Imagine a light source shining from one direction onto the image that lightens a patch on the surface. Close to this and on the opposite side from the "light," you darken another patch. Between them, the two patches suggest a bump.

The Bumpy Road to Texture

Applying this principle in different ways, it's possible to make shapes appear to be three-dimensional objects, to give them projections and indentations, and also to create a variety of relief textures. The most direct method is brushing, usually with a soft edge, and there are a number of ways of doing even this. One is to set the brush to lighten and then darken. Another is to brush in white and black (or tints) at a low opacity. A third way is to brush

in a mask, switch to a selection and adjust brightness and contrast. For added three-dimensionality, you can then apply a slight scale distortion over the bump (either an enlarging distortion brush, or a *Spherize* filter applied to a soft-edged selection).

Shadows and Highlights

There is another procedure for achieving the same effect. It's repeatable, which often makes it more useful. The handmade version is to make a selection and then offset a copy of it away from the light. Subtract it from the first selection and you have the highlight area, which simply needs to be blurred and lightened. Offsetting another copy in the opposite direction and subtracting it gives the shadow area. This is easier to do than to visualize, and it may be worth experimenting with, at least for familiarization. Varying the contrast and the blurring alters the apparent height of the bump and the hardness of the lighting. Reversing the highlights and shadows creates indentations. In practice, the availability of filters such as the *Texturizer* in Photoshop makes it largely unnecessary to do this offsetting yourself. Instead, all you need is a pattern of black and white—in other words, a bump map.

Embossing and Bas Relief

Often, this simulated relief needs to be related to the image, and so a selection derived from the image is used as the underlying bump map. Beveling uses the shape, which is loaded as a selection. The highlights of the bevel can then be brushed in with a large brush, as can the shadows. *Bevel* filters do this automatically and offer a choice of bevel slope (rounded, sharp-edged, and so on), width, and height. A wide, rounded bevel profile generally gives the best effect of volume to a shape.

Embossing and bas relief filters do much the same thing, finding edges in the image and offsetting them, shading around them, or sometimes adding texture. This is relatively simple to do by hand, with the advantage that you can choose how to define the edges. One simple method is to make two high-contrast desaturated copies, one of them inverted, and play with offsetting one against the other.

Map into relief

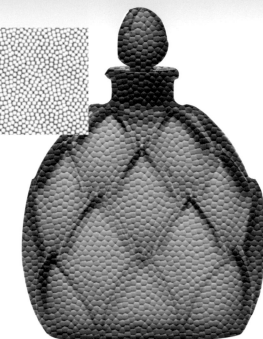

1 Any grayscale pattern will serve as a map for relief shading. Here bright signifies high, and dark low. As it will be tiled, the pattern can be small—in this case 512 x 512 pixels.

2 The *Texturizer* filter in Photoshop applies shading according to the edges it finds in the pattern. The lighting direction is set in the dialog box.

3 Added to another image, the shading gives the impression of a real, three-dimensional texture. The way it combines can be adjusted.

Embossing

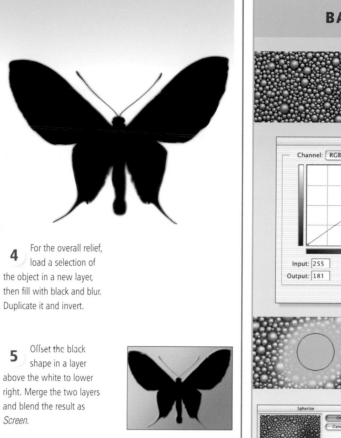

1 Desaturate a duplicate layer and apply 100 percent brightness and 100 percent contrast, then apply a *Find Edges* filter to this.

2 Create a gradient background from lighter to darker away from the imaginary light source. This will enhance the relief impression.

4 For the overall relief, load a selection of the object in a new layer, then fill with black and blur. Duplicate it and invert.

5 Offset the black shape in a layer above the white to lower right. Merge the two layers and blend the result as *Screen*.

6 Offset another copy of the white shape in a layer above another copy of the black to upper left. Merge the two layers and blend the result as *Multiply*.

3 Duplicate the "edges" layer and invert. Offset the original (shadows) to lower right and blend as *Multiply*. Offset the inverse (highlights) to upper left and blend as *Screen*. Slightly blur both.

7 Finally, duplicate the main image and drag it to the top of the layer stack. Combine according to taste— here blended as *Color Burn* with 60 percent opacity.

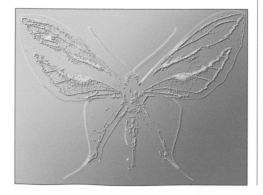

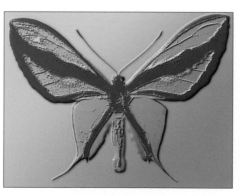

BASIC BUMP

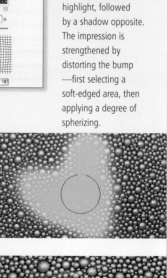

To create the impression of relief by hand, first decide on the lighting direction (here top), then brush in the highlight, followed by a shadow opposite. The impression is strengthened by distorting the bump —first selecting a soft-edged area, then applying a degree of spherizing.

Tiling

Whether you want the effect to be artificial and obvious or random and seamless, tiling is a good way of creating new textures.

Applying texture over a large area would be extremely tedious if it had to be created to the full size of the image. The solution is tiling. This is a step-and-repeat operation in which the source image is copied, pasted, and aligned, over and over. In theory this can be done manually, but in practice it is better performed as a procedure.

Completing the Puzzle

Tiling works best when the pattern is so organized that opposite edges line up exactly. The *Puzzle* texture pattern in Photoshop (in *Presets>Textures*) illustrates this. If you copy it, then enlarge the canvas and paste copies back in, the jigsaw pattern fits left to right and top to bottom. With small-scale random patterns, there is no regularity to begin with and thus there is nothing recognizable to align. But distinctive patterns do obviously repeat—the essential problem for creating natural textures.

However, this is largely of academic interest, as tiling is built into the many programs that create textures. They work perfectly well and there is no point in reinventing the fabled wheel. However, tiling is certainly of practical concern when it comes to building a large area from a small photograph. An example of this is on pages 144-5, in a project where there was a real need to create a continuous area of rainforest. The problem to be solved in a case like this is to prevent the tiling from creating an obvious pattern. This is, after all, what tiling tends to do.

There are two parts to the problem: joining the tiles, then randomizing them. The object of the first is seamless, invisible joins, and with a photograph this is no easy task. The basic approach is to create a transition at the edges from complete transparency (so that no edge line is visible) to full opacity inward. This loses some of the area, but around a 10 percent loss is generally sufficient to give an invisible blend. As this is a perceptual effect, it depends very much on the image as to whether it is really going to fool the eye. The second part of the problem is harder to solve: avoiding obvious repetition. In the example (*opposite, right*) of the autumn trees, the blending is seamless, but the contents of the image remain too distinctive.

Random versus regular

The only solution is to retouch the source image so it is more consistent, and then find a way of rotating copies irregularly and overlapping them, again irregularly. If several variations of the source image can be created by retouching, even better. This sounds like, and is, a great deal of effort. One possible automation is to import the prepared image (or images) into a 3-D program as 2-D objects and make use of the 3-D software's randomizing tools to disperse them. This may or may not be faster.

Actual tiling software does not tackle this issue of randomness because it sets out to do the opposite, but it is well suited to some types of graphic illustration. Photographs certainly make interesting source material, but despite the fact that the effects can be highly decorative, there are only a few occasions when regular tiling can help produce a photorealistic image. The precondition is that the object photographed has a regular geometric outline, preferably rectangular. Given this, tiling software such as KPT 6.0 Projector and the very flexible Terrazzo from Xaos Tools, can create enormous arrays. The example, opposite, is a silicon chip.

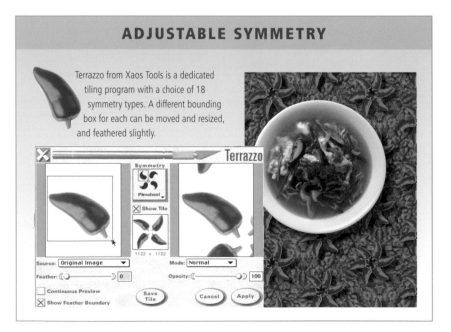

ADJUSTABLE SYMMETRY

Terrazzo from Xaos Tools is a dedicated tiling program with a choice of 18 symmetry types. A different bounding box for each can be moved and resized, and feathered slightly.

Infinite plane

1 The original is part of a photomicrograph of a silicon chip, retouched to improve its detail and add color.

2 One option in this small suite of perspective effects is tiling, with variable viewpoint and field of view, as well as the possibility of mirroring the tiled plane.

3 Arrays of things are a perfect application of tiling, and in this case a way of achieving detailed resolution of circuitry.

3D randomizing

1 The source image is prepared by retouching and by giving it an irregular outline that matches the texture of the subject.

2 In Bryce, the image is imported, together with its Alpha channel, which is used automatically to clip the outline. As a 2D object it will have no depth.

3 The imported object is duplicated by keystroke and then rotated a random amount on its z-axis. This process is repeated many times.

4 The stack of images is dispersed irregularly by operating the slider on the *Randomize* tool. The drawback is that this program concentrates the dispersal in the center, but the set can be grouped, duplicated, and rotated.

5 Dispersion in depth is corrected by grouping and squashing along the z-axis—with *Atmosphere*, *Base Plane*, and *Shadows* off.

Seamless tile

1 The texture of trees is sufficiently complex to work in tiling. A section is cropped from the cottonwoods in this New Mexico scene.

2 To ensure that the later steps will completely eliminate the edge of the frame, the selection is first contracted by more than twice the amount that it will be feathered.

3 The contracted selection is then feathered to give a smooth gradient on all four sides that does not quite reach the edges.

4 The selection is inverted and the contents deleted, leaving a soft-edged tile. This can now be copied and pasted.

5 Two copies of the tile are overlaid to the limit of the transitions, so that the faded opacity of the layers adds up to 100 percent.

WORKSHEET

Idea
Present the idea that these Japanese noodles are served cold, without being too literal

Solution
Surround the noodles with a sea of ice that swirls into an abstract form

Software
Twirl filter

Techniques
Copy and paste, rotation, blend by soft erasing, circular selection

Pushing Pixels

The ability to alter or distort individual pixels lies at the heart of digital imaging, and doing it en masse can create believable effects.

The ability to distort shapes is one of the most spectacular capabilities of digital imaging, and distortion tools are some of the most powerful weapons in the special effects armory. Distortion is about changing the proportions of images. It can be applied in a number of different ways and through different interfaces. There are a number of third-party filters, and within an image-editing program there are several distortion procedures. In this chapter I want to draw them all together and look at them as members of the same family, from simple scaling tools to software that will twist and melt images.

Bloating File Sizes

What makes digital imaging so successful at distortion is the process of pushing pixel values across an image. In principle, this is not complicated—the value of one pixel is moved some distance in one direction. Given this, it's a short step to defining special ways of moving areas of pixels, and some more than others. Used well, distortion tools can give a very convincing appearance of altering an image in three dimensions. All that is happening is that some areas of pixels are being compressed while others are expanded, but this easily fools the eye into believing that an object is being tilted, bent, bloated, squeezed, or otherwise changed in shape. When these changes are made locally and variably, the computation can be heavy, and it draws on a considerable amount of memory.

The clearest and most predictable interface for doing this is to place a simple bounding box around an image (or part of it) and change the shape of the box by pulling or pushing the corners and the sides. The image inside changes shape accordingly, and this is the way that a basic group of image-editing tools works. In Photoshop, the *Transform* tools *Scale*, *Skew*, *Perspective*, and *Distort* do this, and the only difference between them is the restrictions on what can be moved (all corners and sides in *Distort*, one side laterally in *Skew*, and so on). With some software, the box appears automatically around a selection and affects only that. With others you can draw it.

The usefulness of this kind of grid is that you can see the geometry of what you are doing (which is not always obvious from the effect on the image) and how the distortion affects the entire image selection. The latter can also be a restriction, but there are alternatives, as we'll see.

Putty in Your Hands

There are other ways of altering the grid. With the DreamSuite *Putty* filter from Auto FX, handles on the control points of the box let you bend segments as Bézier curves. *Spherize* and *Pinch* filters expand and compress the image from the center outward. *Twirl* filters spin the image differentially; and the *Shear* filter in Photoshop enables the image to be pulled left and right in bands (useful for water effects). Most of these filters make use of a grid to show what is going on. This is also known as "mesh warping," in which the distortion follows the coordinates of an overlaid mesh. Even when the filter does not enable the mesh to be altered directly, it's a useful guide.

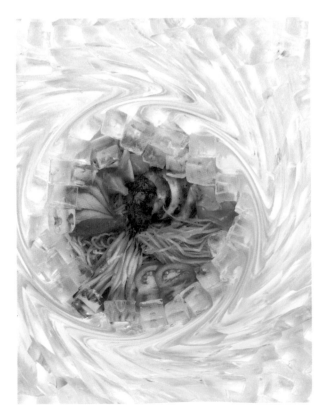

Rotation distortion

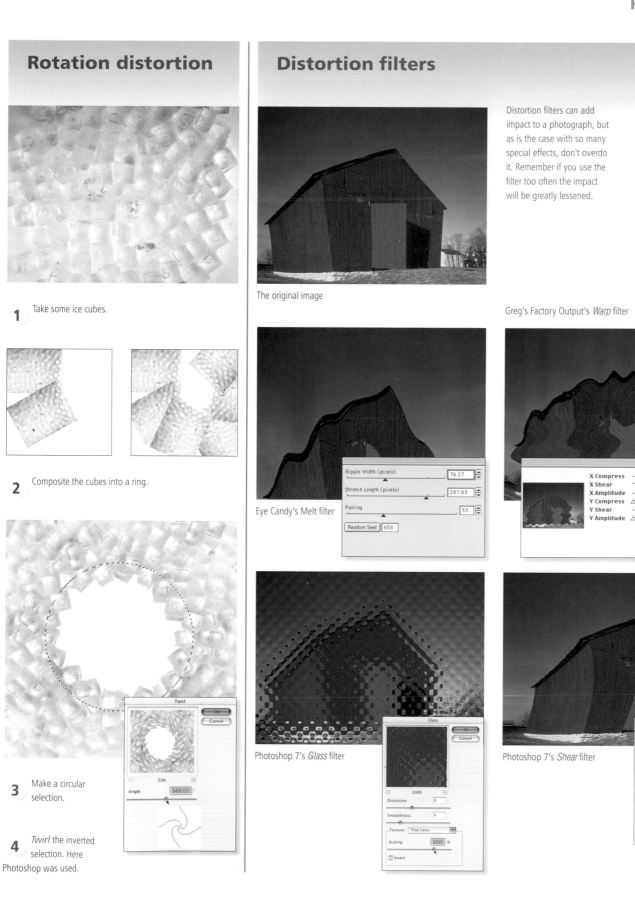

1 Take some ice cubes.

2 Composite the cubes into a ring.

3 Make a circular selection.

4 *Twirl* the inverted selection. Here Photoshop was used.

Distortion filters

The original image

Distortion filters can add impact to a photograph, but as is the case with so many special effects, don't overdo it. Remember if you use the filter too often the impact will be greatly lessened.

Eye Candy's *Melt* filter

Greg's Factory Output's *Warp* filter

Photoshop 7's *Glass* filter

Photoshop 7's *Shear* filter

Melting

Melting in digital imaging is really controlled distortion: taking one of the unique benefits of the technology and creating something new.

Distortion lends itself particularly well to a freehand approach, and this is where digital effects really come into their own. Global effects are certainly powerful, akin to using a fairground mirror, but altering just one part of the image while leaving the rest untouched has major possibilities. In traditional photography, there were ways of adding global distortion during printing, by projecting the image through the enlarger onto a bent surface, but controlled distortion of specific areas was impossible.

Width, Softness, Opacity

The tool metaphor for freehand distortion is the brush, offered by several pieces of software. One is Photoshop's *Liquify*; others are PenTools' *Super Putty* (bundled with Wacom tablets), DreamSuite *Putty,* and KPT 6 *Goo*, each with different interfaces. In its basic operation, the brush pushes and drags the area of pixels over which it passes. Exactly how it does this depends on the brush settings, as in normal image-editing. *Width* determines the area; *Softness* controls how smoothly or sharply the edges of the brush stroke move from the unaffected part of the image; and *Opacity* sets the effect's strength.

It takes a certain amount of experimentation to use a distortion brush in a controlled way. The dragging effect is more powerful than many people expect, and stopping in the middle of an image area can create an abrupt appearance. Following through, with a reduced opacity, often gives a more natural effect. Unlike some brush operations, such as cloning, a lower opacity setting in distortion does not cause blur. It is a useful way of building up to the effect you want in several strokes.

Alpha Channel and Layers

As it's normal in photographic special effects to apply distortion to only one object, you might consider protecting the surrounding areas. The standard method is to use a selection, which for the purposes of the distortion operation you can paint in first as a mask. Photoshop's *Liquify* enables you to access an Alpha channel for protection from within the filter. There is, however, a major difference between distorting a selection and distorting a layer which contains that selection. In the first case, the edges stay undistorted. If the image element sits in its own layer, and is deselected, you can distort the shape as well as the internal parts.

Because distortion is heavy on computation, the interface is almost always in the form of a preview window. This speeds up the operation so that the effect appears in real-time and allows for adjustments before you apply it. In addition to the inevitable reset button, you can usually restore overdistorted areas with a dedicated brush. This simply pushes the pixel values back to normal. Elaborations on the basic warping effect are to enlarge or compress the area under the brush (also referred to as *Bloat* and *Pucker*), and to *Twirl* it. Enlargement was applied to the chili pepper inside the flask, opposite, to mimic refraction.

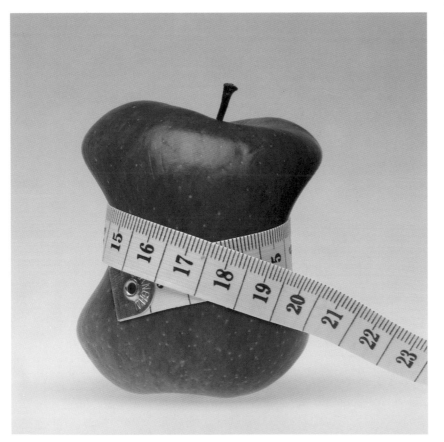

Forbidden fruit for dieters? Not anymore. The final image combining apple and tape.

Distortion brush

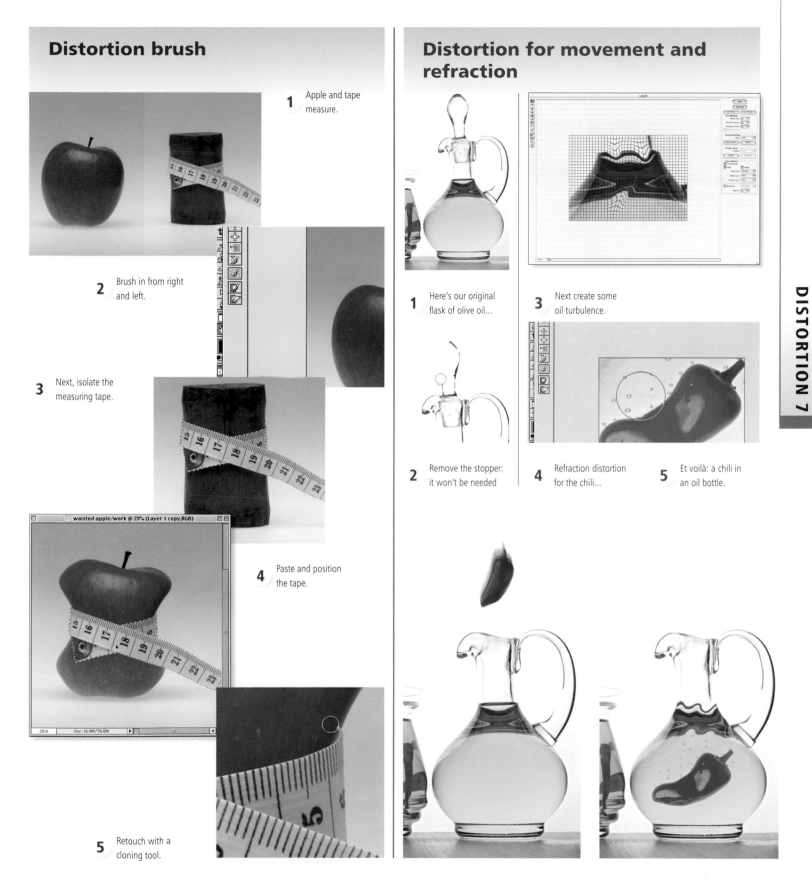

1 Apple and tape measure.

2 Brush in from right and left.

3 Next, isolate the measuring tape.

4 Paste and position the tape.

5 Retouch with a cloning tool.

Distortion for movement and refraction

1 Here's our original flask of olive oil...

2 Remove the stopper: it won't be needed

3 Next create some oil turbulence.

4 Refraction distortion for the chili...

5 Et voilà: a chili in an oil bottle.

DISTORTION 7

WORKSHEET

Idea
Make the line of palm trees bend comically in a strong wind

Solution
Apply controlled horizontal distortion to just the palm trees and their shadows

Software
Displacement map

Techniques
Selection, clone retouching, gradient map

Displacement Mapping

One original technique that has arisen out of digital image-editing is the use of maps that tell your computer how to distort an image.

While distortion brushes are the perfect freehand method, what about the occasions when you want to apply local distortion with precision? One obvious method is to paint over the small area that you change in a mask layer, then apply distortion to that selection. The advantage of this is control: by splitting the operation into two, you can better experiment with different distortions.

Distort or Displace

A selection used like this is a kind of map—a plan for directing the distortion. I've already introduced another kind of map, for depth, used for applying focus blur (the pelicans on page 31) and mist (the Thai monument on pages 64-6). A distortion map, or as it is usually referred to, a displacement map, is the same creature. It is a grayscale image, stored separately from the main image. It serves as a plan of action for how much the pixel values are to be shifted, and it is used alongside a displacement filter.

Displacement filters (such as the one in Photoshop under *Filter/Distort*) set the direction in which pixel values are to be moved, defined by horizontal and vertical co-ordinates. The displacement map, which does not have to be the same size as the image, shows the filter which areas of the image to work on. The convention is that mid-gray is neutral—no movement—while black is full application and white is full "in reverse." Tones in between are affected proportionately. The principle is logical, but visualizing the effect before you apply it takes practice. Obviously, this is a filter to use when you know exactly what effect you want, rather than for on-the-spot experiments.

The example here should help. The idea is to bend the line of palm trees violently without affecting the rest of the scene. This will clearly involve some retouching to restore the hidden areas of the wall behind. In the planning stage we first have to decide what will be displaced, and separate that from the rest of the image in its own layer. This includes the trees and their shadows. Because the bending will be applied gradually rather than abruptly, we need the base of the trees as well. All of this is selected by the usual methods, then copied and pasted into its own layer. The underlying layer is then retouched to leave a blank wall, without shadows.

Sideways Slip

The displacement map is easy to make. The actual gradient slope (from gray to black) and its position is by trial and error, as are the percentages in the displacement filter's dialog box. The background color is set to 50 percent brightness—mid-gray—and a black gradient is applied to this. As the movement is to be sideways, only the horizontal axis is entered in the dialog. One important thing to realize is that the visible distortion occurs in the transition areas only, between gray and black or between gray and white. In this example I've deliberately chosen a cartoon effect to illustrate the point. The tops of the palm trees are not distorted, but shifted, as they lie in the full black area of the map. To have the tops bending over, they would need to be within the gradient slope of the map.

As with any of the distortion procedures we've looked at, it's a good idea to check your image at magnification when you've finished, particularly after extreme distortion. Compression is no problem—pixel values are simply discarded—but stretching, bloating, and other kinds of expansion involve filling in space: in other words, interpolation. This is the same, in a localized fashion, as increasing image size, with all its problems of image degradation, including blur and even pixelation.

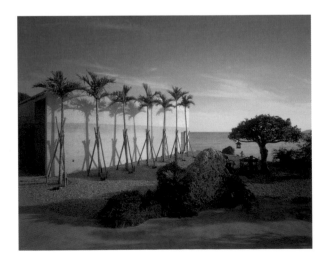

A seaside villa in Okinawa. In the original photograph, a row of palm trees along the side of this modern house are individually braced against the annual typhoons.

Displacing a careful selection

3 The map is made to the same proportions as the image, but smaller. With a mid-gray background (no displacement), a vertical black gradient is applied over the trunks.

4 The displacement map dialog offers a percentage value across both axes, and instructions for what to do with the undefined area that will appear at left.

5 With the displacement applied just to the layer containing trees, their shadows, and the foreground, the final image is a mixture of the two different layers.

1 In a duplicate layer, the trees and their shadows are outlined by careful autoselection, and the inverse is deleted. The areas left and right are partially erased to conceal any unwanted displacement.

2 Retouch the area behind to lose the trees and their shadows. These are now on a separate layer that will be distorted.

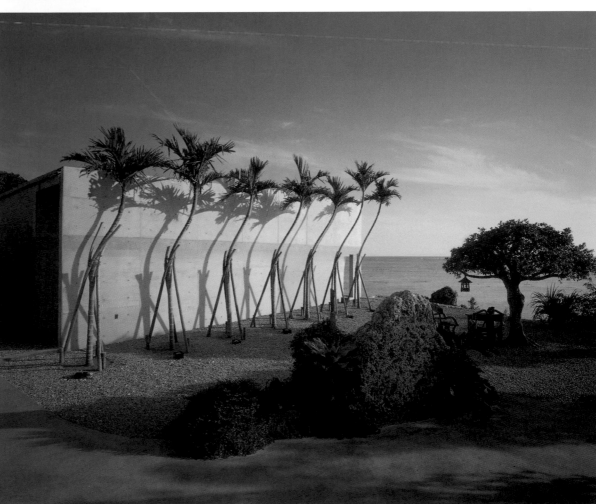

Morphing

Morphing is one the sexiest techniques in recent cinema, but how does it translate to the still image?

One special application of distortion familiar to any movie-goer is morphing. Developed by the effects studio ILM, and used first in the film *Willard*, then more famously in *Terminator 2*, this is time-based distortion in which one image changes into another. The technique has, if anything, become over-familiar in cinema. Like the distortion procedures we've seen, it is purely two-dimensional and works by moving pixel values across the image. Applied well, it gives a perfectly convincing impression that the complete form of one object is becoming something else.

Morphing is most effective as a moving image, but I include it here for two reasons. First, still images make good source material, and second, this is the only process that can produce a particular blend between two images and keep some properties of each. This last effect, in the form of a still photograph, is particularly popular for a kind of do-it-yourself genetics, in which the features of two people's faces are combined into a third.

Morphing should not be confused with blending. A blend of two images based on color and transparency is predictable. Depending on the percentages of transparency, both images show through. In terms of appearance, the objects in the two layers keep their own characteristics. They remain what they are, even though they come together graphically. Morphing uses a different action—it moves features in each image toward each other to create a coherent third image.

Squaring the circle

At its simplest, consider changing a square into a circle. Physically, you would move the four corners inward while pulling and bending the center of each side outwards. To do this automatically in a morphing procedure, you would first locate a number of points on the start image (the square) and on the end image (the circle) that should come together. The key points would be the corners of the square and the centers of the sides, although if nothing else was instructed to change with them, the result would be an octagon. The trick with morphing software is to find ways of shifting pixel values surrounding the key points.

In principle there are several ways. The simplest is for each pixel to move with the nearest key point—more if it is very close, less if it is far away. This works, of course, but the point of morphing lies not just in getting from one image to another, but in the change itself. The movement is strange and fascinating, a new visual experience, but it also has to look believable. This is where perception enters the process, because it is one of the oddities of this special effect that while no-one has ever actually seen, for example, one person's face distort into another person's, we instinctively have a feeling for how it ought to happen. Morphing faces is the most popular use of this software, and to take just one aspect of this, most people watching a sequence would probably be more comfortable with a morph in which the underlying bone structure of the face appeared to move rather than a soft, jelly-like change. Equally, the "right" way for a square to change into a circle would be for the lines to be flexible, but also firm and regular, rather than rippling. There is clearly more to morphing than meets the eye.

Composing a Node

The basic procedure is for the user to define pairs of key points—nodes—in the two images. The more nodes, the smoother the morphing transformation will be, and it is best to locate these points on the clear, detailed, and important features in the image. In a face-morph, the eyes are much more significant than the cheeks, for instance. After setting about 20 of these nodes, run the rendering program for a basic preview. You will see from this where more nodes are needed from the areas that seem to drag behind. When outlines of objects have to change, boundary lines are better than nodes, and most morphing software offers this option.

There are a number of morphing programs available, each with its own method of operation and instructions. In theory, you could create your own morph using only normal distortion tools, but it would take a long time, you would need to have a good idea of where each feature in the first image was going. If you were producing a short movie sequence, it would be extremely difficult to keep the movements smooth.

A short morphing sequence

Compression method

▼ Cinepak

Quality **Motion**

◉ Most **Frames per Second :** 12
○ High
○ Normal
○ Low
○ Least

[Cancel] [**OK**]

◆Action ◆Frame control
○ Preview Number of frame : 30
◉ Make movie Preview point : 50%
○ Make PICS [_____] ◀ ▶

◆Rendering option
☑ Draw "Copyright" [Cancel] [OK]
☑ High-quality rendering

1 The two still images chosen are of a Victorian porcelain doll and a young girl. The lighting is approximately the same, even though they were not shot to be combined.

2 The images need to be equalized as much as possible. The eyes are the immediate focus of attention in any face, and these are matched for size and position.

4 More and more pairs of nodes are added, checking which extra ones are necessary by previewing the render several times, until the transform runs smoothly.

◆Transform velocity control ◆Effect
○ Linear ◉ Color & shape transform
◉ Natural(Slow-in slow-out) ○ Shape transform (use 1st flame)
○ Customize ○ Shape transform (use last flame)
○ Spotted transform

Shape transform [_____] ◀ ▶
Color transform [_____] ◀ ▶

– Shape transform
– Color transform

Image / Time

[Cancel] [**OK**]

5 The dialog offers a choice of transformation of shape and color. In this case, both are selected—the normal method with two different images. The *Velocity* control offers a slow start-up and slow finish, also normal.

3 The work begins by clicking on the first frame (left) at an identifiable point, then on the equivalent point on the last frame (right) to create a pair of nodes.

6 If the output is a movie, as it usually is, the dialog offers a choice of compression and control over rendering quality. Here, best-quality Cinepak is chosen, at 12 frames a second over 30 frames.

Untitled

Rendering Status
17 / 31 Frame complete!
[Stop]

7 In rendering, the morphing program automatically creates the number of frames specified.

dollmorph/m movie

00:00:00

8 The sequence created by the program is saved automatically as a QuickTime movie, running over two and a half seconds and occupying slightly less than 1 MB.

Changing expression

1 Two shots from a portrait session, smiling and unsmiling. Everything else is matched, and without color the only transformation needed is shape.

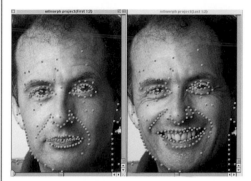

2 The major movement is in the mouth and inner folds of the cheek. The second is around the eyes. The nodes are accordingly concentrated in these areas.

3 The midpoint of the rendering sequence shows that the quality of the transform is high, with the inevitable exception of the teeth, which in effect appear from nowhere (but this is hardly noticeable in the movie).

DISTORTION 7

Motion

Blur was once regarded as an image defect and as a failing of technology. But now it can add dynamism—if used carefully.

Photography has a special relationship with movement. While all other forms interpret movement, photography alone has the ability to capture it. In fact, before cameras and moderately fast film were trained on active subjects, certain fast, complex movements could only be guessed at. The well-known sequences of animals and people in motion, photographed in the late nineteenth century by Muybridge, came about when he was employed to settle a bet as to whether all four of a galloping horse's legs were off the ground at the same time (which they were).

Photography's success in this regard lay in "freezing" motion with absolute clarity. Originally, this was considered remarkable, but now, of course, it is commonplace. The technique is dependant on how the camera is used, in terms of shutter speed, viewpoint, and whether the camera is moving (and if so, whether it is with the subject or against it). For a long time the "frozen moment" technique of capturing motion was considered "correct," but another effect was revealed when cameras were set up differently. When the shutter speed was relatively slow (because of insufficient light, slow film, or just an excess of speed in the subject), the movement appeared as a streak or blur, rather than a clear, frozen moment.

Blurred Vision

Frozen action was regarded as "correct" at the time, so blurring was dismissed as a defect—until it came to be appreciated that the effect was attractive, and that blur demonstrated movement was taking place. But blurring is not what *we* see, it is what the camera sees, and after more than a century of looking at photographs of things moving, we have accepted it as a sign of motion.

Blur has been quickly commandeered by digital special effects to create the illusion of movement in images where there is none, or where the movement is not fast enough. Several filters do this, but they treat it mainly as a convention. The assumption is that if something moves, it blurs, whereas in real photography the camera is usually panned to follow the subject, so it is the background that blurs. But this can be dealt with by simply inverting the selection.

The most common convention, however, is to trail the blur from the edge of the object so the selected image stays sharp and clear. This is unreal in the sense that it doesn't happen in photographs, but it can be justified on the grounds that it conveys the right impression. The edge-trail convention is a form of stylization, as is the staggered trail, in which part of the trailing edge is repeated with diminishing opacity. Andromeda's *Velociraptor* filter does this.

Go for Originality

The real problem with motion blur and its variations is that they have become a stereotype, much more so when they are manufactured as in these digital effects. In fact, the damage has already been done simply by making it possible. In a straight photograph, if for one reason or another the movement is too fast for the shutter speed, the blurring simply happens. These days, most photographers, clients, and viewers are prepared to accept it as an inevitable feature of the image, neither a mistake nor an artifice. But is the photograph "real"? If there is a suspicion that it has been through the mill of digital manipulation, the assumption is usually that the blur has been added, which rather devalues the image.

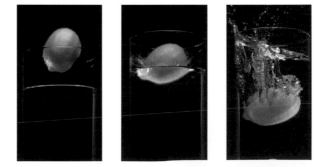

Using a large studio flash, this lemon was repeatedly dropped into a flask of water. The exposure was triggered manually to capture a series of different positions.

(*Opposite*) The final composite, perfectly registered for the flask, compresses the fall and splash into a single image. The relatively slow flash discharge is about 1/500 second.

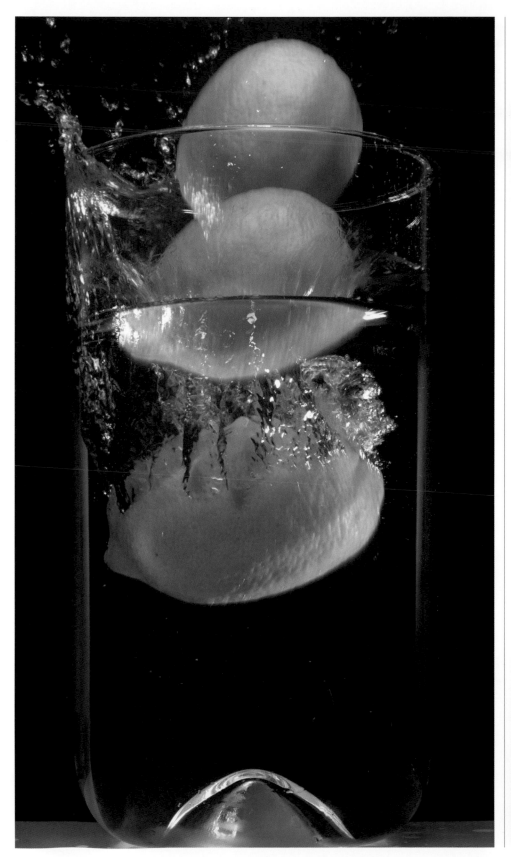

A sequence of splashes

1 Using the completely submerged lemon as the base for the image, the second step, as it enters the water, is added in register as a second layer, in *Lighten* mode. The unwanted lower area is airbrushed out.

2 Some of the water splash from the second stage confuses the image, particularly as it is in *Lighten* mode. It is removed by obscuring it with an airbrushed extra layer.

3 The third stage, of the lemon still in the air, is also added in *Lighten* mode. This needs no retouching as the shadowed underside blends happily with the second stage.

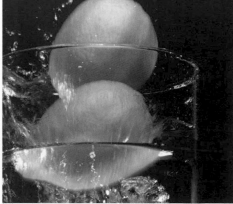

Motion Stepping

Capturing motion is perhaps most elegantly done by using motion-stepping and combining the images into a single, dramatic frame.

Idea
Demonstrate Star Wars motion control techniques as a special effect image in itself

Solution
Show a complex spacecraft move as a series of steps, and add exhaust blur

Software
Standard image-editing and a multilayer composite

Techniques
Motion control and streaked photography, selection, layering, glow, distortion, scaling, colorizing

There are methods for handling motion other than the overfamiliar blur. I want to emphasize that these have nothing to do with the strategies for photographing spontaneous movement, such as anticipating and capturing a decisive moment. Here we are dealing with post-production solutions, used after the image has been acquired. Nevertheless, they often require planning before the event, as in the example opposite.

Small Steps, Giant Leaps

Perhaps the most practically useful device is to show how a section of movement unfolds over time and in space. This means creating or recreating the various stages and presenting them as a sequence. The presentation can be a strip of discrete images or, better, integrated inside a single frame. This takes some effort to set up and execute, and so makes most sense when the subject of the image is the movement itself.

This was the case in the project opposite, to demonstrate how miniatures in a motion picture are filmed using motion control. The specific example is the filming of the Millennium Falcon for the movie *Star Wars* by ILM in

California. As with other set-piece images, the idea was to use the movie special effect for the still image. Motion control is the system by which either the model is moved in relation to the camera, or vice versa. The essence is control and reproducibility, so that the take can be matched with other camera passes for compositing. This is more complex for a filmed sequence than for a still image, with the move planned and executed by computer.

The plan was to show the model (actually two, as it was constructed to different scales for close-ups and distant views) performing a spiral trajectory toward the viewer. The stages, needless to say, have nothing to do with the staggered effect of the filter on the previous pages. The camera was placed on a track so that it could move away from the model, and it was rotated incrementally as it retreated from the first, closest position. The move was plotted first on a computer to give a guide for the positions at which the camera would stop, rotate, and shoot.

Space Walking

For this image, each position was photographed separately, and to enhance the motion, a hot engine exhaust was added. This was done with the time-honored motion blur, with the difference that this was shot for real. It could have been done digitally, but as the motion control rig was available, it was just as simple to make second passes for each of the "near" spacecraft positions with a time exposure. The spacecraft being white, these were recorded perfectly against the blacked-out studio, and were colored later, digitally. The compositing process was straight-forward, if time-consuming. Masking was easy for those elements against the black sky, but more care was needed for the distant spacecraft against the planet and for the transparency of the exhaust. In the end, 31 separate image elements were combined.

Composite motion-stepped images, like this one, capture the dynamism and elegance of a classic sporting stance. But the viewer can quickly tire of images such as these.

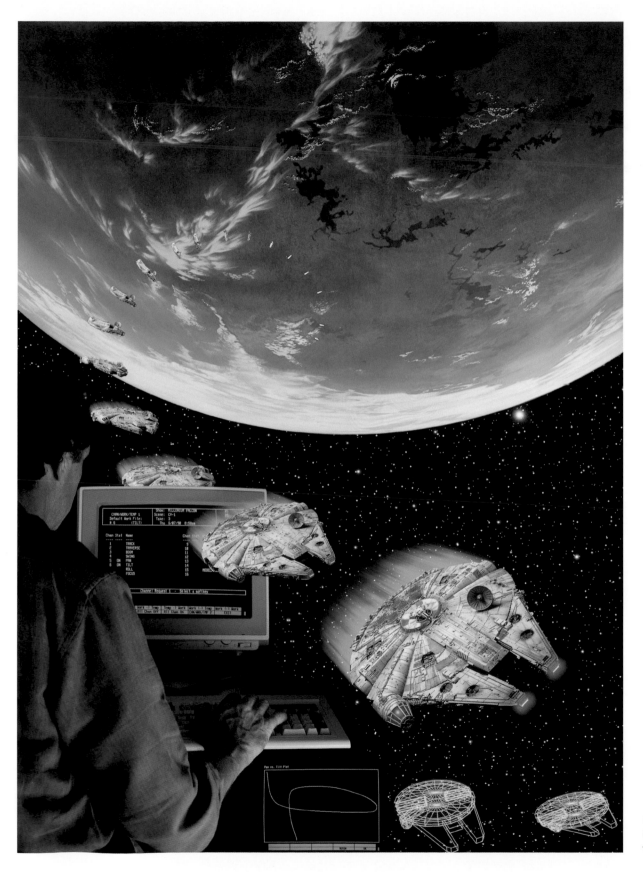

Flying Solo: 31 separate image elements make up this striking sequence.

Spiral approach

1 The shooting stage was prolonged and fairly complex, including a matte painting of the planet, two models, streak passes and the computer setup.

TECHNIQUES

7 To exaggerate the perspective of the streak, and match the edges exactly to those of the Falcon, a distortion tool is applied.

2 For each of the nearer shots of the Falcon, the headlights are illuminated by drawing a path around them, converting this into a selection, then adding a blurred glow.

4 Against a background of the planet, with an extended black sky below, the foreground Falcon is pasted in, including its own black background.

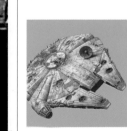

6 The streak from the motion control pass, also against a black background, is pasted into an underlying layer.

3 For the cockpit, the windows are selected, again from drawn paths, then filled with a radial gradient from yellow to orange.

5 The spacecraft is outlined by first using an auto-selection tool on the black, then retouching with brush and eraser on the mask to deal with the dark shadow areas.

8 The neutral streak is first colored approximately by an overlay, and the hue adjusted with the *Hue/Saturation* sliders. The forward areas of the streak are then erased.

9 The compositing and rocket exhaust procedure is continued for the next three shots. The remaining 15 are at a sufficiently frontal angle to need no exhaust.

WORKSHEET

Idea
Demonstrate how artificial clouds for movies are produced in a cloud tank

Solution
Combine the cloud-making equipment with superimposed layers of clouds as produced

Software
Standard image-editing with blended layers

Techniques
Layering, scaling, blending mode

Ghosting

This technique goes back to the earliest days of cinema and still photography, but it has unique possibilities with digital technology.

One form of compositing does not use selection, or at least makes use of it in only a secondary way. This is the technique in which one entire but partly transparent image is superimposed on another. Some parts of it, usually the brighter areas, are visible, but the underlying image also shows through. The impression is of ghosting, and the effect depends on two things: layers, and blending.

Ghosts in the Machine

Layers are included in all full-scale image-editing software, and are indispensable for special effects. Their main function is to keep the different elements in a composite image separate, but they have other important functions. The one relevant to ghosting is that the pixel values in layers can be adjusted without making any permanent changes to the image elements.

The simplest way is to adjust the *Opacity/Transparency*. If less than 100 percent, some of the underlying layer will show through. More interesting, however, are the modes that specify which pixel values are to be affected (see the list in the *Modes* box for combining layers). Some of these

are clearly more useful than others, and with the less obvious modes it is not easy to imagine how they will look without trying them. Even within these modes, there are further possibilities, in particular the sliders that remove pixels from the dark or light end of the brightness scale.

Lighten up

Try experimenting with different modes and settings, judging the effects comparatively by eye. In the example here, the subject is the cloud tank method of filming special effects skies for movies (white paint or dye is injected along the edge of two bodies of water, fresh and salt, and the difference in density between the two keeps the rolling paint from spreading vertically). The photograph combines shots taken of the paint "clouds" through the side of the tank with the set-up, so it was important to show the natural transparency and wispiness of the clouds. The solution, simply enough, was to combine each of the individual cloud layers in *Lighten* mode, with the addition of some retouching to make one cloud appear to pass behind one of the struts of ladder.

MODES FOR COMBINING LAYERS (PHOTOSHOP)

MODES THAT LIGHTEN
Lighten Chooses whichever pixel is lighter in the two layers
Screen Multiplies the inverse of the upper and lower pixels and so is even brighter than *Lighten* mode
Color Dodge Brightens the color of the underlying layer according to the color of the upper layer

MODES THAT DARKEN
Darken Chooses whichever pixel is darker in the two layers
Multiply Multiplies the values of the pixels in each layer and so is even darker than *Darken* mode
Color Dodge Darkens the color of the underlying layer according to the color of the upper layer

HSB MODES
Hue Gives the hue of the upper layer and the saturation and brightness of the lower
Saturation Gives the saturation of the upper layer and the hue and brightness of the lower

Luminosity Gives the brightness of the upper layer and the hue and saturation of the lower
Color Gives the hue and saturation of the upper layer and the brightness of the lower

CONTRAST AND INVERSION MODES
Overlay A combination of *Lighten* and *Darken* modes that preserves the shadows and highlights of the underlying layer
Soft Light Increases contrast by lightening lighter pixels and darkening darker pixels in the upper layer
Hard Light Increases contrast by screening lighter pixels and multiplying darker pixels in the upper layer
Difference Inverts the values by subtracting the pixels of one layer from the other, depending on which is brighter
Exclusion A lower contrast version of *Difference* mode
Dissolve Random replacement of pixels between upper and lower layers depending on opacity

See-through clouds

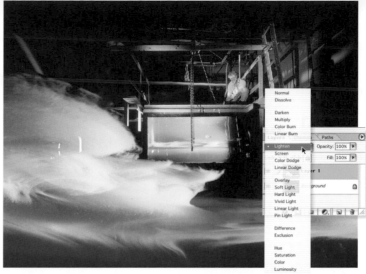

1 To create an invisible horizontal layer that will hold the injected paint in place, the tank is slowly filled with water at two different densities. This takes one day, to keep the waters from mixing).

2 Shot through the side of the tank, individual injections of white paint along the density layer convincingly simulate clouds.

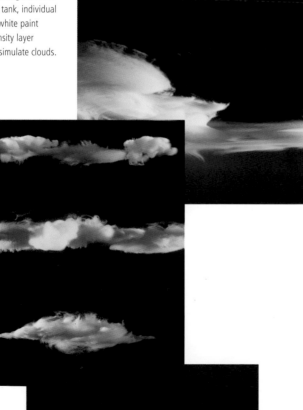

3 The *Lighten* mode applied to each cloud layer in the composite image effectively removes the black background by causing only pixels lighter than those in the setup image to show.

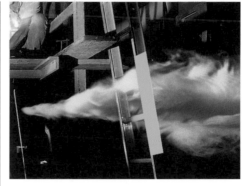

4 An extra touch for believability is to erase a small part of one cloud to reveal the nearer strut of a ladder. The effect is to embed the cloud more realistically into the scene.

5 In the final image, the clouds behave as they would in real life: apparently opaque where thickest, yet partly transparent where wispy, and around the edges.

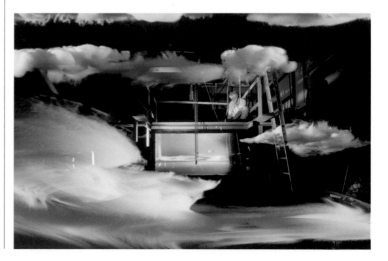

COMPOSITING 9

97

Blending

Digital image-editing lets you create single, composite images with a greater degree of realism than ever before.

The term "blending" is often used indiscriminately, but here it means, as it should, the procedure for mixing images across a zone of transition. More than that, the images are mixed in such a way that the objects they represent appear fused together. This is not necessarily the same thing as just mixing images. Consider any two images that are blended vertically: around the center, each fades into the other. This is really a technique of illustration rather than of photography—an art director's method of handling pictures, even if they are photographs. This is distinct from true blending, as shown here, in which the transition is used to convince the viewer that the subjects of the two photographs are actually one in a single image.

Even within this fairly restricted view of blending there are different styles and purposes (the first tending to follow the second). I've chosen two examples to highlight the most obvious distinction. This is between invented and apparently real scenes. In one, the technique is used to overcome a natural scepticism that two objects could combine in such a way, in the other, it conceals joins.

Point and Shoot

The "finger as candle" is a case of a bizarre, invented object, with more than a touch of Surrealism about it. The idea is uncomplicated, and the correspondence in shape between candle and finger makes it obvious that this is not going to be a difficult job digitally, but it also carries some disturbing implications. It is these that the blending has to solve! There is the potential for something unpleasant in this image, and I wanted to avoid that. Is the candle attached to the stump of a finger, or is the finger somehow set alight? Either way there would be a problem with the image, which should be surreal, and it turns out that this is mainly to do with how the images are combined; it is a question of execution.

This is why I mentioned that style tends to follow purpose. Once you know exactly what the problems are and what to avoid, the details of the transition work themselves out. In this case, it is a question of how much candle to include (enough to show that it is made of wax and that the fingertip is not actually burning) and the distance of the transition (not so abrupt as to appear stuck on, nor so wide that the transition loses material qualities). Obviously there are different interpretations, but this solution is not far off the mark. The technique is as shown in the sequence and revolves around nothing more complicated than careful, partial erasing of the upper layer.

India Rubber

The panorama in Rajasthan, India (pages 100-1) is a different matter. The scene really exists, and the problem was the view of it: it was too wide for any rectilinear (non-fisheye) lens. The solution was to photograph it in overlapping frames and join these so that they appeared as a single image. In principle this is possible manually, which is to say by retouching using the standard repertoire of image-editing tools (erasing, cloning, and so on). In practice, multi-toned skies like this are very resistant to being blended—smooth areas of no detail show up inconsistencies. Stitching software, however, is designed for just this task. As well as deforming the shapes of adjacent images so that all the details match, it equalizes brightness and blends colors to an accuracy of one pixel. The result is perfect, provided that the overlap is broad enough.

The shoot was planned and executed in one session. In addition to the lit shot of the candle, the flame was photographed by its own light to capture its halo.

 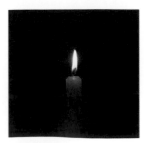

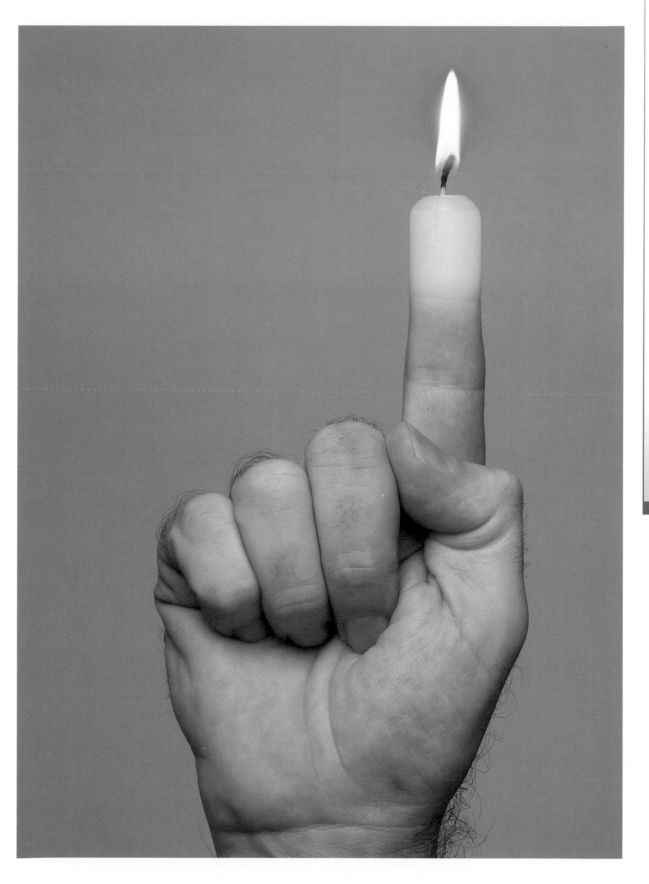

Shooting both elements from the same camera position (using a tripod) and keeping the lights and background the same made the blending procedure much easier. The lighting on candle and finger matches perfectly.

COMPOSITING 9

Blending body parts

1 Despite careful positioning, the forefinger (my own) is for some reason slightly bent. As the flame rises vertically from the candle, the upper finger joint needs to be straightened, using a distortion brush.

2 The candle used is thicker than the finger. This is adjusted at the stage of pasting it in as a separate layer, by compressing horizontally with the scaling tool.

3 Although not strictly necessary, the halo around the flame is an attractive part of the unlit image, although lost in the flashlit exposure. Unretouched, this is added as a third layer.

4 The slightly different, slightly visible background for the candle is erased softly around the edges to merge with the hand's background.

5 Only the reddish halo from the unlit shot of the candle flame is wanted, and certainly not the black background. The blending mode for that layer offers a choice of which tones and colors to add and which to exclude.

6 Retouching is applied to the top of the candle, which has a rather hard, beveled edge, and a little lower to bring the sides of the two elements together.

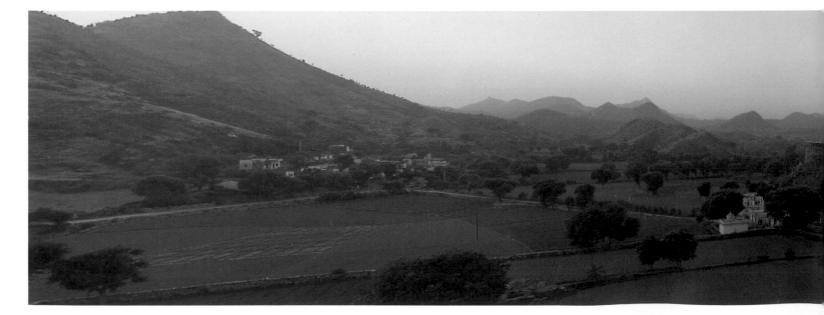

A stitched panorama

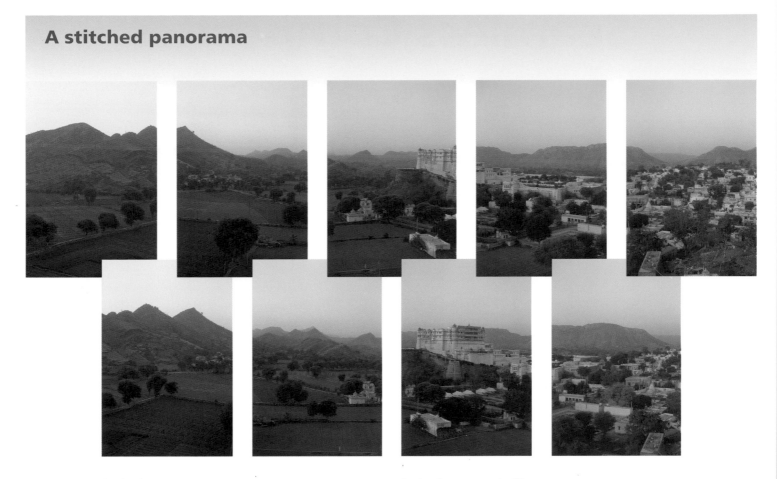

Overlapping sequence
The dawn panorama of Devigarh Fort in Rajasthan was shot in rapid sequence from left to right, overlapping each of the nine frames by about 50 percent—a minimum would be 30 percent for blending to work accurately.

Rendered as a panoramic still
Assembled in Stitcher, the result here was output as a planar image, with the focal length setting in the software lengthened to give normal proportions in the center. The automatic blending shows none of the joins.

COMPOSITING 9

TECHNIQUES

Seamless Composites

Once you've learned the basics of joined-up image-editing, you can really take special effects to the limits of your imagination.

The aim of most compositing, in photography at least, is to conceal the fact that it has been used. In other words, the different images that have been combined should appear as one perfect image, with no jarring differences along their edges or in their color and tone. The meticulous, almost obsessive attention to detail that this requires is linked to photography's relationship with realism. A great deal of image-editing and manipulation is in the province of illustration and has nothing to do with this. Digital illustration does not necessarily need to be seamless; photography does if the image is to work.

I want to demonstrate this with two examples that are both illustration and photograph. In neither case is there any attempt to give the impression that these are images

from life, yet the techniques used are absolutely within the realm of photographic imaging, and include gradients, subliminal noise (simulating grain), realistic shadows, and fading. One is a view of the human immune system, originally prepared for a *Smithsonian Magazine* feature, the other is for a book about a fashionable noodle restaurant in London. Both rely on the basic selection methods we have already described in the book.

The immune system picture combines artwork with a photograph of a man. By shooting the figure in silhouette, the internal elements are allowed to stand out brightly (in *Lighten* mode), but the contrast of the silhouette is also raised to reveal some modeling. The binding element in the food shot is the white background, which is allowed to protrude into the active parts of the image by means of gradient fading. This gradient is applied, as shown, to a mask layer.

Natural Selections

Not only are layers useful for varying the opacity and range of pixel values for separate image elements (pages 96-7), they can also act as a substitute for selections, with considerable advantages. Selection, as we've seen, is essential as a step in compositing. Once this is done, however, and images have been combined, it is often not the best way to define farther changes. Selections are economical in the space they occupy on the disk, but they are a restriction if you want to alter their outlines. At the cost of extra disk space, it is usually more flexible to store each selected image element in its own layer.

One advantage (as we saw on pages 96-7) is that an image in a layer can be assigned a particular style of blend without making irrevocable changes to that image. Another is that you can apply filters to the entire layer, including the transparent surround to the image element—the effect with, say, a blur filter or a distortion brush is quite different from the same filter applied to a selection. And in any case, with a move or transformation (such as scaling), the software is perfectly capable of finding the image element automatically inside the layer— in effect, it finds the selection.

The outline of the man's figure is the critical feature. A mixture of paths, auto-selection, and final cleaning-up with a small eraser gives a smooth, clean edge, yet with detail in the hair.

Compositing with layers

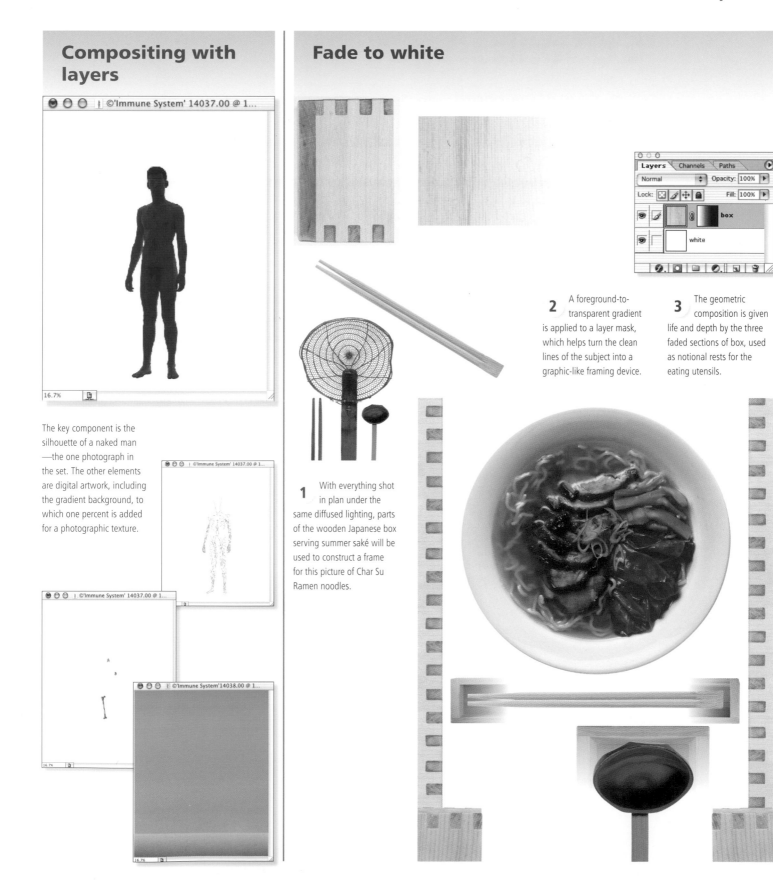

The key component is the silhouette of a naked man —the one photograph in the set. The other elements are digital artwork, including the gradient background, to which one percent is added for a photographic texture.

Fade to white

2 A foreground-to-transparent gradient is applied to a layer mask, which helps turn the clean lines of the subject into a graphic-like framing device.

3 The geometric composition is given life and depth by the three faded sections of box, used as notional rests for the eating utensils.

1 With everything shot in plan under the same diffused lighting, parts of the wooden Japanese box serving summer saké will be used to construct a frame for this picture of Char Su Ramen noodles.

Colorizing

Any color you like is the order of the day with digital special effects. But whatever is in your imagination's palette needs careful application.

The difference between colorizing, as shown here, and color controls is in the level of realism. Color alteration and manipulation is a matter of adjusting what already exists, but colorizing is pure addition. As with all special effects, it's best to have a reason for doing it, and perhaps this caution is all the more apt for stylizing effects like these. Both of the examples here have some justification—the X-rayed hand simulates a known effect, which itself relies on the same idea of separating tones and then coloring them, and the lizard...well, that's just a pun. In one, the colors are added solid, and in the other they blend. But underlying the two methods is the principle that the colors need to be individually applied to specific areas.

X-ray Visions

In the case of the X-rayed hand, the idea is to mimic the color coding seen in thermal imaging. What happens is that gradation of tones in the original black-and-white image is stepped—that is, divided into a number of equal levels—with sharp break-points between each. In graphic terms, this is called posterization. While in some circumstances it is a fault (a loss of intermediate tones when you increase the contrast of an image in Photoshop, for example), it can also be a useful way of colorizing.

In film photography, this was a darkroom process, and quite a tedious one at that. It involved lith film, which has a very simple response: black or clear. By exposing a negative onto different sheets of this film, at different exposures, the range of grays in the original image could be covered as a set of solid blocks. Combining these in various combinations with a set of contact positives gave

the result you see here. Digitally, Photoshop's *Posterize* control does the job instantly. You simply choose the number of levels into which you want the image divided. The *Levels* graph shows how extreme the effect is: a full range of 256 tones is reduced to four. This done, it is a straightforward matter to auto-select each of the four new tones and fill with an appropriate color.

A Calmer Chameleon

With the lizard, the idea was inspired by this particular gecko's ability to adapt its pigmentation to its surroundings, like a chameleon. The rainbow spectrum was airbrushed in freehand, to give a soft but distinct gradation from one color to the next. This was easier to do in broad strokes in one layer and then to eliminate the color outside the outline of the lizard by deleting the inverse selection. Combining the colors with the underlying texture and tones of the skin involved adjusting the blending of the layer. In a case like this, *Multiply* is one possibility, although the darkening from this would need to be adjusted. Another is *Color Burn*, as is simply leaving the blend as normal and reducing the opacity. We have seen how many variations there are in the ways of blending layers. As the final effect is nearly always a matter of personal taste, each situation merits experimentation.

Two original images are the starting point for this composite. The sky is the same as that used with the moon image on page 63.

The final composite. With the blending of the lizard and the clouds complete (this deliberately contradicts the effect of the drop shadow), its new rainbow hues arc across the sky.

Rainbow lizard

1 The lizard's ability to blend its coloring with its surroundings makes selection a long, hand-drawn process.

2 The selected lizard is copied and pasted on top of the sky. In terms of composition it worked better flipped horizontally.

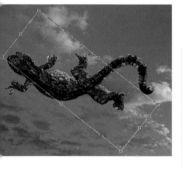

3 A further adjustment to the design of the image involves rotating and repositioning the lizard, so that the clouds will cover just a little of it.

4 For a deliberately surreal touch, a drop shadow is applied to the lizard, to give the sky the disorienting appearance of a flat surface.

5 In a dedicated layer, the first color, red, is airbrushed in over the head, with a soft edge and a large diameter.

6 The next color is selected as the foreground, to be applied with the airbrush. The procedure continues throughout the spectrum, from head to tail.

7 To edit the color washes so that they cover just the lizard, the lizard outline selection is loaded, and inverted. Still working in the color wash layer, the colors in this area will be deleted.

8 To fit the lizard into the sky involves having some clouds partly obscuring it. This is done by duplicating the sky layer and applying gentle erasure to the upper clouds.

A posterized effect

1 The original is a hospital X-ray of a hand—a continuously toned negative. The outline of the skin was retouched and strengthened in Photoshop.

2 Scanned as a grayscale image, the hand was then converted to RGB color mode before starting work. For safety, a duplicate layer was made for the posterization, and the outline of the hand selected.

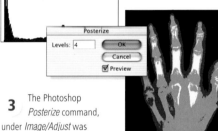

3 The Photoshop *Posterize* command, under *Image/Adjust* was used, set at four levels to produce four different blocks of tone—white, light gray, dark gray, and black.

4 The *Magic Wand* auto-selector was used at a low setting on the lightest, top level. The *Similar* command found all other areas like this.

5 The foreground color was applied to the selected light tone with the *Fill* command.

6 The procedure was repeated for the other three levels of posterization, each being filled with a different color.

7 The final result is a color-coded density map of the bones of the hand. The colors are arbitrary. By working only on the selection of the hand, the surroundings remain black.

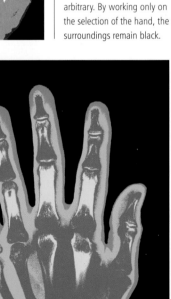

Color Stylization

Once you've grasped the basics of colorizing, you can take the process a step further to create highly stylized images.

I've divided the many available color effects into two, along the lines of the images' intent. The examples on the previous two pages were colorized toward a specific end. They had information (in the case of the X-rayed hand) or an idea (in the case of the lizard) to convey, and color was the means. The examples here are more arbitrary.

Color Without Meaning

The difficulty with these filters, as with the art media ones, is that they don't actually "mean" anything. Yet somewhere there will be an occasional use for them. Even if the color shifts are too great to be used straight from the filter, it is possible to make more subtle use by applying them to a duplicate layer over the original. The next step is merging selected areas, either with brush and eraser tools, or using the different modes for combining layers (such as *Lighten, Multiply, Difference*, and so on). What all of these filters do is shake up the relationships between colors in a scene, which is difficult to do by other means.

Solarization is a rare photographic effect in which part of the image is reversed in tone—the darkest areas turning to white or the highlights becoming dark, depending on whether it is a negative or a positive material. It's rare because it needs extremely strong exposure, but the result seems familiar because of something known as the "Sabattier effect." This is false solarization and easy to create in a darkroom by re-exposing the paper after some development, but before fixing—often a mistake. Digitally it is even easier, by simply combining one end of the scale of an inverted copy of an image, as shown here. Blending sliders are perfect for this.

In the Heat of the Light

Thermography is a medical and surveillance technique in which a supercooled sensor records heat emissions rather than light, operating in the far infrared. There is, of course, no way of replicating the procedure with light, but one filter from nik Multimedia at least makes an attempt at reproducing the appearance, as shown (opposite).

Note, however, that as heat has no inherent color, thermographic cameras assign arbitrary colors based on temperature. This filter is actually making an effect that is twice removed from reality. Again, it is rather spurious, even if striking when used sparingly.

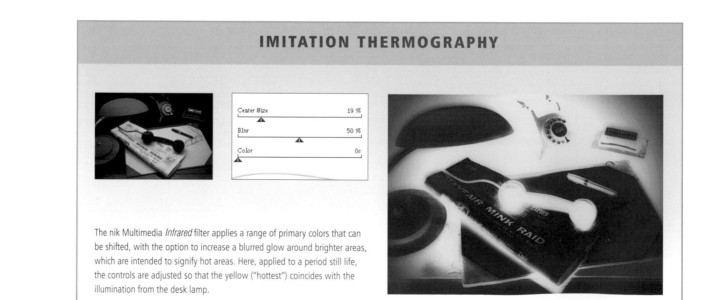

IMITATION THERMOGRAPHY

Center Size	19 %
Blur	50 %
Color	0c

The nik Multimedia *Infrared* filter applies a range of primary colors that can be shifted, with the option to increase a blurred glow around brighter areas, which are intended to signify hot areas. Here, applied to a period still life, the controls are adjusted so that the yellow ("hottest") coincides with the illumination from the desk lamp.

A kind of Sabattier effect

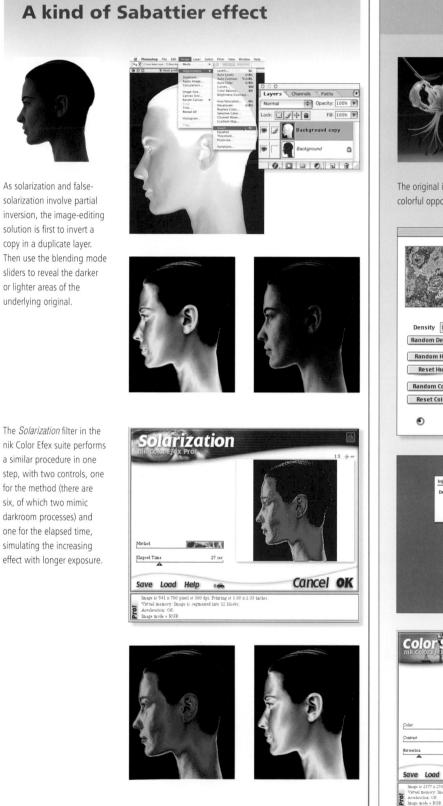

As solarization and false-solarization involve partial inversion, the image-editing solution is first to invert a copy in a duplicate layer. Then use the blending mode sliders to reveal the darker or lighter areas of the underlying original.

The *Solarization* filter in the nik Color Efex suite performs a similar procedure in one step, with two controls, one for the method (there are six, of which two mimic darkroom processes) and one for the elapsed time, simulating the increasing effect with longer exposure.

STYLIZED VARIATIONS

There are several plug-in color stylizers available, which provide a range of sometimes esoteric effects. Nevertheless, these filters have their uses when giving images a splash of color that's beyond the real world.

The original image: a colorful opportunity!

With Chromassage's *Japanese* filter.

With Furbo Filters' *Wavy Color* applied.

With Chromassage's *inject01.*

This time with nik Color Stylizer, which has a range of sliders (left).

Fragmentation

This is one set of filters that does not fulfil its promise. However, you can use the techniques to cut corners in the creation of other effects.

In real life, fragmentation has three aspects—the size of the bits (and their size variation), how far apart they fly from each other, and the pattern of their movement. Breaking (the first aspect) and falling apart (the second and third) are intimately related, even if they involve separate actions, because of forces like gravity and the violence that makes an object break in the first place. As fragmentation and dispersal are linked, any software designed to mimic this needs to work on these parameters at least.

Shattering illusions

First, the image selection has to be divided into many smaller shapes, which can be regular, as in Photoshop's *Extrude* filter, or irregular, as in Xenofex *Shatter*. These miniselections then have to be moved, by displacing them horizontally and vertically, regularly or at random.

The range of available filters is limited, and all fail in displacement. *Extrude* in Photoshop offers only the appearance of square blocks or pyramids. *Shatter* in Alien Skin's Xenofex suite promises an effect similar to that obtained by looking at your selection in a broken mirror, and has sliders for *Shard Size, Displacement,* and *Random Seed,* but

while shards at the edges will separate from the main body of the reflection, those in the center are just shuffled around. The object, if that is what you have selected, does not break apart. The *Shatter* filter in Greg's Factory Output shares this limitation, and it moreover uses only radial shards emanating from the center, which is even less useful.

Scattering Bryce

Sophisticated 3-D software is hardly worth the effort and expense for occasional effects like this. Nevertheless, simpler programs can help a great deal, and I include a solution using Bryce. The image still needs to be cut up by hand in the image-editing program, then each shard is imported into the 3-D program as a 2-D object. With the atmosphere turned off and the base plane deleted, the shard objects can then be dispersed, resized, and rotated, all randomly, using the *Randomize* tool. They will automatically cast the correct shadows on each other. When rendered, these can be brought back into the image-editing program and retouched with edges. This technique is even more effective at dispersing a group of similar (or duplicated) objects, as the butterfly image (below) shows.

After several groupings of six butterflies have been dispersed at different depths, the image is rendered and reimported into the image-editing program.

TECHNIQUES

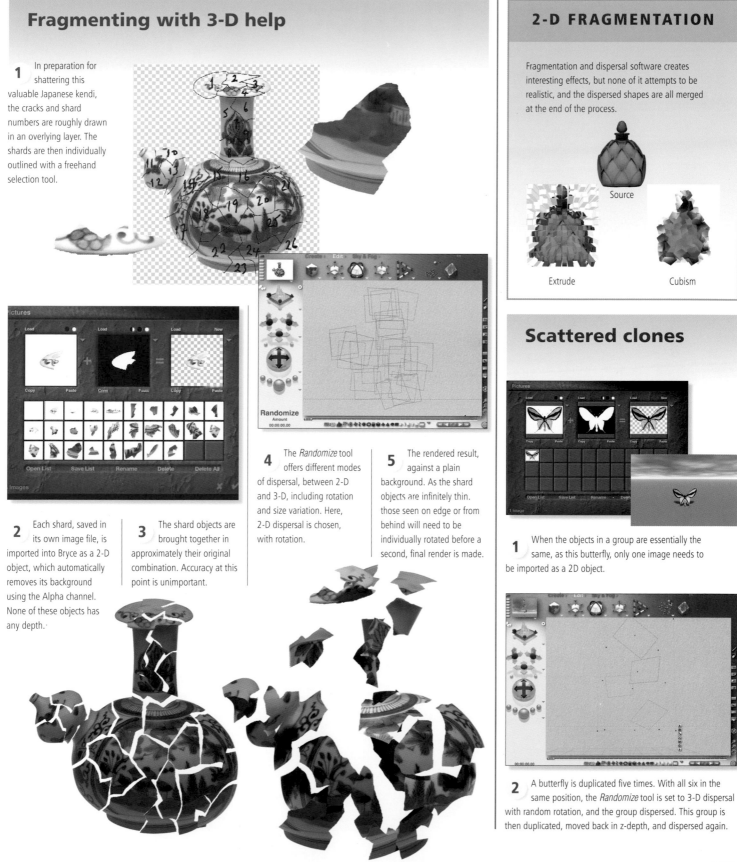

Fragmenting with 3-D help

1 In preparation for shattering this valuable Japanese kendi, the cracks and shard numbers are roughly drawn in an overlying layer. The shards are then individually outlined with a freehand selection tool.

2 Each shard, saved in its own image file, is imported into Bryce as a 2-D object, which automatically removes its background using the Alpha channel. None of these objects has any depth.

3 The shard objects are brought together in approximately their original combination. Accuracy at this point is unimportant.

4 The *Randomize* tool offers different modes of dispersal, between 2-D and 3-D, including rotation and size variation. Here, 2-D dispersal is chosen, with rotation.

5 The rendered result, against a plain background. As the shard objects are infinitely thin, those seen on edge or from behind will need to be individually rotated before a second, final render is made.

2-D FRAGMENTATION

Fragmentation and dispersal software creates interesting effects, but none of it attempts to be realistic, and the dispersed shapes are all merged at the end of the process.

Source

Extrude

Cubism

Scattered clones

1 When the objects in a group are essentially the same, as this butterfly, only one image needs to be imported as a 2D object.

2 A butterfly is duplicated five times. With all six in the same position, the *Randomize* tool is set to 3-D dispersal with random rotation, and the group dispersed. This group is then duplicated, moved back in z-depth, and dispersed again.

109

Scene Photography

Digital special effects mean your images no longer need to be part of the same old scene: you can literally invite the viewer into your world.

Immersive imaging is a completely different way of looking at images. As its name suggests, it projects the viewer into the scene in a way that gives a measure of interaction. One key piece of software responsible for the popularity of these panoramic views is QuickTime VR, developed by Apple. An easily installed extension to the computer's operating system, it enables you to display virtual reality environments—360° scenes assembled from a series of photographs—and move around them by panning, zooming in and out, and even switching viewpoints.

The priorities are a little different from the production of a still panoramic image. The resolution in a VR panorama is lower, and the introduction of panning and zooming movement means that small inconsistencies will not be noticed. But you must keep the camera level!

Composing the View

When shooting, a simple way to remember the overlap from frame to frame is to use the leading edge (the right edge of each frame if you are swinging from left to right). Make a mental note of one feature on this edge, then pan until it is in the middle of the next frame, and so on. It helps to do a dry run before shooting, especially if you are going to add rows above and below. For example, if you are using a wide-angle lens (the equivalent of 20mm on a 35mm camera) and you are shooting vertical format,

Dive into QuickTime VR...

the field of view (FOV) will be about 80° x 60° on a typical digital camera. So with 30 percent overlap, the center row will need nine frames shot, or with 50 percent overlap, 12 frames. To create a spherical image, add more rows above and below, tilting the camera sufficiently to provide 30 percent overlap with the upper and lower rows. A single shot for each of the two "poles" is usually sufficient; for the downward shot, remove the camera from the tripod and hold it at arm's length at the same height.

A Stitch in Time

Stitching takes place during rendering, and the images are blended seamlessly. A cylindrical projection is the most suitable for a single-row panorama such as the swimming-pool scene here, while for a full sphere 360° by 180°, there is a choice of spherical or cubic (where areas of the image are assigned to the faces of a notional cube as seen from inside, but they remain invisible in the VR panorama).

Once rendered, the panorama needs a viewer. QuickTime VR's near-universal availability makes it a prime choice. Some programs have their own native viewers, which are likely to give better quality (such as PTViewer for PanoTools), and there are third-party viewers such as Zoom 3.2 from LivePicture, and Smoothview from Infinite Pictures. If you want to avoid plug-ins, use a Java viewer, though these have small windows and inferior quality.

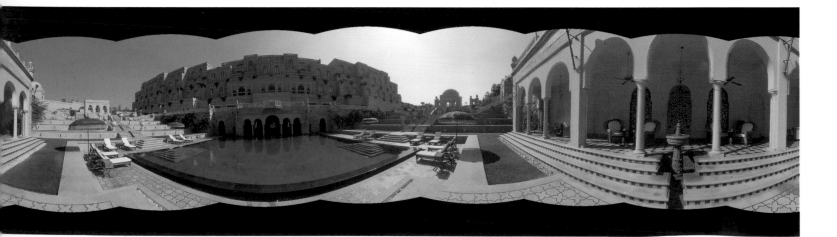

A single-row 360° panorama

1 A panoramic head.

2 Once loaded into the lower window, the images are dragged, one at a time, into the assembly window, and positioned as accurately as possible by eye.

4 Once all the images are in place and the circular panorama has been closed, the equalization procedure analyses the brightness of each and makes adjustments to bring them close to each other.

5 The setup dialog for rendering gives a choice of viewing format (here it's the basic Cylindrical QTVR), and resolution, measured in pixels.

3 The Stitcher software automatically makes a guess at the field of view and so the amount of warping, but a dialog box lets the user adjust this.

6 The movie opens automatically in the window of QuickTime VR, already installed on this computer's system. A flat version of the cylindrical image shows the characteristic curved distortion of each frame.

SPECIAL SOFTWARE TO CONVERT THE VIEW

Flexify is an eccentrically specialized program from Flaming Pear, a plug-in that is designed to make all kinds of interesting projections from a stitched panoramic or spherical image. It will also work with any image, such as a spherical fish-eye photograph or even one shot into a reflecting silvered ball. The results vary from the practical (two mirrorball views from different points in space) to the unusual (heart-shaped distortions, "sinusoidal Sanson-Flamsteed," and "peeled-orange" global map projections that can be printed, then cut and folded together to make paper spheres).

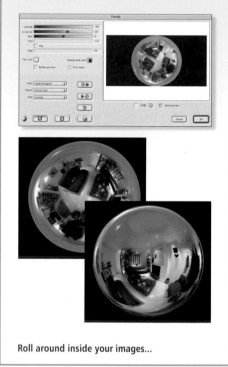

Roll around inside your images...

A 17mm lens on a Nikon D1X was used for this full-sphere view of a living room. The software interprets this as 27.5mm because the CCD is smaller than a standard 35mm frame, and FOV is 47°. The shooting was in three rows with the camera pitched at 90° (horizontal), 45° up and 45° down, with additional shots straight up and straight down (for the latter, the tripod was shifted and the camera mounted on a horizontal arm extended from the tripod head). Although the recommended minimum number of shots to achieve full coverage is 18 (three rows of eight, and one each up and down), for safety 48 were used in this example.

IMMERSIVE IMAGERY 11

APPLICATION

THIS THIRD SECTION takes a slight change of direction. The book so far has been mainly descriptive—in effect, a tour of what is available in the field of special effects that might be useful for photography. A survey of the state of play was essential because so little in special effects is standardized and established. I've been concerned more with showing the tools and techniques than with considering the tasks to which they might be applied. As I mentioned earlier, not only is digital imaging relatively new, both in terms of the cameras and the software, but special-effects software tends to come from all kinds of odd directions, including by-products of other work. As a result, by no means all of it is useful. We need to weed out those effects that don't help photography.

Ultimately, however, it is the final image that counts, and the only justification for special effects is the use to which you put them. So far, I've shown some examples, but always from the perspective of the software. Now we look from the more important other side: its application. When I wrote that the direction changes, it is because this section is mainly about suggestions and inspiration. There is no question about being comprehensive, and to go through the standard subjects of photography would be dull. Instead, I've picked out what seem to me to be the interesting uses of special effects, and I've arranged them mainly by theme.

We begin with one of the most basic media functions: telling a story. Always much easier to do with a sequence of pictures, it is nevertheless possible within a single frame, but this needs careful thought and composition. The image has to work hard in explaining what is going on, and special effects can be

extremely useful in adding descriptive information. Then we take people as a subject (the most popular of all subjects for the camera), but concentrate on the changes in expression and personality that various effects can produce. One important lesson from here is that while pronounced effects tend to produce cartoonlike images, realism calls for very subtle, finely judged technique.

In fact, one overview of photographic special effects looks at the scale of intervention, an issue that affects all subjects, not just faces and expressions. The scale runs from basic retouching all the way up to creating new images in which photography plays just a supporting role. We can even quantify this in a before-and-after comparison, by looking at the percentage of the source image that remains—the source as a percentage of the final destination. This is not just the proportion of the image area, but the proportion of its eventual style and impact.

There is another major division that is closely related to this amount of intervention: between those effects that declare themselves, and those that are hidden. Both extremes are represented here, from images that you would not imagine had been manipulated, to those that are obviously works of the imagination. The last chapters of the book follow this route, from photorealism, through surrealism, to other worlds, and finally to imagery that attempts to conceptualize. The differences are largely between images where there is no way of knowing whether effects have been used, and those where the content is impossible but the effect is perfect. In every case, the absolute is good technique—which is, of course, the purpose of this book.

WORKSHEET

Problem
Describe the mechanics of animatronics

Solution
Use a dramatic animatronic head seen from different angles, in combination with the operator and control console

Software
Standard image-editing composite

Techniques
Careful edge selection and new gradient background

The finished image makes the most of the dramatic modeling of the animatronic faces, while maintaining a link to the distant console via the composition and the snaking cable on the floor.

Cause and Effect

Whether or not effects-enhanced pictures are "real" images is irrelevant. Images like these can still tell a "true" story.

Digital imaging is wonderfully equipped to make extended visual descriptions—in other words, to narrate a sequence of events, or explain a causal relationship. This needs a little explanation, because the "explanatory image," as we might refer to it, is also one aim of "straight" photography, particularly as it is used in journalism and reportage. Leaving art and experiment aside, photography's most successful and practical role is a descriptive one: showing how things are. A street, a person, a building...the camera can do a great job of documenting their appearance.

Planned or Spontaneous?

Going one step further, a photograph can forge connections between people and things in the same frame and, by doing so, tell a story. At its simplest, this can be done by juxtaposing elements in the picture in a relevant way, but it is open to an enormous range of nuances. Much of the time, this storytelling is at least partly arranged, even set up (many famous "real" images were staged), but when a photographer succeeds in doing it spontaneously, the photograph gains from it immensely.

This can be (and is) used as an argument against digital manipulation, on the grounds that the image is no longer faithful to reality, but as I hope this chapter at least will show, this all depends on how you define reality. If real means "as is," then the argument holds water. But if realism is taken to mean an accurate, coherent description, then it opens the door to looking at things more imaginatively. Here we are back to the old argument for and against manipulating photographs, which shouldn't detain us any longer than it takes to say that digital effects used for this purpose are not attempting to fool anyone. In the example here, whether digital compositing was used or not is entirely unimportant to the sense of the picture.

Be the Puppet Master

Just as story-telling in "straight" photography normally uses juxtaposition, the digital equivalent mainly relies on compositing as a way of bringing together into one picture frame the different elements that make up the subject. In this example, photographed again at the special effects studio of ILM, the subject is the technology known as animatronics. The issue here was mainly the discrepancy of scale between very interesting puppets and very uninteresting electronics. The uncomplicated solution was to fill most of the frame with the head of a puppet used in the film *Ghostbusters* and relegate its operation to the distance. I toyed with the idea of showing animatronic movement but decided that the head was a strong enough image as it was, particularly if it were doubled with a profile view.

Creature Features

The scale difference needed was beyond the depth of field of even a wide-angle lens. In addition, the setting of the Creature Shop in the studio needed tarting up, and a digital composite was the clear choice. All else followed smoothly from these decisions, despite the mistake of shooting the head against black (instead of against a contrasting background, which would have been much more sensible).

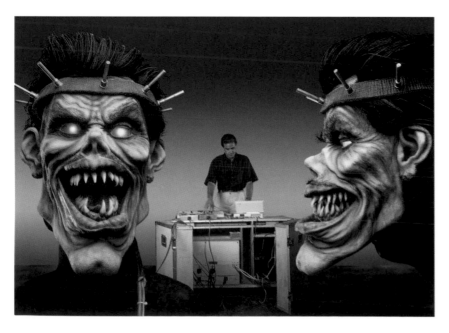

Animatronic puppet

1 The three elements as originally shot are a full-face and profile view of an animatronic ghost monster, and a long-shot of the puppet's operator at the control console.

3 The two animatronic head images are positioned on either side of the console. The shooting was planned against a sketch, and they are exactly to the scale needed—filling the frame.

4 As the black background is too sombre and uninteresting, it is replaced with a gradient fill. First the background selection (saved from the last step) is loaded, and then the gradient applied from top to bottom.

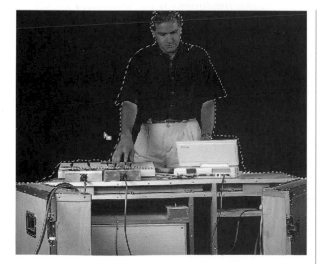

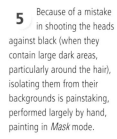

5 Because of a mistake in shooting the heads against black (when they contain large dark areas, particularly around the hair), isolating them from their backgrounds is painstaking, performed largely by hand, painting in *Mask* mode.

2 The man and console were shot against black, so auto-selection (for example, using Photoshop's *Magic Wand* tool) is the simplest and most effective way of isolating them, with a little additional mask retouching around the shadows.

APPLICATION

WORKSHEET

Problem
Composite a sequence of movements by an elephant in the wild

Solution
Combine the successive frames of a motordrive sequence shot with a telephoto lens

Software
Standard image-editing layered composite

Techniques
Copy-and-paste, detailed edge retouching

Compressing Time

Recording action can also be about freezing events into single, composite images that go beyond the mere description of movement.

Many of photography's subjects are events, and sequences of actions. Here, digital special effects can add something new and genuinely useful, without creating a strict representation of reality. Events do not have to be momentous; simple sequences merit this approach just as well. We've already seen how special effects can help construct a unique view of unfolding movement. Or should I say deconstruct. If we take the period of the action as the real subject rather than the individual frozen moments, this kind of image is also a way of breaking it down into its component parts.

The principle is straightforward, even if the techniques are not. First, photograph a sequence with an interval between frames that is sufficient to show difference, but not so great that it is difficult to see the connection between one and the next. This is the ideal, but it is possible to work with less, and in any case each sequence has to be judged on its own merits. Some will work better than others, depending on how neatly or expressively the individual moments are captured. This is no different from straight, unmanipulated action photography, where the most successful images have either an elegance or a strangeness in the way that the subject has been caught.

Framing the Action
The techniques for combining the shots, and the special problems that may arise, depend on the kind of movement and on whether the camera itself moves. If the camera is fixed and trained on something moving within the frame, as in the example on page 91 of the lemon falling into water, then at least one potential difficulty is solved—that of registering the images. There should be no adjustments needed if the shots were taken digitally, although if they have to be scanned from slides, negatives, or prints, there will be some discrepancies. In either case, the background for each image will be essentially the same, and should need no cropping.

If on the other hand the camera moves, either inadvertently or because it has to follow a moving subject, then the background is more of an issue. Again, the first step in compositing is to register the several images, each in its own layer, even though there will be some overlap. The most delicate part of this operation is rotation, which will almost certainly be necessary to correct a slight roll in the images if they were shot handheld. The idea is not to do this repeatedly for fine adjustment, as this can deteriorate the image. The difficulty is that in order to judge the amount of rotation for one layer over another, there must also be no offset between the two. A way around this is to use one edge of each frame for alignment.

Rewriting the Back Story
Having just shot a sequence that you think could work well as a digital composite, it may be worth immediately re-shooting the background, even extending it with several frames around. These can be layered into the composite workfile to increase the blending options. However, when the original action takes place across a wide field of view, there will be no common background, and the answer is to select the subject in each frame and composite them all onto a substitute background—a rather less satisfactory solution.

Blending techniques rely mainly on erasing parts of each layer. Having chosen one of the frames as a base layer, this will usually involve erasing most of the others, to leave just the obvious differences. Do this one layer at a time; for a guide, consider setting the upper layer temporarily to an opacity less than 100 percent, or click rapidly on the icon that makes the layer visible to toggle between two views. As it is often easier to paint something back in rather than erase it, you could also use the *History* brush. To do this in Photoshop, simply delete the entire image in the upper layer, then use the brush set to the stage before the deletion and brush back in whatever you want.

An elephant never forgotten

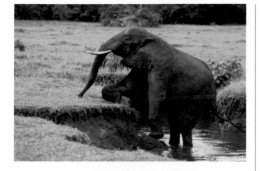

1 Shot in Tanzania's Mikumi National Park, this sequence shows an African elephant climbing laboriously out of the water. There is sufficient overlap to make a single image.

2 The three shots are composited, each in its own layer, using rotation to align the background of stream, grass, and trees in perfect register.

3 Layer by layer, the unwanted parts of the image are erased, beginning at 100 percent magnification with a small eraser brush along the outline of the elephant.

4 The order of the three overlapping images, from front to back, logically follows the short sequence of events, with the standing animal last and so behind.

Beauty Treatment

A quick beauty treatment is perhaps the ultimate temptation with digital special effects, but beware of turning plastic surgeon.

The sheer effectiveness of digital effects at altering photographs has created a demand for a particular kind of self-improvement. Superficial though it is, the idea of enhancing looks is hard to resist. What was once a skilled and costly exercise largely confined to advertising and to Hollywood or rock star portraits is now available to all.

Digital Plastic Surgery

The issue in improving looks is when to stop, and this applies every bit as much to the result as to the execution. Digital retouching, as you have probably experienced, can go on forever if unchecked. There also has to be a limit to the extent of the improvement. It generally begins with removing small blemishes, but it can continue, as we'll see in this chapter, to smoothing skin texture, makeup, and alterations to expression, bone structure, and proportion. At a certain point in the operation, digital effects ends up doing the sort of things best tackled by plastic surgery.

One of the advantages of retouching faces is the relatively large area of fairly featureless skin. This can hide the edges of changes, and also offers the use of very soft edges with selections and brushes without any obvious blurring or deterioration of the image. Indeed, most cosmetic improvements, digitally as well as in plastic surgery, involve smoothing skin and removing detail. Often, "detail" means blemishes and creases.

A Quick Nip and Tuck?

Brushwork is the direct, intuitive approach, and it has an obvious appeal. It offers infinitely subtle and detailed changes, and work can proceed on an almost subliminal level without pause. The disadvantage is that if you are not sure of the exact direction of the retouching, you can get into a complicated mess from which the only escape is *Revert to Saved*. One safety measure is to perform particular stages of the retouching on duplicate layers. For example, the first layer might be blemish removal, the second skin texture and color, the third eye widening, and so on. It is, in any case, logical to plan the improvements, then divide them into stages rather than working piecemeal. The brush tools of choice are *Clone* (*Rubber Stamp*), an

airbrush set to a specific mode (such as *Lighten* or *Color*), a distortion brush (*Smudge* is a variety), and the *Eraser*.

Wearing a Mask

The alternative is global adjustments to selections. This is useful when there are areas that need the same treatment, even if they are dispersed. Freckles are (arguably) just the kind of feature that benefits from this kind of procedure, as would a pattern of spots. The skill in this lies almost completely in the preparation of the selection. Because of the subtleties involved, using an airbrush to apply a mask has a particular relevance here. A compromise that makes use of both selection and brushwork is to create a soft-edged selection as a way of confining the changes, and then use a broad, low-opacity brush over it.

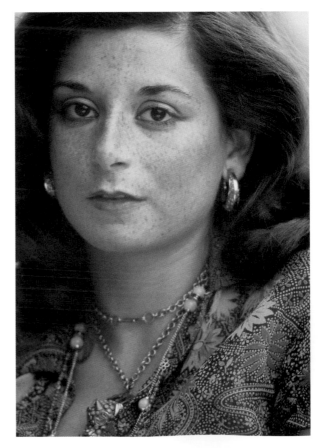

Freckles are common among red-haired people, and the way to reduce their appearance, if that is what is wanted, is to find a way of selecting just that shade of reddish-brown in the image.

APPLICATION

Freckles

1 Other reds in the portrait need to be protected from change, here notably the hair and the lips. A mask is painted over the skin areas that contain the freckles.

2 The red contrast filter in nik Color Efex, which like other filters in the set uses advanced HSB color adjustment, enables the exact hue to be selected, then its brightness and contrast to be altered.

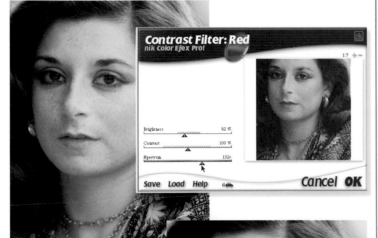

3 A similar operation can be performed in the *Hue/Saturation* control of an image-editing program, using the eye-dropper to select the color of the freckles.

Retouching the eye

1 Obvious small blemishes such as this freckle, are removed by cloning from a nearby area of skin, in *Normal* mode, or by using the Healing Brush tool.

2 By opening the eyelids, the expression can be made fresher. This is achieved by selecting first the upper eyelid and applying this displacement map as negative and vertical.

3 Finally, the reflections of the photographer and lighting reflectors are removed by clone retouching, and the part of the studio light's reflection cleared away from the pupil.

4 The differences are small and detailed, but the result is cleaner and the expression more open and less tired. Eyes always receive close attention by viewers.

APPLICATION

Problem
Make an unfolded flat view of the entire surface of a head

Solution
Use object photography techniques to shoot the head in rotation

Software
Stitcher, image-editing

Techniques
Crop slices from each shot, position by hand, stitch

About face: An "unrolling" view of human physiognomy.

Alternative Views

Once you realize the almost infinite number of ways of editing images, you can create stunning effects by mixing your techniques.

Digital special effects unlock the potential of every kind of image. There's no reason you can't experiment by applying landscape enhancement techniques or interactive features to object or people pictures. Here I've used the principles of immersive imaging in a portrait to create an "unrolling" 360° view around the subject. By shooting in steps, just as in immersive imaging with the subject rotated between each exposure, we get a sequence of images that covers all the angles. This can also be done with any object that can be put on a kind of turntable. The trick is then in combining the sequence into a strip.

A Woman in a Spin

In film photography there is (or was) a way of doing this, using a specialized slit-scan camera. A narrow vertical slit moved across the film so that the image was recorded in a sequence rather than all at once—in much the same way as a flatbed scanner works. Digitally we can do the same

thing without specialized equipment. However, because in this case the view changes while the camera stays still (the opposite of scene photography), a large overlap is the last thing you need. Instead, the image has to be constructed from thin strips. In the example here, the young woman was photographed in rotation (an office chair served as the rig) in several steps. Slightly overlapping slices were then prepared from each shot by cropping.

Blending Natural Textures

The ideal software for compositing is one that can blend delicate areas of texture, such as skin and hair. In this example, the slices were assembled in Stitcher—a contrary use of the program, but its stitching capabilities proved to be the essential ingredient in this improvised technique. Even without a good match, the software blends skin and hair extraordinarily well. Because the details of adjacent images do not match, the assembly has to made by hand.

120

A different treatment

1 The subject, lit softly from top left with substantial shadow fill, is a portrait, but the woman is seated on a rotating chair. The photography begins full face.

2 Sixteen narrow vertical slices from the photographs are prepared in an image-editing program.

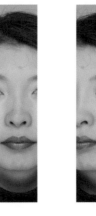

3 One by one, the slices are assembled in Stitcher. As they are not part of a panorama, they must be positioned manually.

4 The complete assembly, reminiscent of slit-scan photography, is a virtual map of the head, as if unrolled.

Enhancement

Where correction is often objective, enhancement is almost always a matter of personal taste. But it can "idealize" an image.

Moving a step beyond correction we reach enhancement, in which the image is improved according to individual taste. If correction is altering the image to what we think it ought to look like, improvement is making it as we would like to see it. The aerial view of a wetland sanctuary in North Dakota, the J. Clark Salyer Refuge, was shot on a hazy late afternoon at the end of summer (opposite, far right), and has a particular color and tonal range. Photographed from a light aircraft at low altitude, the marshland is softly lit and the water mainly gray. Limited and subdued, it gives the view a soft, almost delicate appearance. This is attractive in its own way, but there is an argument for making it look as it would in clearer, brighter weather—which is to say, more colorful.

In Deep Water

Increasing the saturation is the quick fix in circumstances like these, and it can be applied overall or to a range of colors. However, this on its own was not the complete solution, because it would do nothing for the river. Being murky, the waters reproduced as a fairly neutral gray, so saturation or hue change would have almost no effect. In fact, whether a clear, bright day would have had much effect on its appearance is doubtful; any reflection of a blue sky would still have been subdued by the quality of the water. No matter: the job at hand is to enhance rather than achieve painstaking accuracy. The solution is to add

a layer of color and blend it in. In a duplicate layer, the water areas are painted in as a mask, and this is saved as a selection. Inverting the selection and deleting it leaves only the water in its own layer, and this can be filled with any suitable shade of blue.

Alone this would be flat and unrealistic, so it needs a procedural blend. In this case, *Multiply* is the most appropriate choice. The final enhanced version of the scene, with considerably more punch than the original, is neither better nor worse, but merely a different interpretation that mimics better weather conditions.

Ground Control

Following a different meaning for enhancement, the other example is of restoring the reality of a setting. The joining of an American Apollo spacecraft and a Soviet Soyuz was one of the events of the space program. The backup modules were saved for display in the National Air and Space Museum in Washington D.C., and I photographed them for the official book. This involved knocking out the surroundings and compositing the three elements which, because of their size and way they were exhibited, could not be photographed in one shot.

Lost in Space

It then seemed a good idea to take them out of the artificial setting and show the unit in its proper setting—earth orbit. No revolutionary techniques were needed for this, simply a good background of the edge of the Earth at and some stars. The complex paths that had to be drawn to outline the three spacecraft modules were combined and converted into a selection. This was then copied and pasted into a layer above the space background. True sunlight in space is extremely harsh, and the soft daylight by which the spacecraft was shot is inaccurate. However, the eye is very forgiving with diffused lighting, much more so than if a sharply shadowed image were dropped into a diffusely lit background. More than this, the existing lighting shows all the details, and there was no good reason to remove this level of visibility. Only a few reflections from the Earth were added.

A modular approach to image compositing?

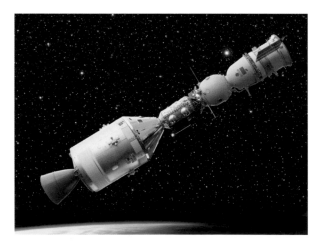

APPLICATION

Relocating a spacecraft

1 This digital assembly of the three components of the Apollo-Soyuz hookup was photographed in the National Air and Space Museum in Washington D.C., for a gatefold in the museum's book.

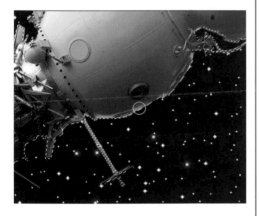

2 The lighting, though softer than it would be in space, is visually acceptable, needing only highlights on the lower edges to mimic earthlight, applied with the *Dodge* tool.

3 Removed from its museum setting, the Apollo-Soyuz spacecraft looks much as it would have from space, with the advantage of high resolution and controlled lighting.

Improving clarity and color

1 An overall increase in color saturation, by a significant 35 percent, takes care of the grass and trees, but it does nothing for the river, which has almost no color to change.

2 Selecting the areas of water begins with an auto-selection tool, but because of the similarities between the margins and some of the shadowed river banks, the process is completed by hand as a mask, using a paintbrush.

3 In a duplicate layer, the inverse of the water selection is deleted, Using the *Color Picker*, a suitable blue is chosen and the selection filled with this.

4 The two layers shown together, with the flat blue overlaying the main image underneath. Combined normally, the effect is very artificial.

5 There are several procedural alternatives for blending the flat blue with the real range of tones in the water. After experimenting, the method chosen was *Multiply*, which increases density, and a reduced opacity of 70 per cent for the color layer.

WORKSHEET

Problem
Create a clean, empty road that stretches to the horizon in an open landscape

Solution
Manufacture a section of road in plan, extend it, add perspective and bends, and combine it with an existing landscape

Software
Standard image editing, distortion

Techniques
Texture, step-and-repeat, perspective and brush distortion, compositing

Alteration

The same techniques that are used to correct or enhance images can also be deployed to subvert or add to reality.

Still within the bounds of realistic appearance, we here go a significant step beyond correction and enhancement into the realm of invention. Creating a believable, photorealistic image runs two risks. One is that the image itself, if it has a single subject, may fail to convince, and the other is that, in a composite, the blend of the two or more subjects might fail. Some projects of this kind may be beyond both software and skills, so it is important to gauge the chances of success before starting. If the result has to be as realistic as a photograph, there are no degrees of achievement—it either works or it doesn't.

The Long and Winding Road

The idea here was to create a partly digital version of what, in stock photography, has come to be known as "the road to nowhere." Such images, always shot from the middle of an empty highway stretching to the horizon, fit certain conceptual needs. The problem is that there are very few places in the world where such views exist, apart from the American West. But as these pictures are conceptual, they don't have to be "real," they simply have to "look right."

From several existing landscape images I chose this one, mainly because it was open, and not so flat as to be boring. But with the low mountains in the distance, it was clear that the road would have to make some acknowledgement of the principles of highway construction and could not simply plow its way straight to the horizon. I sketched the route first on a tracing of the photograph, then decided to bend it from view in the foothills.

On the Verge of Reality

As this was to be a major addition to reality, the pressing question was how to ensure that it looked convincing. There were three alternatives. One was to find and photograph a real stretch of road and distort that into shape. This was rejected because of the time and uncertainty of finding something suitable. The second was to photograph a short section of road and extend it digitally. This was a reasonable option, except that all roads that have been used for more than a few months look distinctly grubby. The third option, building a road from scratch on the computer, was not as difficult as you might imagine. I used photographs of roads for reference and built up the texture with several applications of noise, finally distressing the surface mildly with tire tracks.

The camera position was at standing height, and this meant a very strong perspective for the road—so much so that after a few virtual meters there would be no surface detail to see. As long as the immediate foreground worked, I thought the image would be believable. Roads remain much the same along their length, so a single short section could be extended indefinitely by stepping and repeating. A distortion brush took care of the distant section, and the main effort in blending it into the landscape was devoted to blades of grass and their shadows along the nearest verges.

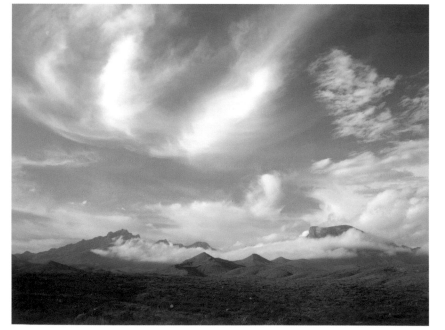

Chisos Mountains, Texas
From the library of landscape photographs, this wide-angle view of Big Bend National Park was chosen to convey wide-open space.

Chisos road

1 Using several photographs of real roads for reference, this short section was created as a digital illustration, using noise filters for the basic texture, with some airbrushed streaking to give a slightly used appearance.

2 The road was lengthened by copying, doubling the canvas height, and pasting. This procedure was repeated to give a four-length segment, and again three times to create a stretch of 32 lengths. This was then scaled down to the width needed.

3 Using measurements taken from the landscape image, the 32-length stretch of road was given extreme perspective to match the original camera height and focal length.

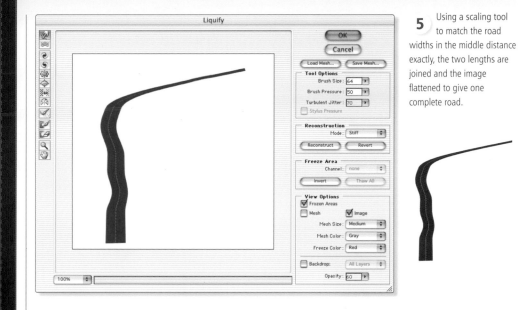

4 To match the distant foothills approximately, a second section of road was distorted by eye to make the appropriate curves, using a distortion brush.

5 Using a scaling tool to match the road widths in the middle distance exactly, the two lengths are joined and the image flattened to give one complete road.

6 With the shape of the road already following a planned sketch, the two important areas for blending are the foreground verges and the far end. Detailed erasing of the road layer reveals grass in the foreground and the undulation that finally hides the road.

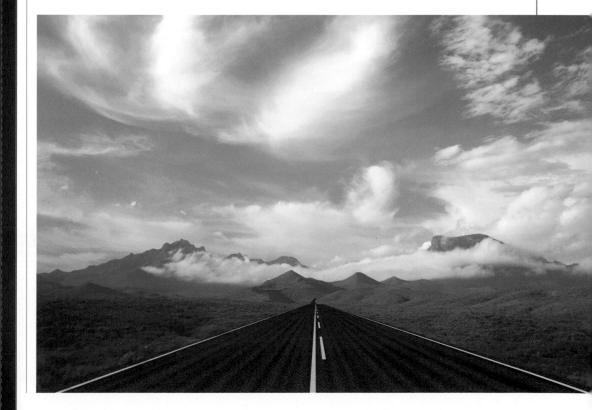

Free Association

Surrealist images and odd combinations of subjects can be achieved more perfectly with special effects than has been possible before.

The Surrealist movement, which began around 1922 in Paris, was originally literary. But it inevitably attracted painters, with its emphasis on going beyond reality to the world of the unconscious, the imaginary, and the bizarre. Although not a coherent movement, a constant was the divorce of figures and objects from their normal functions to create the unexpected. Digital photography has a special affinity with Surrealism, as seamless special effects allow us to realize bizarre imagery perfectly, as if such scenes could really exist.

One of the most widely used techniques in the Surrealist armory was juxtaposition—chiefly of unlikely elements—to suggest connections and provoke the imagination. Juxtaposition is exactly what a lot of digital special-effects imaging is about, through the now-familiar procedures of selection and compositing. These figure prominently in this book in the creation of realistic images, but the Surrealist influence encourages more unusual combinations.

The image on page 128 was created for a CD cover. The idea of using body paint and of a contrast between the natural and industrial came from the musicians. The design was sketched and agreed upon before shooting, and a suitably grim industrial background was found from stock. Because this background needed to be an iconic representation of the worst kind of industrial landscape, I decided to build it up in layers as if one were looking at a scene that stretched smokily into the far distance. For the portrait, we went for a painted look rather than the appearance of real green- patterned skin, which would have looked a little too "mutant." We commissioned an artist specializing in body paint, but to ease the process I used digital retouching to fill in the "difficult bits"—running the painted effect over lips, eyelids, and odd corners.

The other image (below) of a steel eye, is rather more ambiguous and much more in keeping with the original Surrealist pursuit of the irrational. One way of achieving this look is to introduce into an object a property not normally associated with it—in this instance, hard steel around a soft, organic eye. Technically, the main issue was to isolate an eyeball from the surrounding flesh. Eyes are intensely recognizable to all of us, so glass eyes would just not have been convincing enough. Again, this was a perfect situation for digital special effects, which can rebuild a full eyeball from a single segment, as shown in our example.

Bionic composition

1 The starting point is a close-up photograph of a young girl's eye, which has been subtly retouched to knock back the reflections of the studio light.

2 Because the iris is partly concealed by the upper eyelid and varies in tone because of the lighting, it has to be reconstructed from a clear half, here being selected by a path and Bézier curves.

3 The path drawn around the half-iris is turned into a soft-edged selection, copied and pasted into a new image file.

4 The layer is duplicated, then flipped and positioned directly opposite the original half. The two layers are blended by gentle erasing and cloning along the joining edge.

5 A similar but more involved process is completed for the surrounding white of the eye, and this is extended to build a full sphere. The two parts are combined.

6 For the outer metal jacket, a circle is filled with a brushed metallic texture from a KPT filter (*Texture Explorer*), given three-dimensionality by shading and an application of Photoshop's *Spherize* filter.

8 One eyelid is copied and pasted on top of the eyeball as a first step in the composite. This is positioned for as realistic an effect as possible, to be followed by a flipped copy for the lower eyelid.

7 Using a path, a segment is carved out of the metal sphere to make the underlying upper lid. This is reduced in scale so that it can appear to fit just inside the sphere.

9 The finished image has an outer covering of the steel sphere, out of which an oval segment has been cut. Extra refinements are a brass-textured edge to the sphere, shading between the eye and the lid, and again between lid and outer jacket.

Juxtaposing nature and industry

In a studio session, the two musicians are photographed against a plain paper background roll, having spent a combined four hours in body painting.

1 It was more effective in time and cost to complete and perfect the body paint on the computer than by hand and brush. The digital airbrush was set to a pre-selected green and *Color* mode.

2 The two figures were individually outlined and selected using mainly the *Magic Wand* auto-selection tool, and the background was deleted.

The elements for the eventual background had been shot much earlier at an oil refinery. They were chosen for being unmistakably industrial, silhouetted, and largely colorless.

3 The *HSB* control, often more useful than *RGB Curves*, was used to saturate and adjust the brightness of the selected human figures.

6 The middle-ground layer was reused in reverse and distorted to provide a graphically strong foreground element to the refinery scene.

4 The two figures were then composited into a group, pasting the man into a layer over the woman. This done, the group of two was saved as a selection for pasting onto the background.

5 The three refinery photographs were combined in layers, stretching and flipping the images where necessary. Color and brightness were adjusted to progressively knock back the layers into receding planes.

ZUFOLO

Special Sphere

The composited CD cover
The finished composite is a straight combination of the figures and industrial landscape, with a gray "ledge" airbrushed in under the figures to provide an unobtrusive base.

Dream Imagery

Taking irreverence a stage farther, let's now tackle a true Surrealist icon with some of the techniques and strategies we've gathered.

From the beginning, the Surrealists looked to the unconscious as a source of raw material for their writing and painting. In poetry, "automatic writing" was an important technique, meaning "dictation of thought without the control of the mind," but in imagery this was rather more difficult. One fruitful source, however, was dreams, and noone explored this farther or more literally than Salvador Dali, the great showman of the movement.

From Fromage to Homage

Dali was very impressed by Freud's work, then new, and he built a repertoire derived from the Freudian interpretation of dreams. Possibly his most famous invented object was the soft watch—which he himself referred to in his inimitable way as the "Camembert of time and space."

Although anyone looking at Dali paintings for the first time could be forgiven for finding them incomprehensible, they followed an internal logic very closely. To Dali these watches, draped over trees and other objects, represented the lack of meaning and mutability of the conscious world. The way he treated scenes and objects was also important —he used a highly realistic technique, creating what was called at the time "surrealist naturalism," essentially a new

school. Dali also wrote, "Ideas are made to be copied," and the Surrealists freely borrowed each other's inventions. My starting point is an old pocket watch, photographed under diffused lighting in the studio.

Copying the Copyist

Before attempting to "melt" it, I needed to flatten it, for which the most convenient tool is the *Distort* command, using it mainly to create perspective. Perceptually, the effect is to reduce depth. This done, the principal operation is freehand distortion, using a distortion brush. Photoshop's *Liquify* is as good as any. As I've already explained, it pays to become familiar with the different effects of combinations of brush size and pressure. In this case, to make broad changes of shape to the entire watch, I used a very large brush size and a very low pressure.

In the Surrealist tradition of bare, almost alien landscapes and stark features, I created a desert-like landscape in Bryce. Needing to support the watch to make sense of its flowing form, I simply photographed two dried branches decorating a Japanese basket, which were already to hand, and bent them into the appropriate shapes, again with the distortion brush.

The starting point is a straightforward full-face shot of an old pocket watch, no longer working and useful only for photography. Other images were created especially for this project.

The final image showcases
two of digital imaging's
strongest suits—perfectly
executed distortion that
would be extraordinarily
difficult by any other means,
and seamless compositing
of different elements.

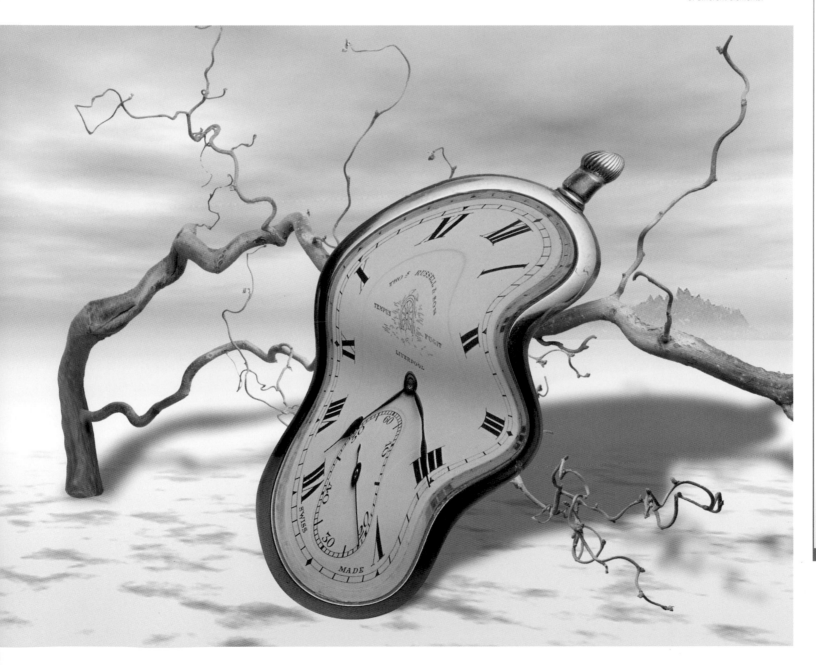

The persistence of imagery

5 objects
65539 polygons
00:00:00.00

1 With the watch outline selected (performed with the *Path* tool for a clean edge to the geometric shape), it was angled to the chosen viewpoint using the *Distort* tool.

2 Most of the work in making the watch flow was executed with the distortion brush in *Liquify*, varying the brush size and pressure to get the exact shape wanted.

3 The setting was created in Bryce with just two elements: an infinite ground plane (represented by the small square), and two interconnected mountains in the distance.

Liquify

OK
Cancel

Load Mesh... Save Mesh...

Tool Options
Brush Size : 150
Brush Pressure : 10
Turbulent Jitter : 70
Stylus Pressure

Reconstruction
Mode : Revert
Reconstruct Revert

Freeze Area
Channel : none
Invert Thaw All

View Options
☑ Frozen Areas
☐ Mesh ☑ Image
Mesh Size : Medium
Mesh Color : Gray
Freeze Color : Red

☐ Backdrop: All Layers
Opacity : 60

100%

4 Dried branches were photographed, then selected and rotated into the approximate position for holding the upper fold of the watch. Next the base of the branch needed to be bent more or less upright with a distortion brush, and retouched with the *Path* tool and *Eraser* so as to appear to be growing out of the ground.

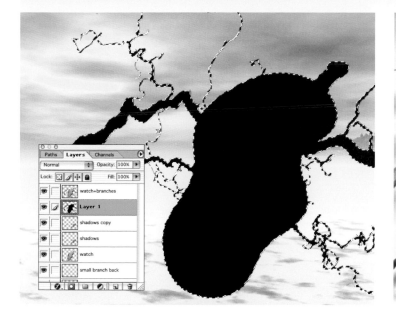

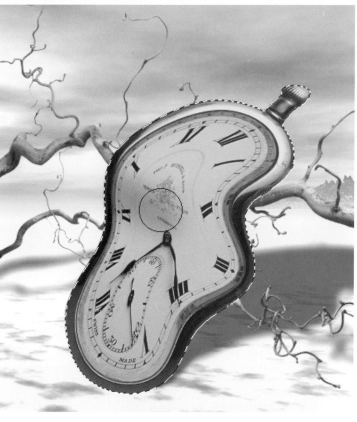

5 For the shadow, the combination of watch and branches was selected, and a copy of this made in a new layer, then filled with black.

6 The shadow, in its own layer positioned under the watch and branches, was distorted by eye with the *Distort* tool. After this, blur was applied across the layer, and the opacity reduced.

7 To make the melting of the watch convincing, a delicate and broad area of shadow was brushed in under both folds, using a wide airbrush and extremely low pressure.

8 For a detailed touch of realism, copies of the nearer parts of the branches were massively distorted before placing as reflections in the polished surface of the watch case.

9 The distorted branch reflections were scaled and rotated to fit into the curved rim of the watch. The opacity was reduced and the *Smudge* and *Eraser* tools used for final retouching.

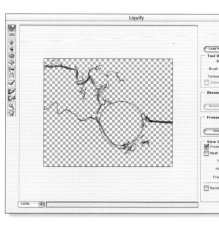

Revolutionary Objects

Combining familiar objects in unfamiliar ways creates "revolutionary objects," but it also makes us think about the original objects' meaning.

We've all heard the old joke: "How many Surrealists does it take to change a lightbulb?" Answer: "The fish." While it's easy from our perspective now to pour scorn on the movement's achievements, its intentions were serious, even if there was dark humor in the work. It certainly revolutionised the idea of what a picture (including a photograph) could consist of. As part of an attack on society's preconceived ideas, the Surrealists attempted what André Breton (who assumed the role of philosopher of the movement) called "a total revolution of the object." They did this by dissociating objects from their normal, everyday functions, creating images that were at once devoid of context and entirely recontextualized. There were, and are, a number of ways of doing this. We've already explored the introduction of an "unexpected quality." Another is to introduce an entirely inappropriate object to a scene. A statement by the 19th-century poet Lautréamont "beautiful as the chance encounter of a sewing machine and an umbrella on a dissecting table" was pounced on by the Surrealists as an artistic ideal.

The Importance of Being Ernst

A related concept was hybridization, in which two objects were combined to make a third "unexpected" one. Several Surrealist painters and sculptors pursued this idea, notably Max Ernst, with his images of women turning into birds, and René Magritte, who searched for a deliberately "bewildering" effect in his objects. According to a theory that he evolved, every object is linked to another, either psychologically or morphologically, even if they at first appear dissimilar. Putting the two together, therefore, makes that subconscious link a conscious one, and the effect can be at once disturbing and oddly appropriate.

In the case of the disembodied hand (my hand) poised in the act of writing a note, the reference goes back to Magritte's *The Red Model* painted in 1935, in which a pair of feet become shoes (or is it vice versa? There is a deliberate ambiguity).

Hand in Glove

Magritte's concern was to displace ordinary objects from reality, in order to undermine them and, by doing so, make it possible to see them afresh. About this image, he wrote (again ambiguously), "One feels, thanks to *The Red Model*, that the union of a human foot and a leather shoe arises in reality from a monstrous custom." Some years ago an art director friend of mine adapted the idea to a hand and glove, which we executed together for a record cover. The image, shown opposite, is an evolution of that idea.

Any image involving body parts put to, shall we say, "unusual" uses is bound to be slightly disturbing, but the aim here is not to be macabre. The key is to keep everything clean, in the lighting (standard soft illumination from above over a light table) and in the blending of hand and glove (very gentle). An abrupt transition might suggest that a hand was actually joined to a glove, but a smooth transition over a distance of a couple of inches makes it clear that one object is turning, somehow, into the other. Note that the stitching above the thumb has been deliberately retained in the flesh of the hand.

Despite the bizarre concept of the image, the detailed realism on which it depends comes from the basic textural similarity of the hand and the leather, which the brushed transition has maintained, including the stitching.

Glove's labors lost

1 Three shots were taken, with the camera locked on a tripod: the key shot of hand with pen, a second with the glove, and a third of just the previously hidden inside lining of the glove.

2 With inevitable variations in the hand position when shooting, the gloved hand is rotated to match the position of the key shot, and slightly reduced to match the dimensions of the hand.

3 The second combination to perform is to replace the wrist with a clear view of the glove's lining. This too involves rotating and a small amount of resizing.

4 The two glove layers, with and without the wrist, are combined into one by carefully erasing corresponding parts of each, using a medium pressure setting on an airbrush.

5 The critical operation is achieving the right amount of transition between skin and glove, performed by erasing the glove layer. The pen is left in the ungloved hand.

6 The blending of skin and glove is completed with many delicate strokes of the airbrush set at half pressure. The background is mainly from the hand-and-pen layer.

Extraterrestrial Views

Convincing alien landscapes are a challenge to create, even with twenty-first-century technology. So how can you still surprise?

With a little inspiration from the Apollo space program, digital special effects have become the method for reproducing extraterrestrial views. But perhaps surprisingly, earthbound photography has a role to play. Decades of movies and television series set in space are evidence of the popularity of the idea of other worlds, and alien landscapes can now easily be built within the realm of 2-D photography and effects just as well as they can in the memory-hungry world of CGI and motion pictures.

An All-Star Cast

The basic elements are a landscape and a sky that contains some obviously alien features (from a menu of planets, double stars, moons, nebulae, and so on). If the job of the sky is to communicate "extraterrestrial," the foreground landscape has less work to do, and simply being barren is likely to be sufficiently convincing. In fact, strange and spectacular earthly landscapes can form the basis for an extraterrestrial scene, with two main provisos. One is that vegetation is too recognizably earthbound to work in such images, and has to be removed (grass, in particular, is very common, even though it did not exist on Earth as recently

as the Jurassic period). The second is that while "strange" helps to denote "alien" by one definition, these days most spectacular landscapes, however remote, are too well-known thanks to tourism and television documentaries.

Some Added Extraterrestrials

The fail-safe landscapes for planetary views are the raw ones with no water weathering and little or no vegetation. Arid and volcanic landscapes fit the bill better than any other, hence their frequent use in science-fiction movies: lava flows in the Canaries and Iceland, deserts (Tunisia for the planet Tatooine in *Star Wars*, for example), and even some rocky coastlines. In many ways, the more anonymous and simple the better. The intended use is as a background, and other image elements will be inserted. A low point of view and a wide-angle lens with good depth of field tend to make the most useful backgrounds. Brightness, contrast, and color can all be easily altered digitally, but distinct shadows will suggest a sun as strong as ours. For planets distant from a sun, a shadowless landscape usually works best. As for what to put in the sky, see the following pages for suggestions.

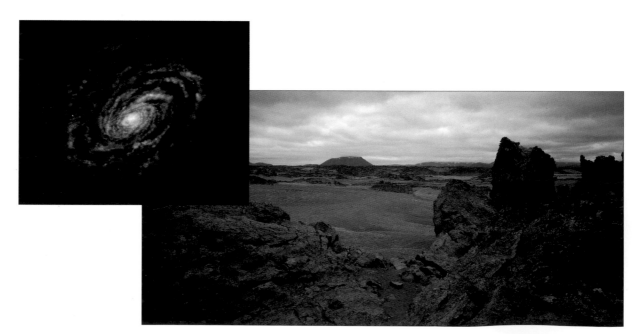

The final image, used in various magazines, is a reconstruction of how our own galaxy, the Milky Way, would look from beyond.

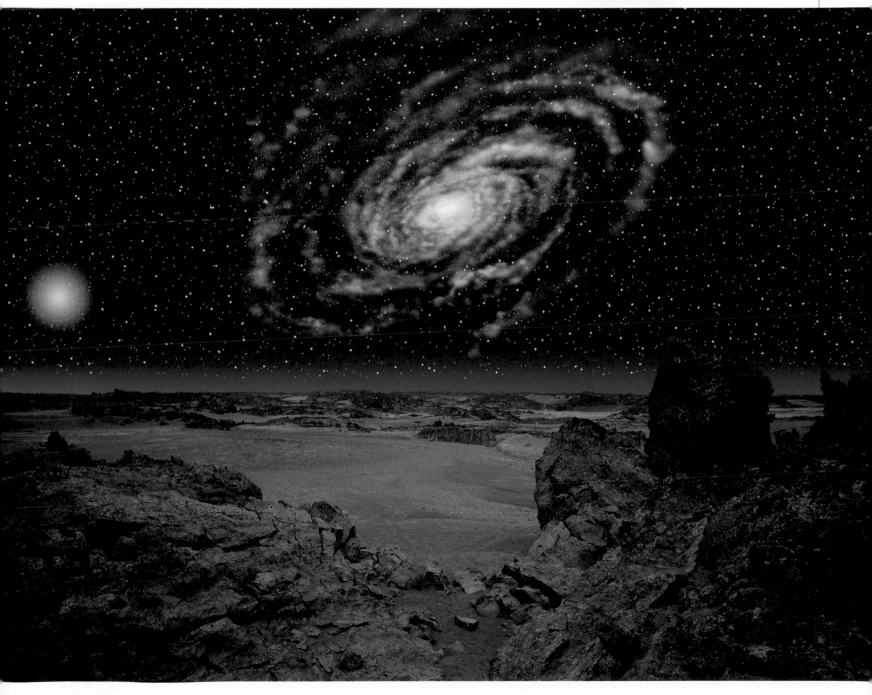

The Milky Way

1 The base landscape was shot in a volcanic area of northern Iceland, with almost no vegetation. The distant mountains with snow are easy to remove.

2 The few visible grasses and lichen are removed by cloning from nearby rocks. To preserve detail in the rocks, a cloning brush is used at 100 percent opacity, without a soft edge.

3 The sky and distant mountains are knocked out using smart masking. The edge of the required horizon is highlighted with a brush, then the area below filled.

4 After the landscape has been extracted, the area above and beyond it is made transparent, and any layer placed underneath this will show through.

5 In a new layer under the landscape layer, a gradient from blue to black is created close to the horizon, to suggest atmosphere and help define the horizon line.

6 A prepared star background (see page 143) is pasted between the landscape and gradient layers. Setting this layer to *Lighten* mode removes the black background.

7 In reality the slight atmosphere would dim the stars, but as their layer is in *Lighten* mode, they remain bright. Airbrushing with black removes those close to the horizon.

APPLICATION

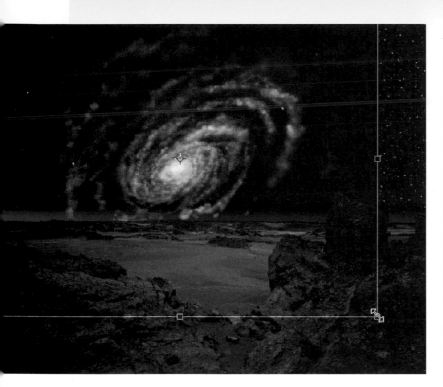

8 The already-prepared spiral galaxy on its black background is pasted in and scaled down to fit the sky area. Like the stars, it is blended in *Lighten* mode.

9 The galaxy was prepared in monochrome, but selective coloring gives it more body— shadows and highlights are shifted slightly in opposite color directions.

10 A spherical cluster of stars, prepared as artwork, is added by pasting and re-sizing. To make sure no black frame edges show, the levels are adjusted to give pure black at one end.

A 3-D GENERATED VIEW

For comparison, a "planet from moon" view created in Bryce. The three elements—landscape, planet, and its rings—were created and rendered separately, then composited in an image-editing program together with the star background (see following pages).

SHOOTING ALIEN LANDSCAPES

Deserts and lava flows are reliable locations, but choose a viewpoint as free as possible from vegetation and other obviously terrestrial features to save time on retouching. The greater the distance to the horizon, the more convincing the landscape will be when transposed digitally to an alien view, although it is also possible to add distance later digitally by cloning. A wide-angle treatment with some foreground exploits a good location to the full. These shots were picked up in the course of various travels.

Space

...is not the final frontier for digital special effects. Using the right package it's far easier to create than most terrestrial subjects.

The foregrounds dealt with on the preceding pages are often the key to believability, but they can be handled photographically. The variety of objects floating in space, however, calls for greater ingenuity. Photography can provide some of the solutions, but there nearly always has to be a degree of digital manipulation.

The first essential is a star background, and if this is needed at high resolution, there is no alternative but to construct one digitally. If you examine a good telescope photograph of a star field, you can see that, far from being simple points of white light, stars vary in size and in color, and some have distinct halos (due to the optics).

Spread a Little Stardust

Digitally, this means starting with a star unit and multiplying it, at the same time distributing the copies randomly across a black background. The numbers are the problem, because they need to be in the thousands. The only advantages are that for this kind of image I am assuming no accuracy at all. If the final star field is sufficiently random, it can be reused without any changes other than occasionally flipping or rotating it. The unit I started with is a flared light, drastically downsized, to make the stars appear as something more than simple points of light. The star field was built up in stages, a hundred or so at first.

Then this compilation was copied, pasted, and rotated, building up by degrees to a layer of a few thousand stars all at the same scale. The number of stars in one complete layer depends on how much effort you are prepared to spend. Larger- and smaller-scale versions of this were made, then layered with very slight shifts in color to each layer. Finally, a few larger stars were given individual flare treatments (for a recap on flare, see pages 34-5).

Planets and moons are more interesting. One rich source of space imagery is NASA. Its space images Web site (*http://images.jsc.nasa.gov*) offers a wonderful range of public-domain images for download, including those from various planetary spacecraft missions and from the Hubble Space Telescope. The higher resolutions are more useful for printing, and some may need some retouching. For imaginary planets, however, the choice is either a model or a digital construction. Models are possible because the shape is so simple—they need only be a hemisphere for painting and can be lit with a single lamp to mimic a sun.

Create your own planet

Leaving photography completely, there are some extremely effective ways of building planets digitally in both 3-D and 2-D. As a planet is simply a sphere with texture, this suits 3-D programs, and our old friend Bryce, for example, is well equipped for the job with its *Materials Editor*. Gas planets (similar to Jupiter) actually need less work because of their banded and not highly detailed surfaces (there are presets for Jupiter and Uranus in Bryce), but another option is to project a flat image already prepared as digital artwork onto a sphere in the program. It can then be lit as desired.

But for a completely dedicated approach to planet-building, LunarCell software from Flaming Pear takes the prize. There is insufficient space here to describe all the details of this extremely rich program, but suffice to say that its parameters accurately cover every geographical and meteorological aspect necessary. It even does craters, nighttime city lights, and storms. For anyone even half interested in space imagery, this is high-priority software, worth far more than its price.

NEBULA BACKGROUND

For vague, wispy nebulae, a simple technique is to inject ink into a tray of water, backlit on a light box, and shoot from above. The image is then inverted and added to stars. Nebulae can also be created in Bryce (using presets), or real ones downloaded from Web sites such as NASA's.

APPLICATION

A stellar line-up

1 As the stars will be too small to register any details, only one original is needed. This is reduced in size to almost a point, then copied and pasted in at random.

2 Once a random pattern of stars has been created (100 or more), the group can be copied, the canvas extended, the image pasted back in and rotated, then displaced to avoid the appearance of a repetitive pattern.

3 Copies of the basic layer, rotated and displaced to randomize the effect, are given alternate color shifts. Enlarging gives a slightly different star size for extra depth.

4 To simulate closer, brighter stars as seen through a telescope, a few different flare patterns are added at random.

Lunarcell planet

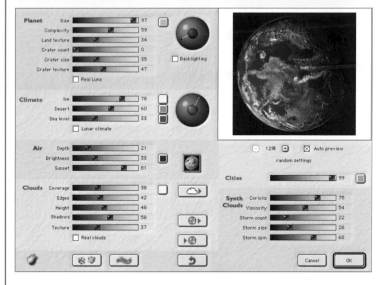

1 The parameters are grouped under planet, climate, air, and clouds. The clouds in turn can be synthetic, as here, or downloaded from the Flaming Pear Web site, which accesses satellite imagery.

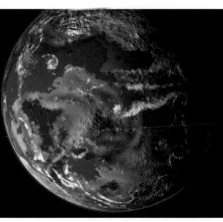

2 A result from the LunaCell software, which works as a plug-in but creates its own images, is an arid Earthlike planet with an atmosphere and oceans.

A PAINTED HEMISPHERE

This version of the Jovian moon Io, with its volcanically active surface, was painted onto a plastic hemisphere using NASA references and lit with a single small lamp against a black velvet background.

APPLICATION

WORKSHEET

Idea
Create an imaginary miniature planet of rainforest

Solution
Extend an existing photograph of forest, spherize it, and add it to a starry background

Software
Image editing

Techniques
Colorizing, tiling, spherizing filter, color matching, blending by soft erasing, selection

Symbols

Creating symbolic images for advertising or magazine features moves photography close to illustration, and closer to the whims of fashion.

One constant demand in advertising and certain kinds of editorial work is to create a single image that will illustrate a much larger theme. When the subject of the advertisement or article is conceptual, then the art director has to search beyond the contents for a visual idea that will both communicate and be interesting. This is conceptual illustration, and there are several ways to deal with it.

One of the most widely used techniques is symbolism, which is largely a matter of sourcing a visual that can be made to represent the subject—such as finding an image to represent, say, silence, hearing, wealth, or insurance. Broad subjects like this do not throw up obvious images, but they do respond to symbolism.

Clashing Symbols

Finding an apt symbol supposes a particular awareness among the audience for the picture, and this in turn means walking a line between the too-obvious and the obscure. Ideas that come easily have probably been used before—an umbrella for insurance, for example—and rapidly become clichés. On the other hand, searching too hard and coming up with an arcane symbol defeats the purpose if people fail to see the connection. Conceptual imagery is also subject to trends and fashions: what works today may be worn out, or even irrelevant, tomorrow.

In any case, beyond the aptness of the symbol is the way it is handled visually. Ideally, the treatment should be intriguing and attractive. It is, after all, meant to catch the eye and stimulate an idea or two. Also, even if the symbolism is a little obvious, the execution can lift it or make us look at it afresh. Traditionally, photography and illustration have always competed for this kind of work, with photography tending toward more straightforward representation. Using digital special effects, however, photography can now embrace illustration without losing its defining qualities of realism.

The concept here is the environment on a global scale— what it should be rather than what it is. Part of the symbol is rainforest, pristine and emerald green, but to make it special, the idea was to create a world of forest. On a normal scale, this would not work visually—the forest texture would be invisible—so I decided to invent a miniature planet, a kind of fantasy. This also has the advantage of being more obviously symbolic.

Out on the Tiles

It also turned out to be an exercise in making much from little. I had already shot aerial photographs of rainforest, but the area captured was quite small. The first task, then, was to create a large expanse from one small patch. As it turned out, the most suitable image had been shot on false-color infrared film. On the face of it, this might seem an unnecessarily difficult source image, but changing the color from red to green was no problem at all with the hue control. This one small area, compressed into a square image, was then tiled over and over again to create a large expanse. I avoided tiling software in this instance (Terrazzo from Xaos Tools would have been the most comprehensive) because I needed to conceal the effect. So as not to show an obvious pattern, the square of forest was rotated, sometimes overlaid irregularly, overlapped, and the edges brushed with an eraser.

The next step was to spherize the forest, using the filter in Photoshop's *Distortion* set. The effect near the edges is not optically exact, but close enough. To bring the sphere to life, I needed more detail and activity. I chose another aerial photograph, also shot over the Amazon and showing a meandering tributary, and blended it into the rainforest sphere, using the hue control again to match the greens, and a large, soft erasing brush around the edges. Over this I added a flock of white ibis, at which point I was ready to float the planet in space.

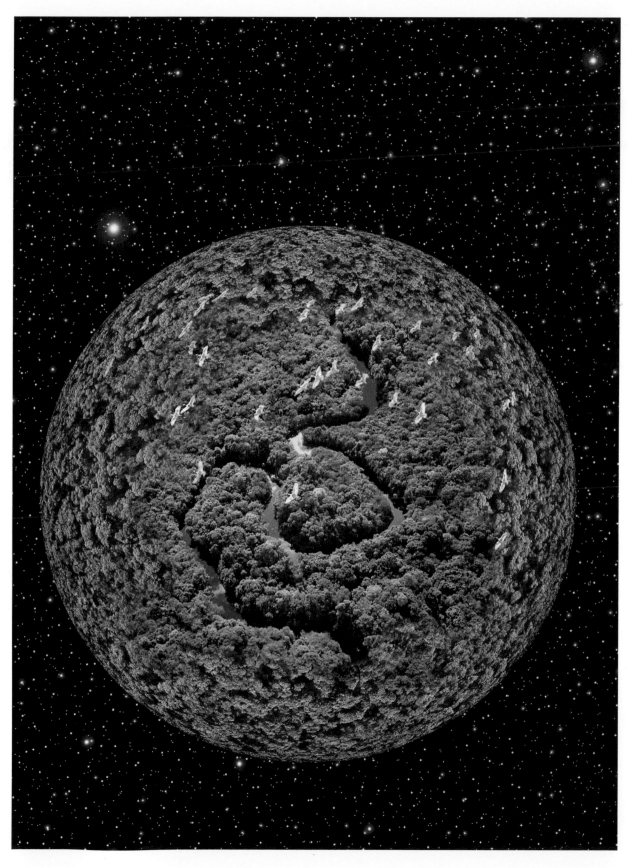

The image, titled *Planet Rainforest*, is completed by adding a dense star background, one of several in my stock library stored on CDs. Glow was added to the most prominent stars.

Planet rainforest

1 Starting with a false-color infrared slide, the first step is to shift the hue completely to a rather more suitable green.

2 To facilitate tiling, the 2:3 format of the photograph is compressed into a square. This does no harm to the proportions of the trees, and preserves more detail than cropping.

3 Tiling is performed by hand to hide any obvious pattern and repetition. The square image is spherized at 100 percent.

4 An aerial view of a river from the same shoot is pasted over the sphere and scaled to fit. This is a normal transparency.

5 Because of the different film stock used for each image, the colors need to be matched by adjusting the *HSL* sliders.

APPLICATION

6 The complex texture of the forest aids the blending of the upper image into the lower. The edges are irregularly removed with an eraser airbrush set at 300 pixels and varying opacity.

7 To animate the image and add depth for realism, I looked through my stock library for an aerial of a flock of birds. These are ibis over the Florida Everglades.

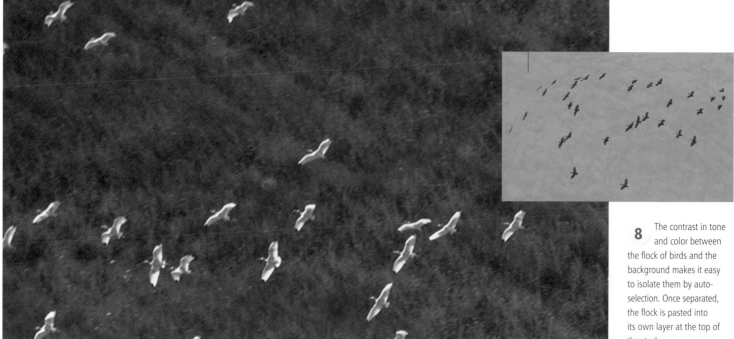

8 The contrast in tone and color between the flock of birds and the background makes it easy to isolate them by auto-selection. Once separated, the flock is pasted into its own layer at the top of the stack.

More Symbols

Let's take the techniques we've amassed a stage further and create some more intricate but still powerful and enigmatic compositions.

APPLICATION

WORKSHEET

Idea
"Mankind's future in the stars," with a couple pointing to an impossibly rich, starry sky

Solution
Composite photographs of people in a landscape with a night sky of stars and galaxies

Software
Image editing with multiple elements

Techniques
Compositing, gradient fill

WORKSHEET

Idea
Manufacturing industry has evolved from individual industrious labor

Solution
Juxtapose basic manual labor with an industrial plant looming behind

Software
Image editing, using levels, gradient fill, channel mixer, and opacity adjustment

Techniques
Scaling, stylizing, color gradients, colorizing, compositing

The first of these two images was designed as a closing illustration for a book about the future, but it has since been used several times as a cover and article opener for magazines. It doesn't say very much, but its continued use is precisely because the content is loose, not specific. This is another feature of successful symbolism: if the contents are generic rather than particular they are more open to interpretation and so to different uses.

The art director's brief was to finish off the book with an expansive view of two people gazing toward a future "out there" in the Universe—simple, like most good concepts. Nor was the content of the shot complicated: two figures in silhouette, standing on a promontory, and a horizon at dusk rising to a night sky rich with stars and other heavenly bodies. The image went through several versions as I managed to improve on the elements. This is the latest.

A New Hope

It was easier to assemble the elements from separate sources rather than attempt to shoot them together. Indeed, the only special photography was that of the silhouetted couple, done quickly in a studio. The vertical arrangement was important, as the view had to move upward in as short a space as possible from a clear horizon to a lookout point on which the figures would be clearly visible, to the heavenly bodies. Night skies do not, of course, look anything like this, and everything in our sky needed to be manufactured and assembled, so the initial preparation was a rapid gradient to black above the figures. Not too rapid a gradation, however, as the shading had to appear realistic.

In the end, the sky came from the Amazon and the rock, way out of scale, from Ruby Beach on the Pacific coast of Washington State, both shot at dusk. The rock was composited by knocking out its sky and removing, with an eraser, the pine trees that originally stood on its summit. Adding the silhouetted figures was straightforward, the only precaution being to match the deep shadow tones,

none of which was pure black. This done, the gradient was applied in a separate layer, and the image was ready to receive a mixture of galaxies, nebulae, comets, planets and stars. These were from a variety of sources, some of them NASA references, but all of them heavily worked with distortion, smudge, and airbrush tools.

In the second image, for a magazine cover, the theme to be illustrated was "industry," but the brief was to elaborate on this by commenting on its evolution, from the simplest act of manual labor up to the industrial revolution. As part of this elaboration, there was also a play on words—industry as manufacturing, and industry in the sense of being industrious, diligent, hardworking.

The Wheels of Industry

This called for juxtaposing two images, one to symbolize the act of work, the other to encapsulate the idea of an industrial plant. The images chosen were, respectively, a man digging (with its connotations of breaking the soil) and a London icon of industry, Battersea Power Station. From these two, the design followed naturally, with the man in front of the power plant, the former crisp and detailed, the latter indistinct, but large in the distance.

The execution deliberately reduced everything to the simple essentials, stressing outlines. Most of the work was in simplifying the power station and knocking it back into a kind of mist. There were many options for stylizing the plant, but the most obvious was to turn it into a plain silhouette. The main body of the building was straightforward enough—a matter of increasing contrast toward the darker areas using the *Levels* command—but I also wanted to alter the billowing smoke from the chimneys, which in the original was mainly white. The solution for this was to invert a copy of the image and squeeze the contrast down to the "shadows"—that is, the smoke. The two layers were then flattened. A color gradient and use of the channel mixer added color. Finally, the silhouette of the digging man was pasted in.

The final composite is one of several versions. By saving the workfile with its multiple layers, it was possible to regenerate the image with different sky features to meet the demands of different publications.

Behold the universe

1 The terrestrial originals were a sunset over the Amazon with rays emanating from the clouds, and another sunset over a beach on Washington's Olympic Peninsula.

2 The silhouetted figures, specially photographed, are selected and pasted into position. The area around the feet is blended with the top of the rock by erasing and airbrushing.

3 The final stage is to add a star background and a number of features, each individually prepared.

Industry

1 The background original is an old shot of a famous power station when it was still working. Its massive simplicity captures the industrial component well.

2 To fit within the final image, a vertical cover format, the power-station needs to be compressed with the *Scaling* tool.

Hue/Saturation...	Ctrl+U
Desaturate	Shft+Ctrl+U
Replace Color...	
Selective Color...	

3 Color will be added later, so the image is at this stage desaturated (NOT converted to grayscale, which would discard the color channels).

4 To make the equivalent of a lith film conversion, levels are used to compress the tonal range from the right, removing the highlights.

Gradient Map...	
Invert	Ctrl+I
Equalize...	
Threshold	

5 A duplicate layer of the desaturated image (before increasing the contrast) is inverted. This will enable the smoke, originally white, to be captured in silhouette.

6 On the inverted duplicate, the same tonal compression is performed, leaving the former highlights as dark areas. The two layers are then combined into one high-contrast silhouette.

7 The silhouette of the power station and its smoke is blurred as part of the procedure to give it a looming, misty appearance, and the opacity reduced.

8 The blurred power station is colorized in two ways—with a gradient from transparent below to orange above in one layer, and extreme adjustment of the red channel.

9 The foreground shot of my father digging, shot in black and white, is colorized for the grass, given high contrast, then pasted in.

The finished composite (opposite) intentionally sets the sharp contrast and detail of the small figure against the less substantial but looming and ominous symbol of industrialization behind.

APPLICATION

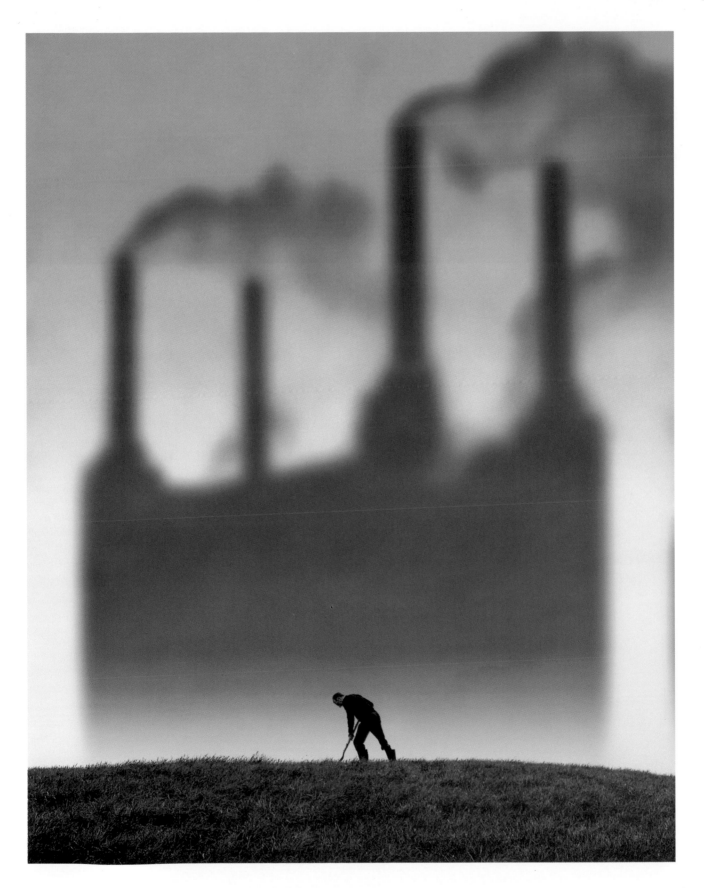

Generics

Some images move beyond fashion to become accepted as universal symbols of simple concepts. When it's not broken, how do you fix it?

Certain motifs are so well-known (and in so much demand) that they are instantly seen as representing something larger, whether it is a concept, a class of objects, or a range of activities. There is no clever symbolism involved. Such motifs are beyond cliché, and have the status of generic images that can stand reuse, repetition, and endless recontextualization. Nevertheless, because they are so familiar the real challenge to the creative digital photographer is in finding new ways of presenting them.

Two such generic motifs are the examples here. We've all seen them countless times, but from a professional point of view they will go on being used, so there is every reason to continue looking for different treatments. In the case of the head and brain, this is one of several similar versions created over a number of years. There are three main elements —head, brain, and background—of which the first two need to be shot or prepared specifically. The choices of viewpoint are frontal, which works well for the brain but not so clearly for the head; three-quarters, which is a more realistic but less generic angle; and profile.

A Head-up Display

The advantage of the profile is that the outline of the head is instantly recognizable, while the brain shape is also obvious from the side. Lighting the head as a silhouette stresses the aim of making a "universal," rather than an individual, head. Equally, of all the possible ways of showing the brain, I prefer the abstract, "brainscan" look. The demands for the background are first to be unobtrusive, and second to have some texture and presence. Again, there are several versions, but this one with a sky gives greater depth to the image.

The second example is a computer screen, which is used more than most other visual motifs to represent computing. Nothing complicated there, but to be generic it should refer to all screens. For this reason, the less shown the better. Like all computer equipment, display monitors evolve rapidly, so there is inevitably a problem of falling out of date, but as every element in the workfile is kept in its own layer, these can be replaced.

How Much More is Less?

The question was, how little can you show of a computer screen and still have it recognized immediately? The answer, at least here, is to use the surround head-on. What is actually on the screen is largely irrelevant, and I chose to leave it empty, reinforcing the image by repetition, showing a succession of screens in the distance. The background fulfils the same function as in the image of the head and brain, which is to say it's a convenient but not insistent setting. To back up the idea that the several screens were floating and arranged in depth away from the viewer, I wanted a real scene, but unidentifiable and with few elements. The landscape, from my stock library, is from Scotland, and has the advantage of a single color theme and being almost abstract in its simplicity. The wisp of cloud in front of the second screen (created by partially erasing the screen layer) adds more realism.

Despite their familiarity, both images remain open to a variety of interpretations, and are therefore an attractive proposition to picture libraries looking for images that have considerable resale and reuse value. The brain image, for example, could be used to illustrate inspiration, dreams, creativity, the merging of mind and machine, the future, the mysteries of the human consciousness... you name it, the image works in all these contexts. Similarly, the computer image could be run alongside features on the possibilities of the Internet, the future (again!), the clash of technology and nature, the advance of technology.... even the tedium of working in an office all day!

The final image, published on the cover of one of the UK's leading TV listings magazines, was used to publicize a popular science program that explored the mind's potential.

APPLICATION

Head and brain

1 The head and the retouched scanner image of a vertical slice of the brain seen laterally were prepared for this composite. The sky was chosen later.

2 The brightness of the silhouetted head was adjusted to maintain contrast for the brain plus some facial detail. Lightning arcs were added for one magazine.

Computer screen

1 Both monitor and keyboard were retouched to simplify their details and smooth the texture. The landscape was selected to add warmth and depth, while remaining unobtrusive.

2 In the final layered image, extra touches to add to the sense of depth and to help embed the screens in the scene are the color shift toward that of the background, and the wisp of cloud.

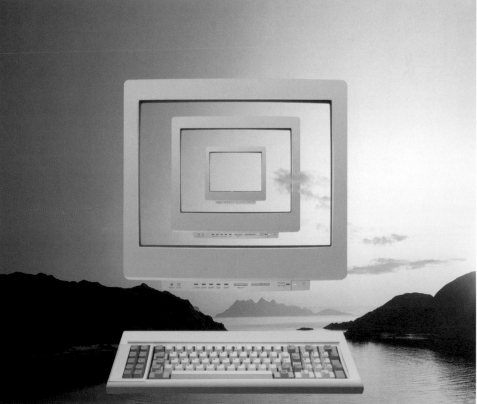

APPLICATION

WORKSHEET

Idea
Particles of light moving together at great speed

Solution
Treat the lights as sparkling flare. Use curved streaking in strong perspective directed toward the viewer to convey velocity

Software
Flare and blur filters

Techniques
Motion control, compositing, flare, blur, color balance

WORKSHEET

Idea
Bottomless sky, for use as a background

Solution
Place an inverted copy of a sky directly underneath

Software
Standard image-editing

Techniques
Copy, paste, invert, blend with a gradient

Abstracts

Far from being vague or pretentious, abstract images like these have a variety of uses, often way beyond their original intention.

If symbols are the most focused and explicit kind of conceptual imagery, at the opposite end of the scale of precision are abstract images. What defines abstract is first, the lack of a clear, realistic subject in the photograph, and second, a reliance on the elements of color, shape, line, direction, and so on. In other words, less content, more emphasis on form.

As abstract images don't pin things down exactly, they not only succeed in comparison with representational images but are often better than words. From a professional point of view, images like these can be surprisingly successful commercially. Graphically, they usually have large areas without detail, which makes them ideal backgrounds to headlines and type. For the same reason they are adaptable as backgrounds in composite images.

Tripping the light fantastic

The apparent simplicity of most abstract images does not mean, of course, that they are necessarily quick and easy to execute. The two examples here are chosen partly to illustrate this by contrast. One was almost as simple to produce as it looks, the other needed a lot of underlying work to remove detail and restrict the image to its essentials. In execution the more complex of the two is the image with the rapidly moving lights, not because the elements themselves were particularly difficult, but because the treatment had to strike a balance between

the lights and streaks being readable and being generalized. In this context, generalized meant imprecise, not sharp. For the lights this was not complicated, but meant a certain amount of experimenting and retouching, beginning with a flare filter (Knoll Lens Flare). Specifically, I wanted a flare effect that was not perfectly symmetrical (more realistic), but which had a definite axis. This was so that the lights could each be rotated to add to the dynamic effect.

Super-cool curves

Dynamism was the entire purpose of the image, and the way to achieve this was through the composition: extreme perspective and curved motion streaks to give the impression that the lights are rushing out toward the viewer. Ironically, although this is a successful stock photograph and has been used many times to illustrate many different subjects, it was in fact created to show a highly specific scientific phenomenon, namely the acceleration of electrons caused by super-cooling. For this reason I went to more trouble than usual, and while the streaks suggest the use of a motion blur filter, in fact the best controlled effect was a tiny light moved along a track by an electric motor, photographed with a time exposure. Track and camera were positioned at different angles, and the results composited digitally, with some shape distortion and retouching as necessary.

For the sky image, the idea was that it should appear endless vertically, as if the camera were floating in a kind of eternal space, yet should nevertheless be a realistic setting with depth. To convey this realism and depth, the image needed certain triggers, in particular a few distant wisps of cloud and a sun, so the choice of source photograph was critical. The execution relied on the extremely simple technique of mirroring. Doing this digitally meant sufficient precision to place the axis of the two images in the center of the sun, which appears as a single element. A small but important final touch was to add a very slight asymmetry, by removing the mirrored version of the long cloud close to the horizon and shifting the upper copy down to straddle the axis, as shown.

The final image conveys the impression of high velocity without using any specific object, largely through the sense that the streaked lights are rushing just past the viewer.

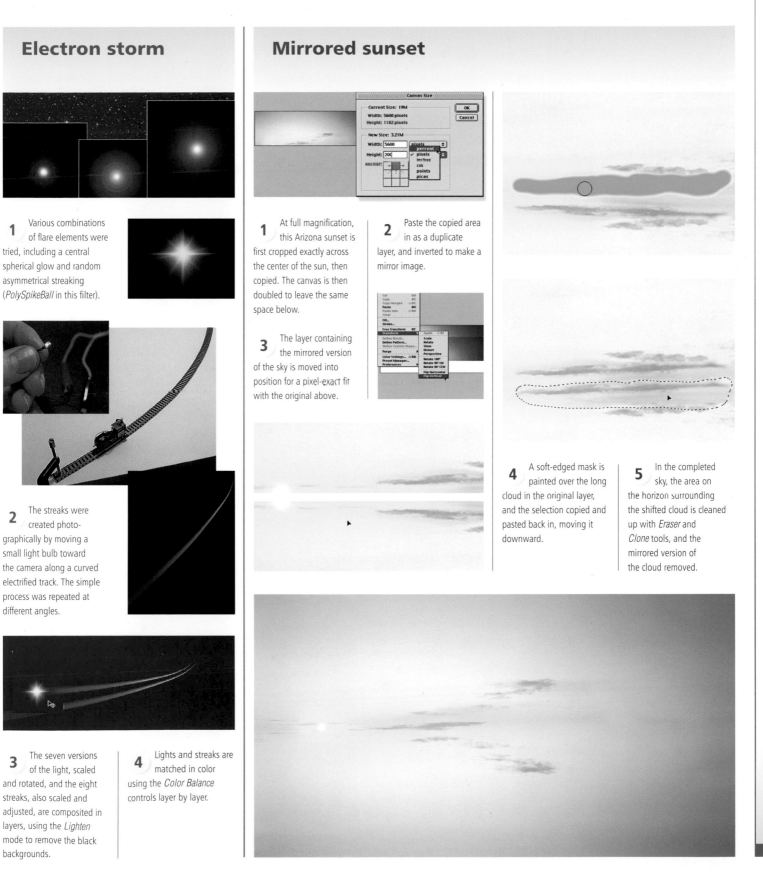

Electron storm

1 Various combinations of flare elements were tried, including a central spherical glow and random asymmetrical streaking (*PolySpikeBall* in this filter).

2 The streaks were created photo-graphically by moving a small light bulb toward the camera along a curved electrified track. The simple process was repeated at different angles.

3 The seven versions of the light, scaled and rotated, and the eight streaks, also scaled and adjusted, are composited in layers, using the *Lighten* mode to remove the black backgrounds.

4 Lights and streaks are matched in color using the *Color Balance* controls layer by layer.

Mirrored sunset

1 At full magnification, this Arizona sunset is first cropped exactly across the center of the sun, then copied. The canvas is then doubled to leave the same space below.

3 The layer containing the mirrored version of the sky is moved into position for a pixel-exact fit with the original above.

2 Paste the copied area in as a duplicate layer, and inverted to make a mirror image.

4 A soft-edged mask is painted over the long cloud in the original layer, and the selection copied and pasted back in, moving it downward.

5 In the completed sky, the area on the horizon surrounding the shifted cloud is cleaned up with *Eraser* and *Clone* tools, and the mirrored version of the cloud removed.

Glossary

2½-D 3-D squeezed in z-depth, a feature of flat images imported into a 3-D program as 2-D objects. They can be manipulated, moved and rotated, but have no front-to-back depth.

3-D Imaging systems that compute objects and scenes in depth, using three axes, which are by custom designated x, y, and z. The z-axis, from front to back, describes depth. Onscreen, 3-D images are typically displayed in the form of wireframe (wire mesh) shapes.

3-D digitizer Device and software that converts a real object into a 3-D computer model. Methods vary from optical stereo scanning to a digitizing pen.

algorithm Mathematical procedure that allows the step-by-step solution of a problem. In imaging software, a set of code that defines exactly how the values of pixels in an image will alter.

alpha channel A grayscale version of an image that can be used in conjunction with the standard color channels, such as for creating a mask.

Bézier curve An irregular curve described by a mathematical formula. In practice, it is produced by manipulating control handles on a line that is partly held in place by anchor points.

bump map A pattern of paired, opposed highlights and shadows applied to an image to create the impression of bumps and dents.

bump shading A way of simulating three-dimensionality in a surface by lightening an area in the direction of presumed lighting, while darkening an opposite area to simulate light and shadow on an elevation, or "bump".

cloning In an image-editing program, the process of duplicating pixels from one part of an image to another.

control point A reference pixel in an image, located by the user, which controls changes to other pixels. Used, for example, in morphing, to direct the movement of pixels from one image stage to another.

displacement map A grayscale image, usually in the form of a gradient of tone, that instructs a displacement filter how, and by how much, to shift pixels within an image. Mid-gray (50 percent brightness) denotes no displacement. Darker denotes positive, and lighter denotes negative.

extrude, extrusion 3-D technique for extending a 2-D object along a third axis.

fade Reduction of the intensity of an effect, usually in terms of its opacity.

fadeout The extent of any graduated effect, such as blur or feather. With an airbrush tool, for example, the fadeout determines the softness of the edges as you spray.

filter Imaging software included in an image-editing program that alters some image quality of a selected area. Some filters, such as *Diffuse*, produce the same effect as the optical filters used in photography (after which they are named). Others create effects unique to digital imaging.

fractal Mathematical equation that can generate infinitely detailed, self-similar patterns, in which the same pattern features are repeated at different scales.

fragmentation The process of breaking up and dispersing components of an image. Used, for example, to simulate an explosion. It is principally a 3-D procedure.

image-editing program Software that makes it possible to enhance and alter a digital, or digitized, image.

immersive imaging The use of photography to take in an overlapping series of views of a scene or an object, with the end-product being an interactive movie in which the object or scene appears to rotate.

interpolation Bitmapping procedure used in resizing and warping an image to calculate new values for pixels. When the number of pixels is increased, interpolation fills in the gaps by comparing the values of adjacent pixels.

iteration The process of repeating an operation. In software, the kind of procedure that requires repetitive calculation, step by step. Fractals, for instance, involve iteration.

knockout Imaging procedure, and software, that removes the background from a subject by means of smart masking, accommodating soft and intricate edges.

lathing 3-D technique in which a 2-D image plane is rotated around one of the axes, like a piece of wood being turned on a lathe. The result is a 3-D object which, viewed along the new axis, is seen as a disk. The process is used for creating symmetrical objects.

layer Image-editing programs divide images into layers that are 'stacked' on top of each other, like virtual sheets of acetate. Each contains separate elements that can be individually addressed and edited.

mask A grayscale overlay that can be used to select or conceal part of an image, and one of the most important tools in image-editing. A mask is stored in an alpha channel and can be accessed as a selection.

morphing The process of "metamorphosis" between one image and another, which uses warping to move pixels. Those pixels chosen by the user are moved to a new position. Nearby pixels follow them to a lesser extent. A spline algorithm is used to control the rate of change.

motion control Precise, repeatable movement of an object assisted by a computer. The technique is used in stop-motion filming and other sequences where precision is vital.

motion stepping Moving an object or an image in discrete steps, to display its motion in overlapping stages.

noise Random patterns of pixels that give a speckled appearance to a digital image. An artifact in photography, but an intentional effect when produced by a filter to conceal banding, or to mimic film grain.

object photography One of two kinds of immersive imaging, in which an object is photographed from many different viewpoints, and the sequence of images is combined into an interactive movie. The person viewing has the impression of being able to rotate the object at will. (The other kind is scene photography.)

parameter A quantity that is constant for any one case or situation, but varies from case to case. A set of parameters defines the way an effect is implemented.

planar An image or effect located in 2-D on a plane.

plug-in (module) Software produced by a third party and intended to supplement a program's performance.

procedural effect An effect that is applied within a range or in a sequence, not to the entire image. Procedural blending, for example, is when one object is merged into another over a mask, which limits and controls the effect.

ramp The term used to describe a gradient, as in a smooth change of color or tone.

random seed The source from which indeterminate, random effects are generated. In those filters that use random procedures to create a natural, organic result, there is usually a choice of seed.

raytracing The superior method of rendering a 3-D construction into a 2-D scene, in which imaginary rays are traced from the viewpoint into the scene. The color and brightness is calculated for each polygon on each object the ray strikes as it bounces around the scene.

render(ing) The process of performing the calculations necessary to create a 2-D image from a 3-D model.

resampling Changing the resolution of an image either by removing pixels (lowering resolution) or adding them by interpolation (increasing resolution).

rig Mechanical support for an object to be photographed, which allows it to be variously and steadily positioned.

Rubber Stamp A paint tool in a image-editing program (especially Photoshop) that is used to clone one selected area of the picture onto another. It allows painting with a texture rather than a single tone/color, and is particularly useful for extending complex textures such as vegetation, stone, brickwork, and so on.

scene photography One of two kinds of immersive imaging, in which a scene is photographed from a single viewpoint, but with the camera swung around between shots. The sequence of images is then combined into an interactive movie. The person viewing has the impression of being able to look around, and sometimes up and down as well. (The other kind is object photography.)

selection An area of the image that is chosen and defined by a border, in preparation for making changes to it or moving it. Any of several selection tools available in an image-editing program can be used to make this selection. If saved, a selection is stored in an alpha channel and can also be viewed as a mask.

smart mask A selection procedure in which the effect of the background on the edges of a subject is computed (including reflections, transparency and overspill), so that when the object is removed and placed against a new background this is eliminated.

software Programs that enable a computer to perform tasks, from its operating system to job-specific applications, such as image-editing programs and third-party filters.

stitcher Software that blends overlapping images seamlessly.

stylize To render an image in a specific graphic style, thus making a photograph non-realistic in some way. In digital imaging this usually means applying a filter that reproduces an art-media effect.

texture mapping A 3-D procedure in which a 2-D surface is wrapped around a 3-D model.

tiling A method of creating or reproducing a large image area by adding adjacent sections of a basic shape, usually a square. For instance, a texture can be extended across the entire screen by copying and joining-up a small square of the texture. One essential is that the joins are seamless, to give the appearance of being continuous.

warp Image distortion in which areas of pixels are moved from one stage to another, as in morphing. In forward mapping some pixels are moved from the source image to the destination and the others follow by interpolation. In reverse mapping all the pixels in the destination image are calculated back to points in the source image.

Index

Further information

WEB SITES

Photoshop Sites (tutorials, info, galleries)

Absolute Cross Tutorials (including plug-ins)
www.absolutecross.com/tutorials

Designing Tutorials (sic)
www.dsigning.com/photoshop/tutorials/

Laurie McCanna's Photoshop Tips
www.mccannas.com/pshop/photosh0.htm

Planet Photoshop
(portal for all things Photoshop)
www.planetphotoshop.com

Ultimate Photoshop
www.ultimate-photoshop.com

Digital Imaging and Photography Sites

Creativepro.com (e-magazine)
www.creativepro.com

Digital Photography
www.digital-photography.org

Digital Photography Review (digital cameras)
www.photo.askey.net

Everything Photographic
www.ephotozine.com

ShortCourses
www.shortcourses.com

Special Effects Software

Please note that complete links to all of the software sites listed below can be found at our URL: www.dpspecialfx.com

Bryce 5
www.corel.com

Chromassage
www.secondglance.com

DreamSuite
www.autofx.com

Eye Candy 4000
www.alienskin.com

Fire 3.0
www.panopticum.com

Flexify
www.flamingpear.com

Flood 1.0
www.flamingpear.com

Furbo Filters Designer Pack
www.furbo-filters.com

Greg's Factory Output Vols 1 & 2

HoloDozo 1.0
www.mmmsoft.com

iCorrect Pro
www.picto.com

Image Modeler
www.realviz.com

Knoll Light Factory
www.pinnaclesys.com

KPT (Kai's Power Tools)
www.corel.com

LensDoc 1.1
www.andromeda.com

Lens Pro II
www.panopticum.com

LunarCell
www.flamingpear.com

Mask Pro 2.0
www.extensis.com

Melancholytron
www.flamingpear.com

Mr. Contrast
www.flamingpear.com

nik Abstract Efex Pro!
www.tech-nik.com

nik Color Efex Pro!
www.tech-nik.com

Paint Alchemy 2
www.xaostools.com

Perspective 1.1
www.andromeda.com

Photo Frame 2.0
www.extensis.com

PhotoTools 3.0
www.extensis.com

PictureMan
www.stoik.com

Portfolio
www.extensis.com

Stitcher 3.1
www.realviz.com

Terrazzo
www.xaostools.com

VariFocus 1.1.1
www.andromeda.com

Velociraptor
www.andromeda.com

XaoS Fractal Zoomer 3.1
www.paru.cas.cz/~hubicka/XaoS

Xenofex 1.0
www.alienskin.com

Other Useful URLs

Adobe (Photoshop, Elements, Illustrator et al)
www.adobe.com

Agfa
www.agfa.com

Apple Computer
www.apple.com

Corel (Photo-Paint, Draw)
www.corel.com

Epson
www.epson.com

Formac
www.formac.com

Fractal
www.fractal.com

Fujifilm
www.fujifilm.com

Iomega
www.iomega.com

Kingston (memory)
www.kingston.com

Kodak
www.kodak.com

Luminos (paper and processes)
www.luminos.com

Macromedia (Director et al)
www.macromedia.com

Microsoft
www.microsoft.com

Minolta
www.minolta.com

Nikon
www.nikon.com

Nixvue
www.nixvue.com

Olympus
www.olympus.co.uk
www.olympusamerica.com

Paintshop Pro
www.jasc.com

Pantone
www.pantone.com

Philips
www.philips.com

Polaroid
www.polaroid.com

Shutterfly (Digital Prints via the web)
www.shutterfly.com

Sun Microsystems
www.sun.com

Umax
www.umax.com

Wacom (graphics tablets)
www.wacom.com